COLORS OF THE SOUL

Also by Dennis Klocek from Lindisfarne Books

The Seer's Handbook
A Guide to Higher Perception (2004)

Climate
Soul of the Earth (2011)

Sacred Agriculture
The Alchemy of Biodynamics (2013)

Esoteric Physiology
Consciousness and Disease (2016)

COLORS OF THE SOUL

Physiological and Spiritual Qualities of Light and Dark

DENNIS KLOCEK

Lindisfarne Books | 2017

2017
LINDISFARNE BOOKS
An imprint of Anthroposophic Press/SteinerBooks
610 Main Street, Great Barrington, MA
www.steinerbooks.org

Copyright © 2017 by Dennis Klocek. All rights reserved.
No part of this publication may be reproduced, stored in a retrieval system, or transmitted, in any form or by any means, electronic, mechanical, photocopying, recording, or otherwise, without the prior written permission of the publisher. This book is based on previously-unpublished lectures given at Rudolf Steiner College Coros Institute in the summer of 2010.

Cover image: *Succession* (1935) by Wassily Kandinsky
(The Phillips Collection, Washington, DC)
Design: Jens Jensen

Published with generous support from the
Waldorf Curriculum Fund

LIBRARY OF CONGRESS CONTROL NUMBER: 2017944836

ISBN: 978-1-58420-960-7 (paperback)
ISBN: 978-1-58420-961-4 (eBook)

Contents

1.	Physiological and Spiritual Qualities of Color	1
2.	The Nature of Color	18
3.	Color Use in Paintings	30
4.	Primaries	62
5.	Turbid Medium	82
6.	Glory Sun	94
7.	Colored Shadow	106
8.	Color Intensification	124
9.	The Grotto	138
10.	Dinshah Color Therapy	145
11.	Circle of Color	160
12.	Indigo	179
13.	Turquoise	191
14.	Carmine	199
15.	Purple	213
16.	Vermilion and Cobalt	229
17.	Flower Essences	241
18.	Conclusion	249
	Appendices	
	1. Homeopathic Qualities	266
	2. Homeopathic Remedies	269
	3. Soul Moods in Colors	271
	4. Soul Wheel	277
	Bibliography and Further Reading	279

1

Physiological and Spiritual Qualities of Color

The subject of color is a very important aspect of healing, especially the healing of what we could call the split in the world created by human beings. Rudolf Steiner speaks about this splitting in many different ways with a kind of hidden language. It is hard to understand the fundamental idea, so I would like to present it in a nutshell. I will then present a little meditation to work with the alchemical principles of Jachin and Boaz—the red and blue in the blood—to understand the Rosicrucian path in terms of healing.

Goethe, as a Rosicrucian, developed his theory of color, which is a Rosicrucian document. Its Rosicrucian element has to do with this problem in human nature of splitting sensation in the sensory world and splitting the human inner life by forming concepts through thinking. This fundamental rift in the cosmos is created by human beings, and there is a whole **blue** dimension in the world of spiritual beings; we could call them color beings, who represent the possibility of joining that split together again. There is a whole hierarchy of beings—archetypal color beings—who represent the zodiacal consciousness of the human. If you consider the zodiac as a whole, you will get this archetypal potential; you get the archetypal human from the zodiacal archetype of color. Color beings live in a certain realm in the spiritual world and present to us only potential. They give human beings the potential for understanding why we need to be incarnated, as well as what Rudolf Steiner calls continuity of consciousness, or the ability for consciousness to extend between lifetimes. There is a domain in the realm of spirit beings who represent what we call color in the physical world. However, what we call color is the corpse

of those spiritual beings. What we perceive as color in the sensory world is merely a reminder of that realm. Our task involves understanding how to develop an organ in ourselves, so that when I perceive color I can simultaneously experience color not only in the sensory world, but also the archetype of that color and how it operates in the totality of a zodiacal "I"-being.

With color, we have the opportunity to navigate and not just understand it. I can create conditions whereby color can manifest briefly my consciousness, but then it quickly becomes a corpse. We call this art. The true nature of color falls into a corpse. When we study color as a science, it has all the nuances of psychology. The various colors are characteristic dispositions of the archetypical human. Color is actually different constitutional entities that mix and match and present polarities, tensions, resolutions, and so on. These qualities are colors that form the basis of psychological properties. Within the different aspects of color we find all the psychological properties in what we call color, but we have to understand that the colors we see in the physical world are not seen as they exists in spiritual reality. A color that we see in the world is just a "message" that represents something. It is presented to remind us of something, but normally we see it only as what we think it is. We might say it consists of molecular vibrations, particulates, or whatever, as we will see with individuals such as Newton, but the descriptions. However, all these things in physics, for example, that we can study about color, only represent a kind of symptomatology of a whole human being. And if you have a problem with a color it means, as we will see, that you do not allow yourself access to a part of your soul. When we need color and cannot gain access to it, we substitute other things.

Nonetheless, if we go into this deep color realm without really understanding the artistic side of it—color keys, mixing colors, value structure, temperature, hue bands, chroma, alternating and complementary colors, and so on—if we don't understand the artistic side of color, we can become ungrounded. Artistic practice and the physics of color offer the necessary ground for understanding how we can take in color and work

with it inwardly as medicine. Color is pure soul from one of the twelve positions in the cosmos. When we can get at least a feeling for these color potentials, then there is a possibility for healing.

Red, for example, in the soul is a symbolic picture, and Rosicrucian healing work takes place through symbols. The first step in Rosicrucian work is study, the act of acquiring ideas. The second step is, now that we have some ideas, to transform those ideas into symbolic pictures. Red in the world is a sensation; red in the world is objective and has nothing to do with you and everything to do with the archetypical condition of a certain configuration coming together, reminding us of something forgotten. The certain way in which light and dark mingle gives us a chance to remember why we returned—because our soul is a light embedded in the darkness of our body. It is the archetypical condition, and if that is good for us and we feel good about it, we are on the red side; and if we do not feel good about this, then we are on the blue side—we have the blues. If your body's a burden, we have the blues, unless we have overcome that; then we are true blue.

Every color is both positive and negative, and that makes it difficult to study. If two people are discussing color, one might crave vermilion and the other might become sick if forced to look at vermilion. Both relate to the same color but in polar ways. This gets even deeper, because we need color; we actually project it into spaces where there is no color. We will consider the colored shadow experiments of Goethe later. There is no color in the shadow, but it appears as color; but it is not color as we usually think of it. However, in the colored shadow experiment, where does the color come from? We start there and begin to understand that color is not what we thought it was and a lot more than we thought it could be.

Color has a huge potential for helping us to understand the soul and ourselves. Early in his life, Rudolf Steiner inherited leadership of the Theosophical Society in Germany, and he decided to have a big conference on the nature of the arts in Munich, the "Munich Conference." He wanted to let the Theosophists know that art was an enormously

important, integral part of the esoteric work in the Theosophical Society. The Theosophists considered color to be simply eye candy. Yeah, we need some art; we will hang a few pictures around the hall for the meeting. Steiner said no; art is the doorway we need to do our theosophical work, especially the aesthetic perception that leads to an ability to form symbols. When I can form a symbol, I am on the path to healing. (That is from Carl Jung.) The ultimate symbol is one that changes, depending on how I look at it. We will find out whether that is red or blue. Steiner wanted to tell the Theosophical Society that change was coming—that we are going to change the way we do business; we are going to change things. Therefore, where the hall was all black and gray, he had vermilion-red curtains installed, accompanied by strange, esoteric mandala images that he and an artist had made. When those theosophists walked into the hall, they thought: *This is not Theosophy. Red is the Devil's color?* However, this became part of his address—speaking about the color red in the mood of the hall, Steiner commented,

> This color was meant to make visible the fundamentally festive mood. Naturally, there will be some objections to the use of red for this purpose. These objections are justified only as long as we rely on esoteric judgment and experience. Such objections are well known to the esotericist, who nonetheless must use the color red in accordance with esoteric symbolism for the purpose under consideration [to have a spiritual meaning, a spiritual conference]. For it must not be a question of what that part of his or her being senses that turns toward the immediate material surroundings, but rather what the higher self experiences in the hidden, spiritual working while the outer surroundings are seen physically as red. (*Rosicrucianism Renewed*, p. 30)[1]

It is not a matter of what you see when you look around at your surroundings and experience red, but rather what the higher self experiences in the hidden, spiritual activity—even as you see your surroundings as physically red. Putting his finger right on it.

1 Steiner, *Rosicrucianism Renewed: The Unity of Art, Science, and Religion: The Theosophical Congress of Whitsun 1907.*

It is just the opposite from what the ordinary feeling says about the color red. Esoteric knowledge says: "If you would attune yourself inwardly as the gods were attuned when they gave the world the green covering of plants, learn to endure the red in your surroundings just as they had to. (ibid.)

If you would be God and you would bring the green covering of plants to the world, you must endure red.

This points to the connection of the higher human nature to red, which true esotericists have in mind when they represent both of the opposite essences of the creative Ground of the World in esoteric symbolism, such as that toward the bottom is green, as the sign, or symbol, of the earthly, and above is red, as a sign of the divine creator-powers of the Elohim.[2]

That red he describes is a kind of vermilion, almost magenta color. He calls *red* creative wrath, a kind of frenzy of creation in the red. You have to endure that to be able to create the green of plants. He is saying: I know you see what you are seeing, but you have to take it somewhere else to see what you need to see; you have to see the red as a symbol of something—a creative act of something, not merely as it appears as a light wave of so many cycles per second. You may understand that light wave or color key as red-blue, yellow-blue, magenta, and all these different varieties of red. Is it red? No, it is not red, because the reds I named are a panorama of different qualities of being. There is the sienna of St. Francis to the Wrath of God. The creative wrath of the Elohim, who create the world, is vermilion red. It is all red, but the nuances of red, blue, and the infinitude of greens in the world all form a whole universe of soul potentials.

Pablo Picasso was asked about the Barbizon painters. They painted out in the Barbizon woods in France. Corot, an early Barbizon painter, did classical, lyrical landscapes, filled with trees and someone rowing a boat. The person in the boat has a little red cap. In this kind of gray-green mood is the glowing little dot of a red cap. This is the Barbizon

2 Ibid., p. 31.

style. Picasso, when asked what he thought of Barbizon painting, said it gave him green sickness—it is too much green. He would rather paint red, yellow, blue and shatter some things, maybe play the trumpet. This doesn't mean green is bad, but Picasso was a bull. He probably needed a green-souled person for a secretary.

This sort of split in human beings in the world is between sensation on the one side (the vibrations of a color on an object) and a color as an experience in the soul. Steiner talks about color simply as vibration early in his work. There is a little book called *Nature's Open Secret*.[3] It contains Steiner's essays when he was editing Goethe's morphological writings in Weimar as young man. He wrote essays about perception, cognition, sensation, and Goethe's idea of the *type* and the *archetype*. It can be a difficult book, because he is trying as a young man to grapple with the philosophical basis for sensation. He came much closer in a later work taken from his unfinished notes.[4] The two books act as "bookends" to Steiner's efforts to work out this problem during his life.

In those early essays, he describes the perception of red. Basically, he says that, if you take a light meter (or a colorimeter) and you put it on the color on an object, it will give you a reading, but if you aim that meter into the air in the direction of red, for example, the meter will give a different reading. And when that red light hits the retina of your eye, this is a whole different matter. In this case, red becomes a phenomenon in your optic nerve. Is this red the same red we find with the meter? Steiner's answer is that red is what it is at each stage, because this is the way sensation works. Sensation actually brings a multiplicity of what is essentially a unity for the spirit. The world for the spirit has an overarching unity, but as it comes closer to manifestation in the sensory world, human sensory experience leads to multiplicity. We look at red and say: That red is different from this red. Those are different reds. That is how my sensory experiences it out there, and I need to take that multiplicity inside,

[3] Steiner, *Nature's Open Secret: Introductions to Goethe's Scientific Writings.*
[4] Steiner, *Anthroposophy (A Fragment): A New Foundation for the Study of Human Nature.*

because as long as it is outside, I can never find the real red. I find red only as a particular frequency of light, as a particular pigment, or red as a hue in the sunrise or on a peach. I find that particular red in that situation. So we say: What does this have to do with me? And Steiner's surprising answer is this: Probably nothing until you become aware of it. Of all the colors we see here, there is much of which we are unaware in them. We have a sensation, but not perception. This is a big key in Steiner's work.

Perception means we can take from the sensation something that is hidden in it. There is something in the sensation that we cannot explain conceptually—otherwise, we would not have to have a sensation. When I look at a red, there is the red; if you are blind, I might tell you it is nuanced—maybe an alizarin derivative, with a little bit of yellow and maybe a little bottom note of something else. I could be as specific as I want in my descriptions, details, and concepts, but you would not have the experience unless you have developed an organ of perception. Blind people can develop the most delicate color perception of anyone. They see it through their hands; but it must first become a *perception*. The sensation must become a perception by bringing to the sensation something that is not present in the sensation. Something is there in the sensation that cannot be explained by a concept, but something is there in the inner life of a person who has a perception not present in the sensation. This is the split, and it is difficult to understand, but don't worry about it. If you can at least get a feeling for this, it can be a kind of mantra of the threshold. The sensory world has fallen into a corpse, carrying something in that corpse that I cannot provide for myself. It is like looking at my hand. I have my hand, but I cannot provide the force of my senses to create that thing out there. There has to be something present in the sensory world that I cannot create in my inner life. It sounds obvious, but it is a big issue, especially with color. Is color a thing out there or something in here? And the answer is, yes. The question is: Do you know it? If you know it, you can be healed. If you don't know it, then it remains split.

Color represents the kind of realm in which we can lift color out of things and take it into ourselves as a form of soul development. When we

lift it out of things and take it in, it starts to represent my soul properties. When I observe it out there in the world, it has very little to do with my soul properties. Then we have cycles per second, frequencies, scattering, and all sorts of optical aspects on which Goethe based his color theory: four books on physical color, optical color, mixing, chemical color, and one book on psychological color—*Farbenlehre*, or color theory. That is five books—four on world phenomena and one on soul phenomena. Goethe's four books on stuff in the world have been pooh-poohed by science. The most important one is on the soul, and it has been relegated to the ash heap of history. It is my mission to resurrect it.

How do I know that a perception I have inwardly of a color matches the thing that is out there? I will say to you there is something red. You look at the red and say, that is red. However, I have no idea if what I say is red is the same red you see. I say "red," and you can point to it, but if I don't like red inwardly, I may not be having your experience. We point to it and say it is red, but when I see that red, I am thinking "Awk," and you are thinking, "Yeah." This is the issue between red as a sensation that we can measure in cycles per second and so on, and red as an inner experience divorced from the physical world in which I have to take that color into me and work with it meditatively to see how it works in me. But we could say (and the language I will use when we do) that color at that level in the soul is "yearning to become." It is trying to become something else. There is a force in it. There is push and pull in it.

Hans Hofmann (1880–1966) was a renowned painter and teacher in the 1950s and '60s when the whole idea was push and pull in color for New York art. These esoteric principles I am laying out as an idea were not lost on artists. They are exactly what the great artists are trying to do. We will get to Kandinsky, Rothko, and a little art history survey in the next chapter. How have these artists used color to express their worldview? The ways a color is used in a particular age is connected to the techniques artists will use. Technique is connected to the way artists make their materials, which allow certain soul properties to be brought

forward. When aniline dyes were developed just before the time of van Gogh, it became possible for him to express things that a century and a half earlier would have been impossible to express, since they lacked the range of colors. That is just one door that opened through aniline dye. This becomes the story of impressionism. Such color ideas as esoteric principles drive the artistic worldview, bringing possibilities for expressing inner states in much more complex ways than was possible when all people had was dirt of various colors being pushed around by animal hairs tied to a stick. Of course, color has gone far beyond that. Color is a doorway to self-transformation. It is the substance of the soul. If you learn to manipulate and work with it, you can actually feed yourself colors to gain balance.

The Munich Conference was really about the incredible functionality of the arts—the need for the arts to be considered as integral to anthroposophic activity. Without them it just becomes intellectual games, but once the arts serve the esoteric principle, there is a possibility for understanding the Rosicrucian path. On the stage and in the decorations for the stage at the Munich Conference, Rudolf Steiner had a symbol with two columns—Jachin and Boaz—based on those from the temple of Solomon. Jachin was blood red, and Boaz was blue—the colors of the blood. Hidden in the blood is a great mystery. Red blood is oxygenated, but the oxygenated blood is the blood that takes the hit. Wherever the oxygenated blood goes, the cells go, getting rid of junk taking the good stuff. Oxygenated blood comes from the heart and goes through the arteries with a mission of power—Vermilion, bright blood. However, as soon as it touches anything in the body, it goes into death. Its mission is to die, because it is so vigorous. That is the pole of Jachin—life going into death. (I will present the full mantra later on).

We can use this as a kind of tool for going through the work, because Jachin and Boaz are the red pillar and the blue pillar. Red and the blue— Goethe called them *primaries,* and there have been numerous studies on red light and blue light. There is great potential for the healing forces of red light and blue light. Of course, there are a lot of other researchers

that we will also consider—for example, the Dinshah color system and Catherine Coulter's system of homeopathy. There has been a lot of work done on using red light to create warmth and blue light to dampen inflammation. Red and the blue are two polar qualities. Jachin represents red blood, which has the great mystery that is full of life but gets totally depleted and dies. Blue blood is the pole of Boaz. Steiner calls it "reddish-blue"; we would call it ultramarine or a lighter hue of cobalt. Cobalt and ultramarine give a red cast to blue in contrast to phthalo blue, or Prussian, which has a slight green cast. Thus the red-cast blue is Boaz, or death transforming into life.

In color theory, the red-blues are on the edge of the spectrum, where ultraviolet goes beyond visibility. Steiner considered that area to form a circle eventually, whereby ultraviolet–cosmic chemistry mysteriously meets and is reborn in infrared–cosmic warmth. Jachin, the pole of "life into death," is the formation of a thought; it is called salt—the corroding or precipitating descending forces, the forces of autumn. Fall is the season when all the living stuff starts to go into this netherworld. It is the pole of Jachin, which is a door that we have to face. In Chinese medicine, this is metal. The element of metal is the Fall. In Chinese medicine, metal refers to hidden vitality in the fixed appearance of the sensory world. It is not the sensory world itself, but the *essence* in the sensory world. Jachin has the hidden flame-like life in the sensory world that we cannot really see. Behind the phenomena of the sensory world is this mystery of the great sacrifice coming from "life going into death," or the pole of Jachin.

The pole of Boaz, the blue "death into life"—that is what Rudolf Steiner calls sulfur, in contrast to salt. It makes new potential—love, surrender, the ascending forces of growth and spring. In Chinese medicine it is the wood element. Between metal and wood we have Jachin and Boaz—the falling of life into death, and then from death comes resurrection. In Chinese medicine that is wood. In wood, mud and water get together and something happens in the spring. Now there is a mantra from Rudolf Steiner for Jachin:

> In pure thinking you find the self
> that can hold itself.

Later we will consider a quotation in which Steiner calls these two lines Rosicrucian study. In the Rosicrucian stream, the first step is study, which is not just reading books, because, "In pure thinking you find the self that can hold itself." *Pure thinking* is thinking with no thoughts. *Study* means that I manage to monitor how thoughts arise in my consciousness and then cancel them out. This is what a Rosicrucian calls study. When I can watch a thought arise and say to the thought, thank you but I am doing something else, and send it on its way, that is study. If I watch the way thoughts arise and go away, I begin to see a picture of myself. The arising and falling away of a thought has a kind of gesture or mood. Does it rise like a tiger or like a lizard, or does it arise like dawn breaking over a dewy meadow? Exactly how do the thoughts arise? If we get into this and are in the dewy meadow with the sunbeams touching little drops on the tips of grass, and then the phone rings, we begin to understand the concept of study. We suddenly go from the dewy meadow to inner broken glass. It takes a while to recover.

Thus, watching a rising thought and then canceling it into silence is study. "In pure thinking you find the self / that can hold itself." These are the first two lines of Jachin. The next two lines are:

> Transfer to picture the thought
> So that you experience creative wisdom.

Creative wisdom is how the Elohim create the world by going into the screaming-red-wrath-of-God room. That is their creative wisdom for creating the green of the plants. This is the picture Steiner presented at the Munich Conference; he had Jachin and Boaz for everyone to see. He had these colors in it, and the people wondered what it meant. He gave these mantras to explain what the images mean. The pillars symbolize what is actually a creative power in human beings. We need blue so we can chill out a little, but we need red when we need to get up and go to work in the morning. If we cannot use red when we need to get up to go

to work, but instead need to substitute green or maybe purple, then we get a different outcome. This is where the whole human work comes into play: Can I watch a color of thought—thought that has a kind of color to it—arise in me, and then say: What color is this? What does it represent? To a doctor or a healer, this is called a diagnosis.

A person walks in and sits down, and you start asking about that person's kidney, and the person starts talking about all sorts of things. You asked about kidneys, but now you hear that this person drinks a lot of soda, which makes you think about phosphorus and so on. Pictures come from people by just being who they are; they give you pictures, and if you do the necessary inner work, those pictures can be rendered in you as color. You meet someone, and the quality of his or her soul color, the archetype, reveals a colored flame. People are colored flames who—depending on to whom they are talking—change in nuance.

That is Jachin—life into death. Boaz, on the other hand, is death into life, or blue. There is also a mantra for that:

> Intensify feeling into light to reveal the forming power
> Concretize the will to being so you create in world being.

This is more difficult than the Jachin mantra. It is about what we call *manas,* or the creation of *manas* and *buddhi,* the transformation of the life forces through and inner picturing process.

When I start to work with colors, I can become aware of how the colors around me shape and change my inner landscape, and how colors in other people around me can shape and change their inner landscape; it becomes a different kind of language. To do this, I have to take the sensation of the others' facial gestures, bodily movements, and so on into myself. If I experienced red outside, would a person remind me of that? Or would it be blue? I could ask someone to stand and then do "red" by moving toward the person with raised arms. Or I could do "blue" by turning and walking away from the person. We could experience an even stronger blue by first walking toward the person and then quickly walking away backward, still facing the person. This would present a darker

blue, more of a cobalt—a shining, Virgin mantle blue. These are just gestures and inner feelings of nuance and relationship. Am I being threatened, can I grab this, or is it moving away from me? A sunny greeting is yellow. These are inner qualities of what is out there, but a translation is needed between the sensation and the perception.

In the next chapter, we will look at a colored-gel test that I developed over the years to help people understand these things. Now, I would like to consider a survey form (page 14). This chart is meant to interface with the color chart (page 15). The top text says "magenta." In the color chart, that color is magenta to the degree that a computer and printer can get it. The bottom text says "green," which is also in the color chart meant to interface with the text chart. Take a few moments to look at the color chart and its little colored discs. Look at one for a while and then try to represent that color to yourself inwardly. Then look at the next colored disc, go inward, and try to find which colors allow you to grab them and which ones just don't appear on your inner screen. This is not a random phenomenon. The colors are designed to be so many cycles per second away from each other when seen from a certain perspective.

The color on an object is a corpse, and corpses have reality. The color as an archetype in the cosmos is an archetype in the cosmos, and that has its reality. An archetypal color is not diminished when an object that has the corpse of that color is no longer present. I may have something that is a kind of turquoise derivative. I can look at the pigments that make up this color, and they are real as long as color on that object is present; but that color is not archetypal but transient. Goethe says "Everything transient is only a parable." Everything that can change or is transient is merely a parable of something permanent. The archetype is what endures.

This doesn't mean that the archetype cannot change, but it cannot change on its own. The archetype needs our interaction through perceiving or cognizing it before it can change. The turquoise on an object couldn't care less about whether I perceive it or don't. It is unaffected by my perception, because it is objective in the world. If I take that turquoise away and try to reproduce it within myself without the sensory

Color Wheel of Remedies

magenta — staphysagria
+ creative, inspired, charismatic, committed
− indignant, incised, wounded, fears the practical life, martyr, self-destructive

purple — lycopodium
+ tactful, benevolent, tolerant, charming, magnanimous
− a free mind with a fixed soul, habitual denial, aversion to change, supports underdog but undermines equals

carmine — pulsatilla
+ devoted peacemaker, seeks beauty, self-sacrificing
− easily crushed, fears anger, needs noticing, guilty conscience when angry

violet — sepia
+ transcendent soul life, deep spiritual roots, devotion to causes especially in the arts, self-reliant, candid
− estranged from life, avoids affection, soul sore, complaining

vermilion — sulfur
+ thorough, prolific, learned, direct
− self-centered, caustic, overwhelming, inflated

indigo — ignatia
+ highly intuitive, perseveres through obstacles, patient
− exaggerates inner drama, grieves unknowingly, numb to life

orange — arsenicum
+ very enthusiastic, loyal, organized, perfectionist
− driven, domineering, nervous, excitable

cobalt — calc carb
+ mystical, intuitive, loyal, deep self-knowledge, true believer, supports causes
− stubborn, brooding, afraid to act, fantasist, lives in the past

yellow — phosphorus
+ witty, high energy, learns easily, many ideas
− scattered, absent-minded, confused about identity, multiple personalities

turquoise — natrum mur
+ truth seeker, keen intellect, fair, just
− opinionated, bitter, relentless, loner, absolutist, unapologetic

green — silica
+ sensitive, rich inner life, capable, self-limiting, meticulous, practical
− apprehensive, anxiety attacks, seeks recognition but fears being seen

lemon — lachesis-nux vomica
+ competent, high ideals, diligent, organized, insightful
− spiteful when betrayed, aggressive to others, closet anarchist, irritable, conflicted over morals especially sex

Archetypes (spokes)
- sepia / fisherman's wife / sore soul
- lycopodium / driven detached / politician
- staphysagria / noble sufferer / Prometheus
- pulsatilla / Cinderella / devoted soul
- sulfur / philosopher / collector
- arsenic / bulldozer / thoroughbred
- phosphorus / actor / Peter Pan
- lachesis / manager / Jacob and angel
- silica / sensitive server / princess pea
- Nat mur / truth teller / Martin Luther
- calc carb / 3rd son / eternal embryo
- ignatia / hidden grief / Romeo and Juliet

		green	lemon	yellow	orang	vermil	carmin	magen	purple	violet	indigo	cobalt	turquo
calm	+												
nervous	−												
happy	+												
sad	−												
confident	+												
fearful	−												
serene	+												
anxious	−												
relaxed	+												
tense	−												
centered	+												
restless	−												
pleasant	+												
unpleasant	−												
secure	+												
doubtful	−												
strengthened	+												
weakened	−												
positive	+												
negative	−												
total	+												
total	−												

Color Wheel with Flower Essences and Homeopathic Remedies

magenta
star of bethlehem - emotional shock and physical trauma or loss. the world is threatening
larch - fear of failure - with great anxiety, inner life threatens

purple
water violet - aloof, arrogant, detached
chestnutbud - repeats mistakes, compulsive
beech - grumbler, satirical fault-finding, sarcastic

carmine
centaury - too devoted
holly - anger, suspicion, jealousy, revenge **pine** - guilty conscience and extreme self-blame

violet
gentian - pessimist /skeptical/ worrier
willow - bitterness/high expectations from life
wild rose - chronic boredom, indifference lethargy

vermilion
cerato - collects opinions, indecisive
vine - domineering, highly opinionated
wild oat - depressed, unsatisfied, restless

indigo
rockrose - terror of death / panic attacks
agrimony - hiding problems / enabler
cherry plum - terrified of losing self-control, suicidal

orange
vervain - idealist, perfectionist, missionary **hornbeam** - exhausted, distracted
white chestnut - compulsive/obsessive

cobalt
chicory - manipulative/ silent resentment
red chestnut - projects self-fear on others
honeysuckle - yearns for the good old days

yellow
clematis - daydreamer
impatiens - impatient
mustard - burned out, life is empty and senseless

turquoise
agrimony - hides fears behind cheerful mask
vervain, overly enthusiastic, hides alienation
sweet chestnut - absolute despair, debating with death

green
mimulus - sensitive, phobic anxious about specifics
heather - look at me dance hypochondria / interrupts
mustard - unexplained sadness/moody

lemon
scleranthus - talkative, superficial, inner conflict
rock water - ascetic idealist, dogmas rule
crabapple - obsessively clean, sees self as soiled

Spokes (clockwise from top):
- staphysagria / noble sufferer / Prometheus
- pulsatilla (Cinderella / devoted soul
- sulfur / philosopher / collector
- arsenic / bulldozer / thoroughbred
- phosphorus / actor / Peter Pan
- lachesis / manager / Jacob and angel
- silical / sensitive server / princess pea
- nat mur / truth teller / Martin Luther
- calc carb/ 3rd son / eternal embryo
- ignatia / hidden grief / Romeo and Juliet
- sepia / fisherman's wife / sore soul
- lycopodium / driven detached / soul

Welcome difficulty.
Learn the alchemy
True human beings know:
The moment you accept what trouble
you've been given, the door opens.
(Rumi)

The heart is the key to the world and to life.
One lives in this helpless state in order to love and to
be indebted to others. Through imperfection one
becomes susceptible to influences of others.
And this alien influence is THE GOOD.
(Novalis)

Roscolux colored gels replace the old Roscolene series and are more durable than the older gels

Roscolux colors
14 straw
34 flesh pink
25 orange red
50 mauve
90 dk yellow green
383 sapphire blue
342 rose pink
49 medium purple
80 primary blue
83 medium blue

crimson / carmine 14 + 25 + 80
scarlet / vermilion 25 + 50
orange 50 + 14
warm yellow 14
lemon 14 + 90
green 90
turquoise 90 + 80
cobalt 383
indigo 383 + 49 + 83
violet (2) 383 + 25
purple 383 + 25 + 34
magenta 383 + 25 + 342

15

experience itself, I now perceive what happened in the sensory experience, and a door is opened for me to a higher reality of that color's existence as an archetype. The higher existence of that color as an archetype is present eternally, waiting for me to interact with it as a representative of my soul's journey to higher understanding. We pass through the realm of color beings to do this. The realm of the color beings is a higher astral realm, and deep feelings exist there that are not personal to me, but I can borrow them when I am blue, or green with envy, or I am a yellow coward. That realm is a sea of becoming, with each color yearning to become something. Matisse said it best: "Painting is like buying a ticket for the train to Paris, and when you get to Paris you realize you really wanted to to to Versailles." Color is a yearning to be something else. While Matisse was painting *The Blue Room,* a rather large painting, a famous Russian art dealer came to his studio when it was almost finished. The dealer saw it and said, "Oh, I just love that painting. I am going to buy it." Matisse said, "That is great! You can buy it; it is almost finished." The dealer replied, "Great. Let me know when it is finished." Matisse needed a little bit of red to finish it, but then this over here needs to change, because now everything else is yearning to settle over there—so, a little more red here, too. The painting was eventually finished, and Matisse packed it up and delivered it. Now, however, he called the painting *The Red Studio,* which created an issue with the buyer, but that is color.

Color yearns to be something else, and that is the signature of the archetype in the astral realm. When we die, we pass through the realm of those archetypical feelings, checking our aura, soul map, configuration of feeling structures, soul gestalt, and how this all connects with what happened to my life, how it matches with the patterns in the archetypes, and what part of my color work completed some karma. We go through death and kamaloca while doing this. In kamaloca (Sanskrit = the location of desires), I go through my life and check my feelings. Were they appropriate to the circumstances or altered in some way? They become altered when I cannot use all the colors available to me. Something happens in my soul, making it difficult for me to employ a particular color in

a certain situation. Because of the yearning principle, all the other colors have to adjust in my aura to make up for the one I cannot use—perhaps because I don't like it or because it reminds me of my boss and my job, or it may be a kind of lemon-green, the color of bile.

Rudolf Steiner said that a painter's color sense is really a highly evolved sense of smell. Smell as a sense is a lower-octave capacity for moral judgment. People ask: What is your aura? However, the whole aura issue can get very "out there." I want to be very precise in this discussion. *Aura is color.* Rudolf Steiner said many times, however, that you experience the aura not out there as a kind of colored cloud floating around a person, but inside as an experience, as if one were looking at that color. He described this as reading the aura. If you see a colored cloud floating around someone, you probably need some acupuncture to help your kidney, because it is not quite tuned right. The goal is to pull it inside and make it a precise inner perception. We learn how to cognize the aura by being aware that, for instance, if we are in the presence of someone who reminds us of indigo, that perception can help us understand the aura. We can build on that kind of perception; we can ask questions from that perception and build symbolic pictures or paint with it, because that level of perception is a universal language of the astral realm. We call it color.

2

The Nature of Color

Returning to the idea of sensation and perception, we will look at the relationship between the color theories of Newton and Goethe for this important idea. We will look at quotations from *Nature's Open Secret: Introductions to Goethe's Scientific Writings*. There, Steiner talks about the problem Goethe had trying to deal with Newton's way of doing science, because he felt that there was something difficult with the way Newton studied color that would make it difficult for people to study in the life sciences properly in the future. That was Goethe's angle on this. He tried to use the color theory as a way of refuting Newtonian physics. Reading the background that Goethe gave on his color theory, we see by the way he dealt with the problem of color that Goethe was full of bile for Newton. According to Steiner, who studied Goethe's morphological writings, it has to do with this issue of *the separation of sensation and perception.*

What is a sensation as a sensory experience? And what does it have to do with me as a being with a soul? The separation of those two is very important when we wish to study science, because the whole problem in science is the bias that applies my subjective inner soul experience to what should be an objective methodology for investigating the world. In empirical physical science, the need to separate one's feelings from the processes of science is an absolute requirement for maintaining scientific integrity. However, this presents a problem when we begin to study the life sciences, because separating the subjective from the objective for the sake of being empirical means removing the ability to feel things from

your scientific capacity. It is necessary that we remain able to feel so that empiricism doesn't run roughshod over life. This is a critical point that Steiner addresses early in his life, and it underpins much of his later work. Nonetheless, he made the point when he was young and assumed it would be understood in regard to his later work.

In psychology and psychosophy (or spiritual psychology), the whole issue is whether one knows the difference between *sensation* and *perception*. Sensation belongs to the world and has nothing to do with the human being. Sensation is the patterns of movement and creative activity of the hierarchies that rule the world; they create sensations. We could say that the natural world is composed of endless sensations. However, when we insert a human being into the mix, sensations are lifted out of the sensory world to become an inner experience, completing what is missing in the sensory world, which is someone to perceive it. The missing piece in the world as created by the Creator was someone to recognize the Creator. This is a fundamental theological issue in dogma; it was at the root of the iconoclast controversy over imagery and idolatry during the sixth century. It was at the heart of theological debates from the second to fifth centuries. The church fathers argued over whether God still inhabited creation or had separated from it and made a creation independent of human beings. People were burned at the stake over this issue. It is not just incidental filigree that Steiner decided to include as ideas in his study of Goethe. It is fundamental and has much to do with the role and the duties of the Rosicrucian stream.

Thus, the Rosicrucian stream is the redeemer of empirical science. It has to include the feelings of the operator–observer, which is a problem for empirical material science. This comes into sharp focus when we study color. If we study the Goethean morphology of leaves, we can look at the leaves and see that one leaf is bigger than another. That is why Goethe's first work was "The Morphology of Plants," but throughout his life he struggled to do the same thing for color that he did for plants, because he recognized in color this question of sensation and perception. There were many philosophers during Goethe's time who were interested

in the problem of color. It was a huge issue, because science was coming from the Renaissance, still based in Greek thought through the Age of Enlightenment when things were becoming mechanistic. Scientific instruments were being invented that allowed science to become very mechanical. This was the time of Goethe. Philosophers were reengaging with and remembering this question: Is God in the creation or not? They felt that empirical science was threatening the ability of human beings to experience the sacred in nature.

In addition to the many others who studied color or colors in nature, the philosopher Spinoza[1] also wrote much on this issue, which was a huge issue in Goethe's time. In the end, empirical mathematical science won the day in the study of color, as well as in the study of almost everything else. We are trying to revisit this question in Anthroposophy, or in a phenomenological basis of anthroposophic science because it has not been resolved but only swept under the rug. It needs to be revived, because it is again the basis of learning to live in a sacred way. Living in a sacred manner means that I enliven my senses and ensoul my life.

This is Steiner's formula. I have to use my senses, which just give me information about stuff, and I have to invest them with the qualities of my life body, or life forces. I have to take my sight and understand that my seeing is connected to my kidney forces. My hearing and tasting are connected to my liver forces. I have to look at my senses and learn how those senses are connected to my life forces. That is the first step—enlivening the senses. The second step is this: Once I have enlivened my senses, I have to learn what the life forces connected to my organs and senses have to do with *me as a soul*. This is the path we are taking in this book—going from the empirical observation of sensation and perception to learning what the color of lemon has to do with my inner life. This knowledge was never lost for artists, because they always look to the

1 Baruch Spinoza (1632–1677), a rationalist of seventeenth-century philosophy, helped make possible the eighteenth-century Enlightenment and modern concepts of self and the universe.

esoteric roots of this kind of work to make their art. This was especially true during the times of Goethe and Steiner.

Kandinsky[2] had a copy of *How to Know Higher Worlds,* which was discovered with notations in the margins. Rudolf Steiner was in the center of the vortex of what we can call Rosicrucian enlightenment, returning to readdress this issue, because contemporary science was becoming so mechanistic that the idea of life forces and spirituality in science was seen as complete fantasy mysticism. Physical science views life force as merely make-believe, or pseudo-science that makes no sense. In actuality, it is a spiritually informed discipline if done the right way. This is a quotation from that book, to try to give you a flavor of how Steiner was wrestling with this problem.

This is from the book *Nature's Open Secret:* "Imagine perception a and perception b. Initially, they are given to us as entities devoid of concepts. The qualities offered to my senses cannot be transformed into anything else through conceptual thinking."[3] In other words, I cannot explain my sense perception based solely on a conceptual model but must resort to abstraction of waves and particles and cycles per second. "Nor can I find any conceptual quality that would allow me to construct what is given by sensory experience if I could not access it through perception."[4] That is, I couldn't begin to explain sense perception if I didn't have it. It seems obvious that he is actually saying it is one pole.

> There is no way for me to communicate the quality "red" to a color-blind person, no matter how I describe it conceptually. *There is an aspect of the sensory perception that never enters into the concept— something that must be experienced before it can become an object of cognition at all.*[5]

2 Wassily Kandinsky (1866–1944) was a Russian painter and art theorist. He is credited with painting one of the first purely abstract works. In addition to his many paintings, he wrote *Concerning the Spiritual in Art* (1910) and *Point and Line to Plane* (1926).

3 Steiner, *Nature's Open Secret,* p. 179.

4 Ibid.

5 Ibid.

He is saying that there is something in sense perception that escapes one's ability to form a concept of it. Within sense perceptions, according to Rudolf Steiner in other sources, are the actions of the hierarchies hidden in the sense-perceptible world. Although he tried to explain it through concepts, I cannot adequately explain it. I need concepts such as Old Saturn and so on to explain it. Steiner tried to explain it with such concepts, but there is something in the sensory world and sense activity that cannot be explained with concepts. There is something in the pure energy of seeing, hearing, and tasting that escapes my ability to explain it. It is perceptible and can be experienced, but I could never explain it fully, and this will always be the case.

> There is an aspect of the sensory perception that never enters into the concept—*something that must be experienced before it can become an object of cognition at all.* So what is the role of the concept that we attach to a sensory?[6]

In other words, what is the purpose of a concept of red? "The concept allow us to say something about the sensory world that cannot be perceived." I cannot actually perceive the action of the hierarchies by looking at red. I have to go inside myself and ask: What is happening in me when I perceive red? I have to work inwardly to transform the experience I have in me so that I can make sense of it, but then I am no longer looking at red but working it out inwardly. In my mind I am trying to form conceptual structures to understand the feeling I have when looking at red; but when I am actually looking at red, I am not inside explaining to myself a concept of how I feel. There is a gap—a split.

> So what is the role of the concept that we attach to a sensory perception? Clearly, it must contribute something entirely new, something that stands on its own yet also belongs to that sensory perception, but without ever appearing in the perception itself.[7]

6 Ibid.
7 Ibid.

If the sensory world were completely autonomous and had absolutely nothing to do with my ability to conceive it, sensing and perception would remain forever split. In the daily round, they are split. As I go about my day and look around, I see some magenta there and green there, and they are split because I am not perceiving the sensory experience. I just experience the sensation. My body is experiencing the sensation. My ether body is creating green when I look at the red. I am not aware of that, but it is happening all the time. In ordinary daily life, my sensation has nothing to do with my inner life. Sitting on your chair affects the sense of touch. Do you perceive it? Are you trying to use your sense of sight to read what I am saying and making sense of it through a conceptual framework? You are still having sensory experience of sitting in your chair but not perceiving it. Thus the world is split.

In daily life this is a philosophical dilemma. All of my sensing—most of my sensing, anyway—is not perceived. It is just sensation, and there is energy in it. I receive light rays; my retina gathers them and transforms them into chemical signals that cause my endocrine pathway to respond. I create hormones that keep me in balance—but I do not perceive it. There are pink rooms in prisons for people who have become agitated or are having a violent reaction on drugs. Pink pulls the life forces from a person. Muscle testing has shown that within 2.7 seconds, inmates who are out of control lose half the use of their muscles in the pink room. They do not perceive it, but the body responds archetypally. The body responds to the pink room, but the inmate does not comprehend what is happening.

This issue of bringing perception to sensation means that I do something inwardly that is present in the sensation but not perceived until I bring understanding to it. When I do so, I am not sensing directly, but I can try to bring the two together, which means letting Sophia out of Lucifer's prison. As I bring those two closer, I become the redeemer and the imitation of the Earth's resurrection, the soul of the Earth. These ideas are contained in the great mystery at the center of Anthroposophy. When sensation and perception are split in daily

life, my inner life has nothing to do with my sensation. A huge amount of sensation remains uncognized.

> So what is the role of the concept that we attach to a sensory perception? Clearly, it must contribute something entirely new, something that stands on its own yet also belongs to that sensory perception, but without ever appearing in the perception itself.[8]

The totality happens only when I consciously perceive what is happening in my sense field. And the code word for that is called *art*. When I engage in an aesthetic judgment, that is exactly what I am doing. I am bringing together a concept with the sensation. I perceive the sensation and bring it to cognition. In this act I ensoul my life forces through aesthetic experience. This is why Steiner was so keen to bring art to the Theosophists.

> The world thus attains its full content only through concepts. But we have found that the concept points beyond the individual phenomenon to the interrelatedness of things.[9]

In other words, rather than just naming a particular red, I think about it inwardly; it's not just that red is out there; it's also in me at a stage of yearning to become something else. When I take the individual red outside and pull it inside, instead of being connected to the thing in particular, it starts to live a life in which it reveals its becoming, evolution, and morphology. The sensory world begins to connect with other sensory experiences in meaningful wholes. I see the red, and the red begins to suggest other things, because red as an entity is the becoming and yearning to become something else.

If I really understand what color is inwardly through concepts, I can say only that the color is a yellow-red or a blue-red. But is it? Is it yellow that is almost orange? How much red is it or how much yellow is this red? We can say that yellow is not red, but it does aspire to be. We find this in Goethe's color theory. It is called *intensification*. Once I begin

8 Ibid.
9 Ibid., p. 180.

to experience the color inwardly, I can no longer think of a single color; I always have wonder what it wants to become? We could call this the yearning to become something else. This yearning is the basis of the astral body, or one's soul life. If I wish to become who I thought I would be before I became who I am, that is yearning, and its essence is color. "Multiplicity is merely a form in which the unified essence of the world expresses itself. The senses adhere to the multiplicity, since they are unable to comprehend this unified content."[10] In other words, I see, taste, or hear something. These are separate senses that give me the impression that the sensory world is a multiplicity, but when I actually begin to be more sensitive and develop inner capacities, those senses merge. I can talk about warm colors and cool colors. I can talk about sour greens and sweet greens. This is a merging of the senses.

We will consider Kandinsky later, as well as Stanton McDonald-Wright,[11] whose whole idea was that music and color are not separate, though they affect different senses. Vincent van Gogh wanted to study piano and took lessons with a village piano teacher. He would play B-flat, and sense it as blue-purple. His piano teacher couldn't understand this, so van Gogh evidently found a new teacher.

This inner concept of a perception actually joins the two worlds of hearing and seeing. This happens when I have an aesthetic experience and form an aesthetic judgment. A composer might ask: Should this bridge be in A-flat or A-natural? We frequently hear this in Bach's music. He begins with natural, and then suddenly one note is flat, and the rest of the piece goes in another direction. If you are sensitive to such things, when that flat first note hits, it makes you wonder what's happening. The languages of music and color are very close. Goethe referred to this in his "Verses in Prose": "Reason, with its tendency toward the divine, engages only in what is alive and in the process of becoming [this is the key], and

10 Ibid.
11 Stanton McDonald-Wright (1890–1973), a contemporary of Kandinsky, was an American artist who, with Morgan Russell (1886-1953), established Synchromism, the first American avant-garde art movement to receive international attention.

the intellect only in what is finished and rigid, in order to put it to use."[12] Splitting reason and intellect is the whole issue for Newton and Goethe.

Newton studied color from a purely analytical, intellectual point of view. He considered colors to be particles moving through space, and that the particular size of a particle would affect the eye, causing one to perceive a particular color. Newton shined light through a prism, which spread the light. He supposedly said that white light is composed of all the colors. Newton's famous experiment shined light through a slit into a prism, which in turn projected a spectrum on the wall. Then he had another prism that he turned upside down (or so the story goes), and when the spectrum passed through the second prism it reconstituted the spectrum into white light. This was his famous experiment. It is said that he then wrote that white light is composed of all the colors. That idea fit the current model and became the standard. Nonetheless, the experiment was challenged during Newton's time, but unfortunately he was unable to replicate the experiment.

If you search online for Newton's prism experiment, you will immediately receive thousands of results, but you have to read deep into those results to find a scholar who has actually investigated this assumption deeply. I found one such researcher, and he debunked the idea. He went into Newton's work, looked at the exact experiment, and said that it shows something different. In fact, it actually supports Goethe's point of view. However, one has to manipulate the two prisms in a particular way to see the light as a slight sliver of white, and apparently Newton did this, since it is in his notes. The experiment in which the whole spectrum suddenly appears as a white light was the one that became famous. Moreover, if you can work with that idea in terms of particles or waves, as color and cycles per second, the mechanistic point of view adopted that view and worked with it. That was eighty years before Goethe, who saw that idea as a problem. He used the prism in a different way. Goethe's approach to Newton was that he showed only a part of what color is. We can see why Newton described what was out there as he did, but he used

12 Ibid., *Goethe to Eckermann*, Feb. 13, 1829, p. 268.

an intellectual process to form a concept about color rather than what Goethe would call reason.

Reason is connected to imagination. When the intellect finds an answer, it becomes ensconced in the intellectual structure, but according to reasoning, it could be like this and it could be like that. That is reason. What's your reason? Not your answer, but what is your reason? If I ask for your answer, you get one feeling; but if I ask for your reason behind that answer, you get a different feeling. Goethe uses reason in this way. Reasoning is interested in "becomings," but intellect is interested in answers that can be applied. This is the difference between research and development. Research is reason—we never know where it is going. Once we find the answer, we give it to the development department, and they find applications for it. This kind of thinking in science is the difference between research and development; truly creative scientists use reason to come up with an idea, and then the development people take the idea and build from it. This is what happened with Newton. Most of his work was actually theological and alchemical according to Newton's great biographer, Edwin Arthur Burtt (*The Metaphysics of Sir Isaac Newton*). E. A. Burtt studied Newton's output and wrote that most of Newton's work was theological speculation based on an alchemical perspective. That was eighty percent of his work. The other twenty percent was the *Principia Mathematica* and writings on the orbits of planets and calculus—and this twenty percent is what intellectual reductionists took up during the Age of Enlightenment, since it could be used in the most practical ways and gave contemporary physical, empirical science its foundation.

The great majority of what Newton found has been disproved, as with Goethe. This is because Newton's thinking was actually more in the realm of reasoning. It was alchemical and theological, which was simply accepted in those days. It was a way of doing science. This was the period just coming out of the Renaissance. Nonetheless, the intellectual side—the mathematical side—was taken up and applied, and that is what Goethe resisted. He believed that something had been introduced into science that would create problems for life sciences. It works fine

for physics and mechanics, but it is a problem for life, or we might say for *soul*.

You, the reader, might wish to try an experiment at this stage to gain a deeper understanding and an inner experience of color and what is to follow (pages 14–15). The chart shows the methodology to use. The experiment requires colored gels or transparencies. If possible one should use Roscolux theater gels. These are available through theater-supply shops or online, including as a set for color therapy. The colors you need to use are mixtures of the gel colors. If a group will participate, you will need large sheets, otherwise a set of small gels will do. Either way, it helps to work in pairs.

You will need a white blank wall for viewing. In addition, you need a consistent light source. One looks through the gel at the illuminated white or blank wall as the gel color sinks in. One partner reads the list of colors or qualities. In the chart, on the left, it says *calm, nervous, happy,* and *sad*. You will be looking through the gel. While one partner looks through the gel, the other reads the list slowly, about three seconds apart. Do not go into the intellect, but simply respond. The partner reading the list says "sad" or "happy," and you wait for two seconds and then nod if that is your response to the color. Your partner checks that box and goes on to the next quality. You nod only if you feel that the emotion is present in you as you look through the gel at the blank wall. It does not matter whether it is positive or negative. It is important only that the response feels confident. Don't try to second-guess or try to intellectualize as you are doing this. Just let your senses respond. When you look at your list, you see some of them are positive. When you go through the list with your partner, your partner will go through all the colors, and then when you are done, the only ones that are checked are those you identify as feeling responses to the colors. It does not matter whether it is negative or positive in the moment of taking the test. It just matters that you connect that word with that color.

Now pick another color and start over and then another color and start over again. One might feel calm and serene for three or four colors.

That is allowed because that is part of the soul world. So don't think that if you put confident for green, you cannot be confident about something else. That is not what this is about. It is just a test. Don't try to second-think it or intellectualize it. If you say a word and don't get a response, just move on.

It is best to use theater lights, as they are very well engineered. If you go to the theater-supply shop and ask for a Roscolux 14 and a 25, they might guess that you are using them for viewing rather than the stage. In practice, some colors, such as magenta, require multiple gels to make the color when a strong light is shown through it. The idea is that the light coming off of the light wall will travel through the gels so that you can see the color as light. The thing that matters is that, as you do the test, you are looking at the same illumination for each color.

3

Color Use in Paintings

We begin this chapter with a quotation from Rudolf Steiner to give some background to our discussion.

> Schiller contrasts the necessity of reason with the necessities of the world of the senses—everything that lives in human drives and emotions. There, too, a person must follow a natural necessity rather than one's free impulses. Then Schiller looks for a middle condition between the necessities of reason and the necessities of nature. He finds it in what occurs when a person forms something aesthetically—when rational necessity tends toward what the person loves or does not love, and when a person's thinking follows or avoids inner impulses and pictures instead of being bound by rigid, logical necessity. However, this state also suspends natural necessity, for one ceases to follow—as through compulsion—the necessities of the natural senses. Those necessities are ensouled and spiritualized. A person ceases to want only what the body wants; rather, sensual pleasures are spiritualized. Consequently, the necessity of reason and the necessity of nature approach each other.[1]

"Rational necessity," for Rudolf Steiner, means that one has to understand something, to see things that one does not fully understand. Somewhere in this, Schiller is looking for a middle condition. The feelings that lead us to love or not love something are the balance between rational necessity, the need to understand something, and natural necessity, which is the sensory world. Our senses are ensouled and spiritualized.

1 Steiner, *The Riddle of Humanity: The Spiritual Background of Human History*, lect. 9. This and some other translated quotations in this volume have been edited for modern English and gender-inclusive language.

The way vital forces are returned to the sense zones is contained in what Schiller calls the freeing of natural necessity from rigidity. What Schiller calls the spiritualization of natural necessity (he might have called it, more aptly, "ensouling") contains what we referred to as the functioning of the life processes as soul processes. The life processes become more ensouled; the sense processes come more to life; this is the true process you find described in Schiller's letters on aesthetics.[2]

This is the traditional function of the arts and aesthetic experience in general. How do these two poles and art come together? The pole of rational reason and intellect, or cognition, is the pole of light. The pole of the sensory world is the pole of creative darkness. These two poles are the most fundamental aspects of color.

Color has four aspects, the first of which is value. *Value* describes the relationship between light and darkness. Ever since the most ancient times, value structures (light and dark structures) have been the means of depicting inner states in response to what people encounter in the outer world. This includes drawing, painting, and sculpture. An arrangement of light and dark areas in significant patterns is what we call a "value structure." These usually go from the darkest dark to a mid-tone to the lightest light. This is the first attribute of color.

The second attribute of color is "temperature." As we begin to move lights over dark, and dark over lights, something happens to the light and dark that gives the appearance of a color rising and becoming cooler or warmer. This is the principle of dynamic color and was the predominant modality of the ancient world that determined the rules of painting and depiction. This is "dynamic color." At certain times, dynamic color came to the fore; other times it simply served light and dark to reveal form. These are two aspects of light and dark. One reveals form, and the other is created by dynamic color. With dynamic color, we get impressions of warm and cold, even in black and white. This is a great mystery. Later, we will consider how different painters through time used these ideas in their art.

2 Ibid.

The first image is called a Fayum painting (figure 1).[3] During late Roman times, the Roman Empire had expanded into Egypt, and the old generals and dignitaries of Rome were sent to the hinterlands for their swan-song assignment. They were given discretionary income, a nice place to live, and good jobs out in the hinterlands. As a result, the wealthier Romans adopted the Egyptian burial practices of mummifying and the Coptic art of mummy portraits. Figure 1 shows a Fayum portrait of a Roman boy of the second century AD. It looks like something you'd see anywhere today. It is encaustic, made in wax, and was placed on the mummy. The light and dark value structure builds up the form. The color is pretty much a monochrome scheme, but the real issue in these Fayum portraits is the way light and dark value is used to create a kind of colorful quality. Later, we will look at Rudolf Steiner's color theory of image and luster colors. Everything I have to say about this falls exactly in line with his color theory.

Figure 2 portrays a slightly different idea, but the same type of mottling of light and dark structures, with very little change in hue, the third quality of color. The first is *value*—light and dark; the second is *temperature*—cool and warm; and the third is *hue*—for example, yellow-red, blue-red, or pure red. Such specific colors are the hues on a range, or hue band. The fourth one is *chroma*—intensity.

Figure 3 looks a little like something you would see on the street—a very contemporary look in second-century Roman art. The Romans had a very naturalistic way of using value and depicting forms. After Rome fell, the center of learning moved to Arabia, while Europe saw the beginning of the Middle Ages, when a gesture of sorts overtook the whole world, even Arabia. Miniatures and illustrated manuscripts became the new wave in art. Thus, the sixth-century *Book of Kells* (figure 4). Linear forms and flat color superseded the whole idea of a value structure of light and dark gradients. The Fayum portraits, with their light and dark

3 *Fayum* (or *fayum mummy portrait*) is the modern term for a type of naturalistic painted portrait on wooden boards that were attached to Egyptian mummies during the Coptic period of the Roman Empire (c. 1000 BC–AD 1000). For more background on this topic, see https://en.wikipedia.org/wiki/Fayum_mummy_portraits.

Color Use in Paintings

Figure 1 Figure 2 Figure 3 Figure 4

gradients, and this new type of painting, in which the colors are isolated by lines, are the two great divisions of art according to the great art historian Heinrich Wölfflin.[4]

Wölfflin proposed that there are two fundamental impulses in art: linear, with strong outlines and flat colors, with little modulation or value changes. The painterly style, by contrast, uses mottled colors with subtle gradients and vague separation of colors. Figure 4 is an example of linear painting. Gradually, the painterly style became romanticism and the painterly style, with blurry edges, deep shadows with a lot of contrast between light and dark, and colors coming through one another. In figure 4, color values are restricted; there is little change and mottling in the face; it has strong outlines and "local," flat color. In the other images, the colors migrate around and the outlines are much less intense. These are great tools for understanding art history. The mottled, soft edge, very strong contrast of light and dark, defines the Romantic painterly style. Linear, local color represents the linear style.

The linear style tends to be developed in ages when people are looking toward Classical values and a more ordered life. *The Book of Kells* came during a time of chaos. Monks in the monasteries made this type

4 Heinrich Wölfflin (1864–1945) was a Swiss art historian whose objective classifying principles (painterly vs. linear etc.) were influential in developing formal analysis in art history.

33

Figure 5

of illustrations for the Bible to hold the world together and rejected the Romantic style with its vague edges. The subject and background are distinctly defined. Very often classical style is a reaction against romanticism and vice versa. Oscillations in the ways in how people use colors and light and shade expresses the soul mood of the time. During the third century and fourth centuries, Europe saw the hordes of barbarians coming, and people in the monasteries sought to bring order to the chaos. After the fall of the Roman Empire everything was up for grabs. There was lawlessness in the countryside, so artists used a very restricted style.

Figure 5 shows another illustrated manuscript style. It is very intense, not unlike what we see in Arabia at the time in their miniatures—floral arabesques, knots, and small manuscript illustrations as attempts to control: extremely linear style and very stylized faces. We do not see any mottling of light and dark that might be considered arbitrary. Light and dark and the use of color is like a mosaic.

This very linear quality eventually gave way to Romanesque art, which rebelled against the restrictive, lassical worldview. Romanesque art began to adopt Roman values and art—that is, naturalism (figure 6) rather than a transcendent ideal of geometrical space with hard outlines and flat colors. The Roman ideal was the natural, as we see in the Fayum mummy portraits. The pendulum was swinging back around the seventh century. It was still a book illustration, but now meant to show

a transcendent quality of nature. The use of light, dark, and colors brings a little more of the feeling life into the very restricted formulaic Middle Ages. There were strict formulas, including for how long each segment of the finger of Christ had to be. These formulas were passed down through a very traditional structure for painting. In figure 6, we see a reaction against that. Where is that actual fold going in the garment? It is meant to show the whirlwinds around the evangelist—that he is receiving a presence from the Lord. It is still a book illustration but turning away from the classical style to use more of a value structure, though it still uses local color.

Figure 6

Now we begin to see the return of value and gradients in art. When you have a value gradient that goes from light to dark through a gradient, it is more difficult to know where the image is. Not seeing a clear edge is a romantic quality, having to do with feeling life. The painterly style means coloring outside the lines—letting the color itself determine where the edges are. The struggle over defined or undefined lines drives art history. The two great driving forces having to do with value, temperature, and hue and how they are used express the cultural worldview of a given period. Figure 6 is seventh- or eighth-century Romanesque art, showing a shift away from very restricted monastic book illustration.

Now we leap to 1200 or 1300 (figure 7). Giotto represents late Romanesque, early Gothic style. Romanesque art gradually freed itself of linearity. We see it in churches of the Basilica style, in which

Figure 7

Romanesque arches are becoming almost Arabian, until we get to the Gothic arch. "Gothic" is not an actual real style, but represents a return of Romanesque naturalism, in which values begin to reflect what we see in the sensory world. It was strictly forbidden during the Middle Ages to represent things of the sensory world. Instead of depicting naked people battling snakes, we depict Christ in his glory as a geometric form, with very clear colors, so nothing needs to be invented. This reaction led to the Renaissance, a recapitulation of the fall of Rome and Greece.

Renaissance means rebirth—in this case, a kind of resurrection of classical Greece. It was the beginning of the real spread of big cities and commerce. As they were plowing, farmers started finding statues of naked people in the ground, and they were shocked by what people were doing back then. The Romans had taken the Greek models and spread them all over the place. Then, to save their statues from being demolished by mobs when the barbarians "arrived at the gates," they took them into the country and buried them. The Renaissance reaction was a rebirth of classical Greek and Roman naturalistic art.

In figure 7, we see Giotto's depiction of the Virgin in the late 1300s and early 1400s. He uses the gold background of the Middle Ages, but the mottling of the face and gestures are not hieratic, or prescribed. Rather, it begins to move in a direction of how any mother and a child would look as real people in the natural world. At that time, painters

were struggling with how to render space—whether to show space as heaven and a gold background or as it appears here on Earth. Gold backgrounds trace back to seventh-century icons, which used gold backgrounds because in heaven the streets are paved with gold. We cannot tell where that background is in space, because space on Earth is an illusion. In the fourteenth century, Giotto still makes a gold background, but he paints a naturalistic Madonna and child. The child is still shown as a little wizened old man but

Figure 8

he is moving, which is a radical departure. This is not the Madonna and Christ in the hieratic pose; rather, it is something you might see on a street corner, though here it has a gold background. Thus, art shifts into a naturalistic gesture of value, light and dark, and color—almost a Fayum gesture.

The next image is also from Giotto (figure 8). It shows the struggle over trying to depict naturalistic space. They had inherited a perspective device from the Romans. At the ancient Villa Boscoreale just north of Pompeii, there are perspective drawings on the walls of the villa; this is second-century perspective. It had three or four vanishing points—something being resurrected today. People wondered what it would look like to show St. Francis driving out demons at the city gate. We can see that the buildings and St. Francis are not really in the same space. This is the beginning of what would eventually be a way to depict space through form—perspective through color. It eventually leads through the centuries to impressionism. Form and color can go together to create a sense of how things exist in space. This is really the key to the

Figure 9: *The Arnolfini Portrait*, 1434

Renaissance, which was trying to use color and form so that people appeared in space.

Now look at this painting from 1400 in the north country (figure 9). The Renaissance actually began earlier in the northern countries through the development of tempera painting. In the tempera painting technique of the artist Jan van Eyck, it was possible to make paintings in which the value structure could be controlled in a remarkable way. This was accomplished by mixing egg yolk with pigment. Painters made little crosshatch lines with a two-hair brush to build up the shading value structure. Today we might call the places where the crosshatch lines meet "pixels." They controlled the value structure at the time of Van Eyck through this very tedious means of making strong outlines and filling them with crosshatch lines. Painters such as Van Eyck further developed the egg-tempera technique—which began with thirteenth-century, late Romanesque painting—by making an egg-oil emulsion.

The contribution of Flemish painters in the fifteenth century was "underpainting" with tempera and crosshatch to build up a very developed value structure separate from the layer of the color. They used egg tempera for the value structure. In fact, they created the value with a piece of silver. They would take an oak panel and use skin glue from a rabbit with ground-up bleached bone. Artists would grind the bone very fine and mix it with gelatin made from animal skins, and then paint that on the oak. Once it dried, they took a piece of silver and drew a very fine light and dark structure on the bone. The bone would pick off little pieces of silver, and then, using atomizers, they would spray a little bit of vinegar on that. This would oxidize the silver, making a light and dark structure. This is called "silverpoint." This technique allowed artists to make a finely developed and refined light and dark structure on a ground. Then, using egg tempera mixed with oil, the artist could then use a stick with some hair and a very fine rabbit or goat chamois and, dipping it in very gelatinous paint, use it as a roller over the colors already established. This "underpainting" allowed the artist to separate the value structure from the color structure. They could complete the value structure first and

Figure 10

then work with it until they got what they wanted, after which they added transparent colors on top of the settled silverpoint drawing, so light would enter, reflect off the ground, and come back through the color. Thus, a light-and-dark layer and a color layer merged together.

Let's now look at the wedding scene and the mirror in figure 10. This is a detail of the mirror behind the people, with them reflected and the artist looking back at them. This is what people were trying to do—verisimilitude. This detail reveals an issue with which artists were struggling: becoming conscious of their own perception—being conscious of what is happening in the sensory world and trying to make the sensory world somehow become a concept. To do this, they had to settle the value structure to such a degree that their colors were left as layers on top to tint the underpainting. The artists developed their materials and techniques to this end. It is difficult to do that kind of painting all at the same time; it requires a two-haired brush.

Andrew Wyeth (1917–2009) painted with egg tempera on a panel and then used a two-haired brush to go back and make tiny gradations of light and dark using crosshatch. Van Eyck said, we could go one better by mixing oil with egg. The oil allows us to make a tacky kind of gel that we can spread with a roller on top of a settled design. This gives us images such as this mirror—a detail of a detail of a detail of the painting. We can just go in and in and in, and the whole thing holds up. This is an

Color Use in Paintings

Figure 11 Figure 12

attempt to come down into the sensory world and say: I need to understand what my sensation is doing.

This is during the 1400s in northern Europe. The technique that was developed there is "grisaille." The word comes from the French word *gris*, meaning fog or gray. Artists wanted to settle the gray, and on top of that paint a layer of brighter colors. The Renaissance had its roots in the north, but it traveled south through artists such as Albrecht Dürer, who traveled south to sell his prints and paintings to nobles. Consequently, these methods traveled south to Florence during the 1500s.

Now we move on to the great Florentines and Leonardo da Vinci (1452–1519). Figure 11 represents the next big step for grisaille, in which the underpainting is settled but the over painting is done with layers and layers and layers of extremely, finally diluted pigments. This became possible in southern Europe because they had access to certain drying oils and resins (lavender spike oil) that had been unavailable in the north. Painters such as da Vinci could expand oil painting beyond tempera because they had walnut trees and lavender growing on the hillsides. They could make spike oil (a slow-drying oil) that allowed them to make layers ever

Figure 13: *La Circoncisione*, 1587

finer and finer, one over the other, in seemingly infinite layers. This is a detail of the *Mona Lisa*. In the gradients it is difficult to tell where one thing begins and another ends. This is moving inexorably in the direction of romanticism. These southern artists inherited the technique of the northern painters, but they became very romantic with a technique called *sfumato*, meaning mist, or fog. The hard edges of the van Eycks and details such as a small figure in a mirror fell away to be replaced by soft indeterminate transitions (figure 12). This is a Romantic gesture of what started in the Renaissance as a classical gesture in the north. The northern Flemish school used cold light, local colors, hard outlines, and settled designs. This is what we saw in Van Eyck. The southern art of Florence and Venice is not settled in outlines. Da Vinci is, in a sense, a northern painter in the south.

I include Tintoretto (1518–1594) here (figure 13). He is a southern painter who also inherited a kind of northern gesture. This is an underpainting with very evolved light and dark structure, local color, hard

Color Use in Paintings

Figure 15: *David with the Head of Goliath*, 1607

outlines. However, a dark kind of romantic gesture is starting to creep in, replacing very clear spaces as in van Eyck and others of the north. Looking at the overall color scheme, we see blue and red, and never the twain shall meet. Tintoretto is a southern painter painting in a northern kind of style. In art history, this is what you see: The Renaissance has handed along certain cultural values: Are we Romantic or classical? Gestures of romantic and classic keep oscillating until we reach modernism, when Romantic and classical styles oscillate at the same time. And the two schools are battling each other. Is it a Romantic age today or a classical age—and the answer is *yes*.

Taking a step further, where artists are working with webs of color with a splayed brush, we come to Michelangelo da Caravaggio (1571–1610). Caravaggio (figure 15) was a late Renaissance, early mannerist Italian painter. The northern school is known as "white ground" painting.

Figure 16: *Self-portrait*, c. 1629

It starts with a light ground and then silverpoint. It establishes the value structure of the light and dark, with colors painted over it. The southern method, by contrast, is "dark ground" painting, which begins with a dark ground. With the ground of darkness in place, the artist uses rags to wipe out spaces of white until the image emerges. This is a kind of southern school conjuring in a Romantic way. With the quality of a dark ground painting, the figures emerge and then merge back in. This is the turning of the screw from the high Renaissance, with its classical inheritance from Greece and Rome, toward a Romantic rebellion against the classicism of the high Renaissance. This is late Renaissance, early Mannerism.

Artistic trends then begin to go in the direction of what eventually became the Reformation. Caravaggio was among the southern painters, who took what they inherited from the north completely in a southern Romantic direction of dark ground and lost edges. The people in the north then looked to the south for their cue on what the Renaissance, or post-Renaissance, should become.

Next, we come to the Dutch artist Rembrandt (1606–1669). He was a northern Flemish painter painting in the southern method (figure 16). Tintoretto was a southern painter painting in northern method. The northern method was classical; the southern was Romantic. Rembrandt was a northern painter using a southern manner to express the drama of the

Color Use in Paintings

Figure 17: *Adoration of the Shepherds*, 1646

Inquisition, which has expanded in response to the Protestant Reformation in the 1600s. No one knew what the values were, and artists were tired of classical styles arising whenever they wanted to express the common folk. Rembrandt's school found beggars and outcasts and painted pictures of them, making them look like saints. This was the "Rustic School." It was an inheritance in the north of the southern, Romantic values.

Figure 17 is a nativity by Rembrandt. Compare that to the nativities of Tintoretto with the northern method of local colors. Rembrandt took dark-ground painting in a direction of highly romantic passages in which light seems to come from the figures to be swallowed by the

45

Figure 18: *Madame Moitessier*, c. 1856

darkness. This is the gesture of the Reformation in the late 1600s. Trade had become corrupt in Italy before moving to Holland, which then became a major trade center, since they could grow abundant flax in the lowlands. Flax makes linen; linen makes sails; sails drove the ships. Linen also makes excellent painter's canvas. Another important product of flax cultivation is flaxseed oil, which became the basis of oil paint. Oil painting reached a peak in Flanders, because they had all the materials and a new bourgeoisie. Numerous people of means wanted their portraits painted, and Rembrandt made a good living painting portraits for the emerging merchant class in Holland. Nonetheless, he began depicting religious subjects, which led to his own

Color Use in Paintings

Figure 19: *Christ on the Sea of Galilee,* 1854

"reformation"—from rich young portrait painter to eventually dying in poverty.

Now, moving from the 1600s to the 1800s, figure 18 shows a portrait of Madame Moitessier, done in a classical style by the French painter Dominic Ingres. France became the center of culture with the age of Enlightenment. Ingres painted in a northern manner, with local color and clear outlines. It is representative of the spirit of le Roi Soleil and a new wave of culture, mechanical things and devices, and clear laws in the age of Enlightenment. This is one side—a classical approach. However, at the same time a contemporary of Ingres is Eugène Delacroix (1798–1863). These two styles of painting existed in France at the same time—a very romantic, scumbled,[5] painterly style, and a more classical linear style. Even though Delacroix in a certain way uses local color in this painting of *Christ on the Sea of Galilee* (figure 19), the whole mood

5 *Scumble* refers to the technique of modifying color by applying a thin coat of opaque paint to achieve a softer or duller effect.

47

Figure 20: Chevreul's color solid

is a kind of inheritance from the Romantic style. The clash of these two poles is approaching a kind of explosion or a great fusion that breaks things apart.

Delacroix is an interesting painter. He had a friend named Michel Eugène Chevreul (1786–1889), the chemist in charge of manufacturing pigments for the royal tapestry works in France. Chevreul studied color for making tapestries in such a way that he became a stimulus for the methods of impressionists. Tapestry looms had become very sophisticated, and the operators wanted to be able to make strong color changes with the least amount of shuttle movement on the loom. Chevreul developed the pigments so that if they removed only one thread, a whole area in the color would shift. He developed a principle that would later become "simultaneous contrast." As a friend of Delacroix, they discussed this technique, and Delacroix took Chevreul's idea and used it in his painting. Figure 20 shows a color solid by Chevreul. This was the time of aniline and synthetic dyes that could be structured to have a hue band around the outside and a value structure going from a mid-tone to dark above. By going the other way, one could go to a lighter version of the same hue. Chevreul made the first color solid.

Color Use in Paintings

He designed it to show that all of the colors are interrelated. The hue band is continuous—if we go toward the dark, it is a shade; if we go to the light, it is a tint; and we get the opposite color when we go from the outside to the inside through the achromatic center.[6]

The color solid was a great revelation to painters—a color wheel that allowed them to predict how two colors fit together to appear as something else. If I put a red and a yellow together, making thin little dabs of them together, they will appear orange. This is the beginning of understanding color radiation in optical color, the basis of impressionism. We see this in a detail from Georges Seurat's *Sunday Afternoon on the Island of La Grande Jatte* (figure 21). Pointillism and impressionism as movements derived from Chevreul's ideas. Pointillism involves making little points of pure color and juxtaposing them next to one another, so that when we step back, the sensation is to see the points of red and yellow as shades of orange. This is also the principle behind Ben-Day dots in printing and lithography. The impression of that third color forms in us. We mix the colors with our soul. Something happens in us so that two colors come together. This is "radiation."

Next is Paul Cézanne (1839–1906) and *La Montagne Sainte-Victoire* (figure 22). When I was in graduate school, I was a color-field

Figure 21: pointillist detail, c. 1886

[6] The center of a color wheel is the "achromat" in color terminology.

Figure 22: *La Montagne Sainte-Victoire*, 1890

painter. I focused on how color in a painting structures the space of the painting. This is known as color space, and Cezanne was the granddaddy of color space. I was in love with Cézanne. I lived in Philadelphia at the time, and the Philadelphia Museum of Art had one of the largest Cézanne collections, so I spent a lot of time there. Cézanne turned everything I just described to you on its ear by holding those two sides together. He did this through a technique called a passage. By underpainting, I establish my light and dark through a gradient from lights to darks. My color becomes a kind of glaze on top so that you see the underpainting shine through.

Cézanne liked the principle of the ordering but wanted to allow what impressionism offers to come in. He said, "We have to make impressionism worth hanging in a museum"—meaning that it needs order; it cannot just be slap-dash. Thus, he replaced the value structure of light to dark with a hue-band of yellow to orange to red to purple to blue, with the green in the middle. He calls each of these elements in the

Color Use in Paintings

Figure 23: *The Yellow Christ, 1889*

picture a turning. In place of a light-and-dark value structure he substitutes a hue shift to make the action—the color space in a painting—live. This is the basis of modern art. It breaks through all the crust of underpainting, classicism, and romanticism, bringing it together in one painting discipline. I include just this one Cézanne here, because otherwise I might take up the whole rest of this book on him. Nonetheless, this painting is representative of his work. The colors are symphonic. They

Figure 24: *Bottles and Knife*, 1912

Figure 25: *Cathédrale de Rouen*, 1894

are all moving or turning with the same color sequences and movement. When I stand in front of his paintings, my inner experience is a feeling of sublime music.

Around the same time, we have Cézanne's contemporary, Paul Gauguin (1848–1903). In figure 23, *The Yellow Christ,* we see that he returns to hard outlines and somewhat flat colors and a kind of classical quality. Two contemporaries mirror each other with polar tendencies.

Figure 24 is by Juan Gris (1887–1927), slightly later than Cézanne and Gauguin. The painting is at the beginning of Cubism. Cubism is not interested so much in color—what about form? For Cubism, form is what gives art meaning. Now, instead of turning, we get these conflicting planes of light and dark. In Cubism we see a method that resembles a shattered mirror. Modernism shatters the old classical–romantic polarity and turns from color toward form.

Color Use in Paintings

Figure 26: *Bedroom in Arles*, 1889

Figure 27: *Green Stripe*, 1905

Claude Monet (1840–1926) was a contemporary of Juan Gris. Monet's cathedral series returns to color. In figure 25, *Cathédrale de Rouen*, we see linear and painterly qualities, two polarities.

Vincent van Gogh (1853–1890) also held the two poles together (figure 26, *Bedroom in Arles*). It shows another return to local color, but it vibrates because van Gogh used Cézanne's passage technique. If you really go deeply into a van Gogh, you see that it is not really local colors but scintillating.

Henri Matisse (1869–1954) was a *Fauve* (wild beast) painter. Matisse painted a portrait of Madame Matisse (figure 27) with a lime green stripe down the middle of her face. People wondered whether he had been drunk. Matisse carried the torch of the perception of the most subtle color aspects of *Les Fauves*. It appears at first to be local color, but when you refine your perception, you see that everything is interacting with everything else; all of the colors, when you are sensitive enough, begin to show. That green strip is reflecting from something in the room or maybe out on the lawn, and then showing up in a shadow on her face. There is red on the light side and, through simultaneous contrast in the shadow along her nose, she has a green stripe down the front. (We will look more

Figure 28: *Oriental: Synchromy in Blue-Green, 1918*

closely at colored shadows later.) There is actually no single color there; we perceive color there because of the polarities presented. Matisse is moving here in the direction of post-impressionism, in which color is the way the soul operates.

Stanton MacDonald-Wright (1890–1973) was an art critic. He worked with the idea that color is music. He would paint a painting like this (figure 28, *Oriental: Synchromy in Blue-Green*), and then invite a musician such as Alexander Scriabin and his quartet to come and play the painting. They wrote musical scores in color.

Esotericists at the time were very interested in this idea—it was very anthroposophic. The theory behind this is seen in the Munsell Oswald Color Solid (figure 29). It represents a further development

Figure 29: Oswald's color solid

Color Use in Paintings

Figure 30: *Prismes electriques, 1914*

Figure 31: *Der blaue Reiter, 1903*

of Chevreul's work, stimulating the idea of saturation, or chroma. We have a hue band on the outside, dark value below, light tint above—a shade and a tint—and as we move out in the hue band, we get chroma. People were starting to work with chroma, because they understood that the intensity of color enhances the optical mix to change the way things appear. They were trying to make the color do things within the viewer. A color became an idea on its own.

Sonia Delaunay (1885–1979) was a theorist and a painter whose idea was Orphism. Sonia Delaunay's paintings (figure 30, ***Prismes électriques***) were probably better than those of Robert Delaunay; her paintings are intended to be a symphony of color, having to do with the way the color can, as Rudolf Steiner said, lift off of objects. This is a person walking under the sunlight.

Now we come to the great Wassily Kandinsky (1866–1944). Figure 31 is *Der blaue Reiter* (so named many years after it was painted). Early on in his life Kandinsky was interested in Russian and Tibetan shamanic practices, and the horse is the shaman's drum. This is his symbology. The blue rider on the horse is a nod to the idea of shamanic

Figure 32: *Lyrically, 1911*

Figure 33: *Improvisation 26 (Rowing), 1912*

Color Use in Paintings

Figure 34: *Succession, 1935*

trance in transcendent spiritual experience. He wrote *Concerning the Spiritual in Art* (2012), a seminal work in contemporary art history. This painting is the version done when he was doing naturalistic paintings as a Russian soul. A later version on the same theme, *The Rider,* (also titled *Lyrically,* figure 32), was painted as he began to move into abstraction and was searching for how the composition of line, tone, and color itself can represent inner states—can cause you to have a spiritual experience.

Kandinsky was a contemporary of Rudolf Steiner. *Improvisation 26 (Rowing)* is a later Kandinsky painting (figure 33), showing the idea he eventually evolved—an unusual iconography that tries to depict sounds and, eventually, music. Figure 34, *Succession*, is a painting Kandinsky intended to be played. It was influenced by the idea that sounds, tones, and colors are connected with the inner life of people. This was a widespread goal of many painters of this genre.

Figure 35: from *The Art of Color, 1961* Figure 36: *Ancient Sound, 1961*

Figure 35 is by Johannes Itten (1888–1967). We are moving now toward the Bauhaus. If you are a painter and love color, you need Itten's book, *The Art of Color,* on color meditation.[7] Itten was a teacher at the Bauhaus, and he would do paintings such as this as meditative devices to see how forms would arise from value structures in the color. This is just one example of exercises in which you can see forms arising from color. This became part of the methodology of all the people of the Bauhaus, including Paul Klee (1879–1940).

Klee was a painter in the Bauhaus. *Ancient Sound, Abstract on Black* (figure 36) and *New Harmony* (figure 37) are known as magical square paintings. Paul Klee painted mood structures using pure colors and field properties of colors. He was exploring the idea of how different qualities of color create different inner experiences. A magic square is actually

[7] Itten, *The Art of Color: The Subjective Experience and Objective Rationale of Color;* also *The Elements of Color: A Treatise on the Color System of Johannes Itten Based on his book* The Art of Color, (ed. F. Birren); available online as a PDF (https://monoskop.org/images/4/46/Itten_Johannes_The_Elements_of_Color.pdf).

Color Use in Paintings

Figure 37: *New Harmony, 1961* Figure 38: *No. 17, 1957*

a mathematical methodology and a technique used by the Kabbalists. He was not just playing with fun colors; these are actually Kabbalistic meditations on how color happens. I used to do an exercise when I was studying painting, in which I would make a kind of word poem using different qualities of cold, hot, wet, dry and seasonal things. People had watercolors with a grid and would make magic squares. Then we would compare the magic squares and find very similar color choices. There is something in the magic square paintings that is very profound. Paul Klee was a master at them.

This next image should be about 10 feet tall. This is Mark Rothko's *No. 17* (figure 38). We are now solidly in the contemporary realm. Mark Rothko (1903–1970) was a Russian, New York painter who said that color simply by itself is a doorway to religious experience. If you have ever been in front of one of his works, you know that it is a totally

COLORS OF THE SOUL

Figure 39: *No. 14, 1960*

consuming event; it grabs you and pulls you in. Rothko made hundreds of huge canvases of particular colors in context. This next one, *No. 14* (figure 39), reminds me of a Rembrandt. Figure 40 shows the Rothko Chapel in Houston, Texas. The huge central painting contains many colors being very busy. When you step back, it appears to be just gray-black; it is not black, but it is black.

Rothko took his own life. His artistic evolution goes from paintings similar to those of Kandinsky, invoking a kind of magical shamanic

Color Use in Paintings

Figure 40: Rothco Chapel, 1971

practice, eventually exploring all kinds of colors—you sit in front of his paintings and sort of have to cry. It is a huge outpouring of psychic energy of color, and the form is reduced to almost nothing, so that the color can come forward. And yet the color is reduced to almost nothing so that the form doesn't overpower it. He was another person who held the tiger by the tail. He held the two poles together.

This survey gives a brief picture of how certain artists brought together image colors and luster colors, or classical gesture and romantic gesture, as two poles in art and color. These then break apart, come together, and then break apart—even in the life of a single artist. It offers a way of seeing art. If we understand and work with this and then you go into a museum of art, suddenly the paintings are not just things on the wall but beings who speak into us.

4

Primaries

Before beginning this chapter, it is recommended that the reader obtain two optical prisms. It is best to experience for oneself the phenomena described and discussed in this chapter. Prisms are widely available online and through scientific and other stores. Goethe's work with the prism is an important aspect of Goethean study, and I would like to put it into the context of Newton's work with prisms. First we will look at ideas surrounding Newton's finding from a particular perspective, and then consider his actual work. Finally, we will duplicate Goethe's work. In this way we can experience what actually took place when Goethe made his discoveries.

First, consider this question: Why is the sky blue? This is a Goethean question. Why is the sky blue, and why is the Sun yellow? In Goethe's time, this was the big question, and much research was done and numerous theories proposed.

> Why is the sky blue? Clear cloudless daytime sky is blue because molecules in the air scatter blue light from the Sun more than they scatter red light. When we look toward the Sun at sunset, we see red and orange colors because the blue light has been scattered out and away from the line of sight. White light from the Sun is a mixture of all colors of the rainbow. This was demonstrated by Isaac Newton, who used a prism to separate the different colors and form a spectrum (see below).
>
> The first steps toward explaining the color of the sky were taken by John Tyndall in 1859. He discovered that, when light passes through a clear fluid holding small particles in suspension, the shorter, blue wavelengths are scattered more strongly than are the red. This can

be demonstrated by shining a beam of white light through a tank of water with a little milk or soap mixed in. From the side, the beam can be seen by the blue light it scatters; but the light seen directly from the end is reddened after it has passed through the tank. This is commonly known to such physicists as "Rayleigh scattering"—after Lord Rayleigh, who studied it in greater detail a few years later. He showed that the amount of light scattered is inversely proportional to the fourth power of wavelength for sufficiently small particles. It follows, then, that blue light is scattered more than red light by a factor of $(700/400)4 \geq 10$.

Tyndall and Rayleigh thought that the blue color of the sky must be caused by small particles of dust and droplets of water vapor in the atmosphere. Later, scientists realized that if this were true there would be more variation of sky color with humidity or haze conditions than is actually observed, so they supposed that the molecules of oxygen and nitrogen in the air are sufficient to account for the scattering. The case was finally settled by Einstein in 1911, who calculated the detailed formula for the scattering of light from molecules. The molecules are able to scatter light because the electromagnetic field of the light waves induces electric dipole moments in the molecules.[1]

Molecules in the air scatter blue light from the Sun more than they scatter red light. This is "Rayleigh scattering." Lord Rayleigh was the physicist who discovered that, when red light passes through a clear fluid holding small particles in suspension, the shorter blue wavelengths are scattered more strongly than the red—Rayleigh scattering. This is the idea behind the rainbow effect; it is the idea behind prisms; it is behind color in general according to physical science.

However, the scattering of the light by particles is countered in science by the idea of wavelengths. The whole question with color is this: Is it a particle, or is it a wave? Science cannot get to the bottom of this. Is light made up of particles or waves? The answer is: *Yes.* If you measure it as a particle, it appears as a particle; if you measure it as a wave, it appears as a wave. This is just physics, and it drives the physicists crazy. So Newton felt that color is particles, but everyone who came after him

1 See http://math.ucr.edu/home/baez/physics/General/BlueSky/blue_sky.html.

has thought that color is waves. Others found that maybe it is particles after all. Rayleigh scattering is generally the way that most people first hear about color in the atmosphere. Rayleigh scattering can be demonstrated by shining a beam of white light through a tank of water with a little milk or soap mixed in. According to Rayleigh's theory, if we look from the side, we see the beam by the blue light it scatters, but seen directly from the end, the beam is red once it passes through the tank. However, to explain it as particles bouncing, refracting, or (as Newton would call it) *refranging,* light is a concept that can be seen from a couple different directions. It is not a finished and settled idea, because there are a lot of problems with color, as we will see, that go against these ideas.

Nonetheless, Rayleigh's idea of scattering held for a long while. They "found that the amount of light scattered is inversely proportional to the fourth power of the wavelength for sufficiently small particles"—but if they are bigger particles, then we don't know. We go from particles to waves in attempts to explain it. It follows that blue light is scattered more than red light by a factor of 700/400 x 4, more or less equal to 10. That little \geq means more or less. So it is the more-or-less that sounds a little fishy in terms of saying this is what it is. It is more or less a factor of 10. Is it more or less? We are moving from intellect to reason, but it is in the clothing of intellect. Color does this because it is so darned wiggly. Tyndall and Rayleigh believed that the blue of the sky must be caused by small particles of dust and droplets of water vapor in the atmosphere. Even today, many people say that this is how it works. Scientists later realized that, if this were true, there would be more variation of sky color according to conditions of humidity and haze than what we actually see. Thus, they proposed that the molecules of oxygen and nitrogen in the air account for the scattering effect.

Now we are getting to molecules; it is not the water or the dust; it is that the air molecules of nitrogen have a different scattering ratio more or less. The case seemed like it was finally settled by Einstein, who calculated a detailed formula for the scattering of light from molecules; an electromagnetic field of the light waves induces electro-dipole movements

in the molecules. This is an example of what Goethe would call "intellect describing a phenomenon." If it cannot be this, then maybe it is that, but then, this is what it is, or that is what it is. One of my hobbies is finding these things and poking in there, because it just keeps going from things to molecules to electromagnetic dipole movements. Then, we say: What is that? Well, it is induced by blah-blah-blah. So it may be dark energy, which is seventy percent of the universe that cannot be seen and measured. We don't know what it is, but it has to be there by our calculations. Seventy percent is a lot. Now, when we come to color it gets even stranger. If we try to find the root cause of how things got this way, it is useful to go back to Newton's experiment. His experiment involved these four things—when you have a few minutes sometime, just take a colored pencil and fill in the blanks with R, O, Y, G, B, and V, or red, orange, yellow, green, blue and violet. That is what those colors are. I will explain in a moment.

A Newtonian scholar went into Newton's notes and papers and found a series of experiments related to Newton's idea of color that could not be replicated, though they are the foundation of the ideas mentioned previously. Thus we take another step with color away from art and into science. Here we see oscillation in science similar to what we saw in the romantic versus classical in art. This oscillation has to do with the way we deal with phenomena. Newton's way of dealing with phenomena leads to developing the intellect. He would make a narrow slit for sunlight to pass through, making a very narrow band of light that he then passed through a prism. Because the light was restricted to a thin white bar, it shined out of the prism and projected a spectrum of color on the wall. So our question is this: What in the prism causes this phenomenon? What takes place in the prism?

Let's look at Newton's famous white-light experiment according to the diagram on page 67. Newton was a good scientist, but certain things have been discovered about light since then that were unknown to him. He did his experiment with the four steps we see here and, as we will see later, they point in the direction of the experiments Goethe did with the

prism, which we will replicate. At a certain stage, Newton and Goethe observed the same phenomena. That is my point—scientifically. However, they approached it from two completely different directions, and "therein hangs the tale" of Newton and Goethe. Goethe was vitriolic in saying that Newton was wrong. In the next chapter, we will look at Goethe's experiment with suspended particles in water, what is called in anthroposophic language and what Goethe called *die trübe,* meaning a turbid medium, or turbidity in old German. Goethe was struggling with the idea of a turbid medium, trying to bring it into the context of Newton's finding. So there are two very different ways of looking at the same thing; these two geniuses found the same thing, but they found it from completely different points of view.

Number 1 in the diagram. On the left is the generating prism, and then you have a little bar of light entering—white light (w). When white light enters a prism, it refracts, or bends, because light going through a denser medium changes direction. It even changes speed, according to science. It slows, which in theory it should not do—but it does. When the light exits the other side of a windowpane, it speeds up again. When light goes into a denser medium it bends, or refracts. In the diagram and in number 1, we see the white light entering and being bent from its original direction by the density of the prism, but what comes out of the prism is what Newton calls a *refrangibility factor,* which allows us to see components of what we think of as the spectral properties in white light. Thus, Newton tells us, "White light is composed of all the colors." That was his discovery. To prove it, he allegedly—this is the part no one can replicate—placed another prism in the spectrum upside down to *de-refrange* the light and shoot it back into a beam of white light. This is the "alleged Newton recombination experiment phase 1: complete spectrum results from breakup of white light on the left then is recombined by the prism on the right." People went nuts over this. It was like the ideal experiment—here it separates, then it goes back together, and then comes out as a white beam. Mission accomplished; where is my Nobel Prize? However, Newton was

Primaries

1 Alleged Newton recombination experiment, phase 1. Complete spectrum results from breakup of white light on the left, and then is recombined by the prism on the right.

2 In number 2, the spectrum on the left is passed through a prism that has been moved up through the color band. Green at the top and magenta at the bottom support Goethe's veiwpoint.

3 In number 3 the second prism is moved up even further, and the second spectrum is split into green at the top and blue indigo and violet at the bottom.

4 In number 4, the second prism is moved up again, and the once-whole spectrum joined in the middle by green is seen to be split into the warm colors above and the cool colors below. No green is evident. This supports Goethe's view of the split spectrum.

Diagram 1: Newton's prism experiment

never able to repeat that experiment—this all comes from a Newton scholar who loves Newton.

There was a problem with his experiment, so Newton moved on to phase 2, where it gets very interesting. Here the spectrum on the left is passed through the right prism, which has been moved upward through the color band, with green at the top and magenta at the bottom. Newton moved the prism so that the magenta side, the more refracted side, skipped the prism. He got a pure magenta beam at the bottom. Now we see that the colors violet, indigo, and blue come together but stop in the prism. Red, orange, and yellow go through the second prism, and they also stop, but what comes through is a green. Thus there appears to be a kind of splitting in the spectrum in the way it behaves. If you just move the prism a little, you get a kind of freewheeling magenta, but then all the others collapse and the only thing that comes through from the rest of the rainbow is green. Although the first stage cannot be repeated, this second one can be replicated by anyone.

This second experiment seems counterintuitive; we would think that if I take blue, indigo, and violet together, I will get something when they come through the prism, but they don't go through the prism. We are being scientific, so our question is: Why?

If you have one, this is a good point to get your prism and do some "prismology." If you do not have one, scientific-quality prisms are available at reasonable prices. Two prisms work best for these exercises. A large prism will have two narrow sides and a wider side. Seen in cross section, the triangle will have two equal sides leading to the apex with a broader side as the base. You will want to hold the broad side away from you with the apex joining the two narrow sides pointing back towards you. Smaller prisms usually have three equal faces. When seen from the end the cross section makes an equilateral triangle. Use this prism by pointing one flat side away from you and the side with the apex pointing towards you. You can use either kind. Now, you need to follow the directions of how to look through the prism. Hold either prism horizontally with one flat side away from you. Again, if you have the larger prism,

hold the prism horizontally, with the wider side away from you and the two narrower sides that meet in a point directed toward you if you have an equilateral prism, the apex should be pointing towards you and a flat side away from you.

Now look through the bottom portion of the pointed side of the prism. Looking through the bottom bar locate diagram 1; you may have to juggle it around a bit to find the diagram looking through the bottom bar but keep moving the prism until you can see the diagram in the prism. You should see a very intense magenta bar below the dark line. And that is because the dark bar is thin. If you do this experiment by shining light through a prism rather than looking through a prism it is necessary to compress the light through a very, very thin slit. The light from the very narrow slit then needs to pass through the prism and you will see the spectrum. If you do that you will not see magenta manifest like you do when you look through the prism at this diagram; you will start to see colors that you normally would not see in the nether parts of where the visible spectrum starts to disappear into ultraviolet.

After seeing that magenta below the dark bar by looking through a prism let's turn to the diagrams of Newton's prism experiment (on page 67). This diagram illustrates a series of prismatic experiments done by Newton by shining light through a thin slit and then passing that light through two prisms. In diagram 1 a beam of white light is entering a prism from the left. It splits into parts in the prism and then exits the prism as a series of colors, with red at the top then orange, yellow, green blue indigo violet and magenta at the bottom. Although in a real experiment with this arrangement the magenta is difficult to separate from the violet. In diagram 1, a second prism intercepts the colored spectrum and is illustrated as reintegrating it back into a beam of white light. This is the classic Newtonian experiment. And in reality according to what I could find it has never been repeated. The scholar whose work I used to make these diagrams stated that in reality even Newton couldn't repeat it so he did a series of other experiments to see if he could manipulate

the prisms to make the spectrum reintegrate back into a white light. The other diagrams on the page are illustrations of the variations that Newton performed with the prism experiments, and others can reproduce these variations.

In number 2 of the diagram, the second prism is moved up so that the magenta portion of the spectrum just passes through the very tip at the bottom of the second prism. This shift radically changes the spectrum. It splits the spectrum into blue, indigo and violet down below and red, orange and yellow up above and the only color that escapes is the green that unites the warm and the cool portions of the spectrum. That means that in this position the light is split into a magenta band at the bottom and a green band at the top. The rest of the colors are not projected out of the prism.

In number 3, a second prism is moved up even more, and the second spectrum is split into green at the top and blue, indigo and violet at the bottom, and magenta goes away. Now we get blue, indigo, and violet showing as spectral bands, but the red, orange, and yellow are still being combined in the prism, and what is coming through is a green.

In number 4, the second prism is moved up again and the once-whole spectrum joined in the middle by green is seen to be split with the warm colors above and the cool colors below, but green goes away. This is Newton's experiment according to the records that I could find. One out of the four is the one that gets carried on by modern science, but it is the only one that can't be reproduced. It is interesting to note that the other three that can be reproduced and actually point to what Goethe found about magenta and green, are thrown into the ash heap of science.

To understand better what is going on in these prisms, we should realize that there is an unusual aspect of light taking place in one prism that is known as a refraction, as Newton called it, of refrangibility. What is refraction? What happens when light is refracted? When light is *reflected,* it just comes back at an angle off the surface, but when it is *refracted,* it is bent back, and part of it travels back over itself somewhat. This puts a kind of tension in the light frequencies and unusual color phenomena

are the result. There are many curious things when it comes to light, and deep secrets are involved.

Goethe, being the curmudgeon he was, wanted to write a book to refute Newton's idea, so he borrowed prisms from a doctor friend who had a lot of money. At the time, a lot of the prisms were actually water prisms—huge troughs of glass filled with water that one could look through. People were doing all kinds of experiments with optics. It was also the beginning of microscopes, while telescopes had been invented 150 years earlier. Knowledgeable people were interested in two things at that time—plants and optics. Surveying with transits and telescopes and all sorts of optical devices was a useful skill as well as having knowledge of plants. People coming to the New World had to experience unknown plants and they also had to have skills as surveyors so they could stake their claims.

Goethe was a scientist with a deep interest in plants, especially the metamorphosis of plants, as well as having a deep interest in optics. He claimed to understand that color had another dimension, but he had not actually experienced it so he decided to do experiments. He borrowed prisms from a doctor and kept them for a while. Eventually the doctor said to his son, "Goethe has had my prisms for a couple of years. I want them back. Go over there and get them." So his son kept going to Goethe, who said, "Yes, I will give them back." But he never did. Finally the doctor's son said, "My father told me not to leave your doorstep without the prisms." Then Goethe reached into the box, picked up a small glass prism and, just on impulse, turned and looked through it at a window that had bars in it. Diagram 2, figure 3 (page 72) represents what Goethe saw. It represents black bars of the window frame with white sky outside.

Take your prism, hold it horizontally with the apex pointed towards you and then look through the bottom bar of the prism and see what Goethe saw. He saw areas where color appeared, but he also saw that there were areas where it didn't appear. When I look at diagram 3 through the prism, I see areas of color in specific areas near the dark bars, but there is no color in the middle of the whites. Goethe was surprised and

Diagram 2: Goethe's prism experiment

then turned and looked out the window at the blue sky and saw only blue while looking through the prism. He knew that the light was still coming through the prism, but where was the color? Then he looked at a cloud through the prism and saw color again where the light cloud met the darker sky. Then Goethe recalled a quotation from Plato's *Timaeus*, describing how a ray from your eye meets a ray from a thing out there, and the moisture in your eye harmonizes the fire of the light coming from that thing, and we experience color in that union. That is the way Plato described it. He goes on to describe how color arises from this union between my visual ray and the creation—that it arises where a light passes over a dark, or a dark passes over a light.

Goethe recalled that quotation and said that Newton was only half right—actually he said that Newton was wrong, but we will get to that. According to Goethe, Newton didn't understand that he made the light suffer by squeezing it through a very narrow slit, and that the suffering of the light, as it has to engage the darkness, manifests as color. Goethe then called color "the deeds and sufferings of the light." There are acts of courage and creativity, and there are great dramas of falling and incapacity in color. *It is the soul.* Goethe kept a couple of the prisms and returned the rest of them to the doctor—for now he had his principle.

Now look again through the bottom of your prism at the little window (number 3 in the diagram) and draw a diagram on your paper of what you see. Draw a little **+** (a cross like the window bars in the image), look at your diagram through the bottom bar of the prism and then make a mark where you think you see the colors.

Now, make the same diagram with the little cross in there, with the bars, but look at the diagram through the top bar of the prism. Make a diagram of where the colors show up around the bars while looking through the top bar of the prism—maybe a red here, yellow there, or turquoise. If I am in the right space, I can see that there is actually a kind of violet on the black. When you look through the prism at this cross, there is color around the horizontal middle bar, but there is no color around the vertical bar.

Now look through the bottom bar of your prism again, and keep the diagram in focus. While observing the diagram through the lower bar of the prism slowly rotate the prism until the prism is vertical instead of horizontal. Play with that for a little while, as Goethe did. Record what you saw when you rotated the prism.

Next, look through your prism at the black circle (number 4 in diagram 2) and make a drawing of what's happening around the circle. Do not make a drawing of the top or the bottom of the whole light field; just make a diagram of the colors you see around the circle. Now label the diagram with the names of the colors where you see them—you should see similar bands of colors to the first experiment. If you look at the first diagram we went through, we saw red, orange, yellow, blue, indigo, and violet. There is no magenta or green. Take your prism and hold the diagram in focus and rotate the prism. There is something consistent, but it is sort of maddeningly consistent. Nowhere do we see magenta or a green, but there is this kind of splitting of the warm side of the spectrum (the red, orange, and yellow) and the cool side of the spectrum (the blue, indigo, and violet). They remain separate in these diagrams.

Goethe was playing with the idea that maybe Newton did something special in the way he did the experiment—that maybe Newton's results were merely a special case. In his later years Goethe was sort of an "enemy" of the rainbow, because people would want to look at the rainbow as a prism, and Goethe's only answer would be: Do my experiment and you will see. But a rainbow is a kind of convenient fable; that was how Goethe looked at it, because there is a certain something that is happening in the rainbow.

When we look through the bottom of the prism at the circle and the window bars, we see what is known as a split spectrum. The way Goethe worked was to look through the prism rather than projecting light from the prism onto a wall. When he looked through the prism, he saw that where light met dark, or dark met light, there was this splitting of the spectral qualities in two distinct regions. Goethe knew, therefore, that Newton could not be a hundred-percent correct, because there are

two different parts of the spectrum. That meant to him that the rainbow where all colors appear as one whole phenomenon must be a special case. Goethe felt that something else must be happening. There is another property of light and color that Newton didn't understand. And, to prove this, he did the experiments involving tiny bars, like that first one, where he would see that it might be getting close to a rainbow, and then it would seem to disappear.

Now look through the bottom of the prism at diagram 2, number 2 on page 74. It is a black field with a white bar in it, and the bar is narrow. If I look at the top of the bar, I see red very close to the top, orange, and then yellow in the white bar; it is red right at the top, then orange below it, and then yellow. What you will see depends on how close you are, how big the bars are, and how far away you are from the diagram. If you are not getting results, try moving closer or farther away from the diagram. I can now take a black sheet of paper that blends in with the field and slowly raise it under the white bar to make the white bar narrower. I am squeezing the light bar with the black paper. As you watch the white bar become narrower a change will take place. The top of the black paper can be seen to have a turquoise strip of color. The center of the white bar that is being squeezed is yellow. As I raise the black paper to make the center white bar narrower the yellow in the bar is met by the turquoise of the black paper. The result when the white slit becomes squeezed to become very narrow is that the turquoise and the yellow overlap and appear as green.

Now look at the opposite image with the white field and a black bar that is narrow (diagram 2, number 1). Look through the bottom of your prism. Now at the top we have a turquoise right against the top bar, going down into the black with a violet on the black bar. It is the same as before, except now we have violet on the black bar at the top rather than violet on the black ground. In this case below the bar we have a red near the black bar that is fading out to a yellow on the white ground. It is the same patterning of the two split spectra, but the two of them have reversed their position. I am now going to reverse the procedure and

instead of squeezing the white bar with the black paper that matched the black ground, I am going to squeeze the black bar with a white paper that matches the white ground. Now turquoise is at the top of the dark bar with a violet on the dark inside the bar, and at the bottom of the bar there is a warm red that is shading into yellow on the white ground. But the very bottom of the dark bar is a warm red with a yellow on the white ground and the dark bar itself has a turquoise at the top with a violet on the dark bar itself.

With the white paper moving up, essentially I am now squeezing the warm spectrum that is on the white ground and moving it up across the dark bar until a red at the top of the warm spectrum below the black bar intersects with the violet that is at the bottom of the cool spectrum on the black bar itself. As I move the warm red up into the violet—Huh? Suddenly a bright magenta shoots out of the small slit. The magenta is lighter than the dark bar itself. That is not intuitive. That is very counterintuitive. Suddenly a light arises out of darkness. In the opposite case the green that appears is darker than the light bar underneath it so there is not much to object to with the appearance of the green. But with the magenta a color arises that is actually lighter than its ground.

When I squeeze the slit into a thin dark line the violet that is part of the cool spectrum that is on the dark bar itself is overlaid with the warm red that is part of the warm spectrum that forms at the junction of the white ground and the dark bar. In essence this is moving and casting a red over a violet. The curious thing about this movement is that the red is darker than the black underneath it, and the violet is just maybe a tad lighter than the black. But the violet and the red are two dark colors over a dark black. But as I go through and squeeze and make the black slit very narrow, the violet and the red cross each other and I see the luminous magical magenta arise. But look, the magenta is lighter than the dark ground below it. So I take two dark colors over a black ground and when I cross them, they create another color that arises that is raying out of the darkness with an intense magenta. Goethe called that magenta

ruby-magenta-purpur, which gives us our word *purple*—this is what they used to call purple.

That appellation had to do with the fact that magenta is the color of the creative wrath of the Elohim. It is an original color of the creation, the wrath of the world-creators who spread this creative light out of the darkness to make the world possible. From that creative deed of birthing magenta out of all this, darkness then fell to earth, then green, as the light that burst out of the darkness, then fell back and illuminated the darkness. It is these two great polar colors, magenta and green, as representatives—and that is why we don't see them in the split spectrum. We could say that magenta and green are visiting here. Where you do see them, you see green as a great sacrifice in the whole world; where you see magenta there is the beginning of opportunity.

Magenta shows up at first light, at 5 o'clock in the morning. If you are up in the morning before the sunrise, look to the east and you will see that there is a brightening on the horizon that changes the indigo of the night sky into a kind of greenish hue. Then the greenish hue begins to rise and magenta begins to appear and lifts, and then leaps to the other horizon. If you really want to experience this, go out and watch the sunrise, because the sunrise is more archetypical than the rainbow.

But the play here is the two polar qualities that, when you use the prisms in this way, you actually see that Goethe's experiments actually coincide with Newton's findings in his prism experiments. The great mystery of green and magenta—I'd always read about Newton and was interested in Newton for a long while, because Goethe had such a deal with Newton that I thought there must be something in this guy. I found that Newton's experiment actually formed a basis for what Goethe found. So what is the difference between Newton's experiment and Goethe's experiment? Newton projected the light through and had to reduce it to a slit, but Goethe looked through the prism and allowed the world to come in to him.

Rudolf Steiner spoke of a quality in Goethe that was a kind of carryover. According to Steiner, Goethe had been a famous sculptor during

Greek times and developed a deep appreciation for form and relationships of form. Consequently, Goethe brought with him in his physical and etheric bodies the great ether body of a Greek. Goethe was a huge man with a very powerful body and very strong forces, and he had an ability to use his life forces as a kind of buffer for his sensory experience. We could say that he had contact with what Rudolf Steiner calls *buddhi*. Steiner talked about transforming your sensory life through contemplation of taking in things like this from the world as inner pictures and working with them as a process of becoming.

The essence of the work is "becoming through reason." When you experience the world as *becoming*, your heart opens to possibilities, and you begin to take in the sensory world. As Steiner puts it, you take it in without elaborating it with concepts. You take in sensory experience, and your thinking is present but not full of thoughts. This is very important. "In pure thinking you will find the self that can sustain itself."[2] I have read other translations of this verse, for example, "...that can hold itself in check," meaning you have to develop a kind of thinking whereby you can perceive how your thinking arises under the impact of a sense impression. This is the work. When I can hold my own thinking. I may look at the color red and ask: What is this red doing within me? What is this movement going from a red intersecting violet as magenta arises from it? When I duplicate that picture in myself as a meditation, I create an organ of perception in myself for the spiritual archetypes behind the human astral body.

The great archetypical color beings hold the key for us to the astral body as an archetype. I place myself consciously within their consciousness as a meditator; that is the Jachin pole. First I find pure thinking. I find the self that can hold itself in check, meaning I can check when I am thinking, and I can think without thoughts. I can judge when I am thinking with thoughts and when I am not thinking with thoughts, but I am still thinking. Thinking without thoughts is pure thinking. In pure

[2] Steiner, *Finding the Greater Self: Meditations for Harmony and Healing* (tr. M. Barton) p. 59.

thinking you find the self that can hold itself in check. This is a Rosicrucian phase of the work called study. We are now studying the archetypes of the human soul. The human soul is becoming, and the becoming is when one hue in my soul crosses another hue, and the pressure becomes so intense that a new light bursts from it. This is the light of coming into *carne*—incarnating. Magenta is the color of incarnating, coming into the meat, *en la carne*.

This incarnating, whereby dark violet and blood red cross each other, is the raying out—the pressure of a deeply creative act. That is the Elohim. If I take this in and hold that picture in pure thinking—form it and move it as inner becoming and put it to silence and listen—I begin to move into the next level; I transform a thought into a picture. When I transform the thought into the picture, I experience the creative wisdom of the Elohim creating a world from magenta that falls and sacrifices itself to be clothed in green.

The world is a symbol of my work on myself. It is a symbolic content that I take from my study, pour into an imagination, and give it back to the creative beings. They are grateful when we pay attention to the deed they are always doing. With every sunrise and light ray spreading across a green meadow, we are enacting the primal deed. Putting pictures like this into your sleep by forming them and then watching them dissolve, I enter pure thinking. I check my thought-formation by allowing it to go away, and then I listen in the morning to what happens and watch the sunrise. When I watch a sunrise in this way, I participate consciously in world creation. I am collaborating with the way the great plan is being depicted for me in the sensory world, which I think of as "stuff out there." But I have to carry reverence to it. I have to carry to it a feeling of gratitude for what it really is, the symbol given to me. Otherwise, it remains just another piece of something that doesn't make sense. If I continue in this way, I begin to have an experience, and once this begins to work in you it starts to become a practice.

I am describing the drama of the soul coming from a spiritual domain and entering material meat—Word becomes flesh...the Light

of the World comes in and dwells among us. As the light comes into the flesh, I awake to the fact of my incarnation—why I chose to return to a body that suffers. Is it because I am bad? No; it is because this is the plan. If I can understand that it is the plan and not the result of being bad, I then start to see how life goes into death, but death creates the new life. Then my troubles become less troublesome. My soul is freed of the belief that I am bad, and I start to believe that maybe I need a little more education. Maybe I just need to understand something from a different angle. This is the soul, and the different angle is that I have to awake in someone else, but I may be magenta and they may be green. They may have their whole soul oriented to the light coming and dying into stuff. That may be their outlook: everything dies. Or their outlook may be the exact opposite: I am dying, but I am going to get out of here and create something never seen before.

This is the magenta, and the great secret is that green and magenta are deeply attracted to each other. They have a deep affinity for each other, because they recognize the completion. This is the great secret of the soul. You choose parents who will give you the dilemmas that allow the energy in you to overcome them. Your anger becomes resolve. Things are transformed because of resistance. This is the law of the soul.

There is an image titled *Grotto* by Liane Collot d'Herbois (1907–1999), a brilliant anthroposophically inspired painter. Moving through the grotto, we are in one color going one direction, then we turn and are in the opposite color. Wherever we turn, we are in a particular color, but if we look behind us we see the opposite color. This is the consciousness we need to understand color. It is the deepest soul training I know of—how to live in soul, how to be in the soul—because the soul always yearns to be the next thing; it is never satisfied. The grass is always greener, so you have to wear rose-colored glasses to deal with it.

These polarities are also in our language, because they are in our soul. When magenta light comes in the morning and streams across what would otherwise be a green meadow, the mood becomes one of sacredness. We all know this. If you are out fishing or sketching or watching

the birds, it is a sacred moment, the wedding scarf of a new day. That is how the Greeks described it—the wedding shawl of the new day. These are symbolic languages that describe what color gives to us, inspiring us to research the soul through aesthetic and symbolic perception. It is symbolic consciousness that heals. The more we get into the healing mode of the symbols working for us, the more we make friends with beings on the other side who understand their role in our dilemma. They generally do not understand our dilemma because they are not human, but they understand their role in our dilemma, and they look to us to recognize them so they can evolve. The being of magenta wishes for us to recognize it so we can evolve. They wait every morning and every evening, the first to come and the last to go. This incredible symbolic soul drama is played out in the world for us because of who we are and why we are here. We call it color.

5

Turbid Medium

Goethe's discovery of turbidity and how it acts gave him an opening to refute Newton by looking at him from another side. The stimulus for this was a passage in Plato's *Timaeus* (c. 360 BC). *Timaeus* is probably the most controversial of all that Plato wrote. Many scholars think that perhaps he was not in his right mind when he wrote it. It doesn't make much sense to a lot of people. However, *Timaeus* is Plato's most deeply esoteric work. Goethe went back to this text for his perception that Newton was missing half of the problem and did not recognize that he was introducing another element when he squeezed the light into a slit—that the size of the light beam and the prism itself introduced something in addition to the light. Moreover, we did not address this in our prism work in chapter 4, because I wanted to leave it as an open question. Why do we not always see green and magenta in the spectrum? Why does there appear to be a split? How does the split come together? What was the action of the prism?

The action of the prism was connected with the earlier gel test. By taking in the colors but not giving you concepts right away, I wanted you to experience the colors as Goethe would have done. I wanted those colors to ferment, so that when we return to them, you would have an inner experience of what the soul is doing in the presence of the sensory world. This is really the whole purpose of this book: What does your soul do as you have a sensory experience? This is the Rosicrucian core of the work in Anthroposophy. It is central to much in Rudolf Steiner's work, but it is hidden like salt in a casserole. It is also what Goethe called an *open secret*.

Because of who Plato was, in his *Timaeus* he included the activity of the human being in the experience of perceiving. Aristotle worked to avoid the issue, so for Plato this is a new thing. Something happened between Plato as a summarizer of the ancient world and Aristotle, who brought abstraction to the study of nature. All the great thinkers around Plato's time—Confucius, the Buddha, and Patanjali—were summarizing thousands of years of esoteric development. This impulse came to a head around 600 BC. However, there is a split in Greek thought between Plato and Aristotle that set the stage in the fourth century for the Arabian development of analytical science that we inherited, including medicine, empirical science, and mathematics. The important issue had to do with whether I can become aware of sensory experience when I have it in my soul, or do I have to start abstractly quantifying my experience? If I start quantifying through mathematics I don't have to worry about my feelings, because science is all about counting and measuring. On the other hand, if I have to worry about my feelings—if they are part of the experiment—they create a bias.

This is the crux of why Spiritual Science presents a conundrum. Is it objective? Goethe had a term for his work in the color theory: *subjective–objective*. It means you take your subjective experience and make it objective through practice, through rigor and self-analysis. This is the way Goethe described the work I am describing: subjective–objective. We take the subjective quality of our sensory experience (what happens when I see red) and objectify it through experiment, practice, observation, and phenomenology. Thus, our subjective experience becomes objectified so that we can take it back into the world as true phenomenology, connecting it to an experience we are having within the soul without bias. Steiner said that in pure thinking we find the self that can hold itself in check. This means that, when we have a sensory experience, we need to go to pure thinking to hold our feelings in check; we hold the self in check by asking ourselves what is happening within, subjectively, when I look at red. What we realize from this question is that certain feelings arise if we do it long enough as a little exercise. If we do the exercise of watching the

magenta arise from the darkness and then fall again as light into green—if we do that and work inwardly with it, we begin to connect with our feelings about incarnation and excarnation; those colors are archetypical movements in the archetypical world of that process. Magenta is breaking the creative force of the Elohim out of prison. Their prison is having their work diminished by human beings. The activity of the Elohim is to create life. It is *An Outline of Esoteric Science*, chapter 4 in a nutshell. It is called magenta and green—the escape of the hierarchies and their fall into earth. If you work with the pictures, or transform the thoughts in *An Outline of Esoteric Science* into pictures, we experience the creative wisdom. This is how Plato began to experience in himself, how the cosmos interacted with his humanity. Aristotle spoke of ten categories and felt a need to analyze and try to find a primary cause, a secondary cause, or all the causes. Research into life became analytical. For Plato, however, it was the inner experience that mattered.

Plato had much to say on this problem of color. "White and black are similar effects of contraction and dilation in another sphere, and for this reason they have a different appearance." The other sphere is that of the archetypes, and white and black are similar effects of contraction and dilation. "Wherefore we ought to say that white dilates the visual ray." The visual ray is what comes from you, and his perception was that white dilates that visual ray—it spreads it out—while black concentrates it. The visual ray is very controversial—is it real or not real? I have read websites where people talk about the visual ray. One asked: Why do your windshield wipers always go bad right where you are looking? Interesting question. Above and below where you are looking they don't go bad, but it is only right where your visual ray is that they leave the streak.

This is the question: Is there something coming from me when I see? Is there something coming from me when I hear? Absolutely, according to Rudolf Steiner. It is your soul. Plato wrote:

> Wherefore, we ought to term white that which dilates the visual ray, and the opposite of this is black. There is also a swifter motion of a different sort of fire which strikes and dilates the ray of sight until it

reaches the eyes, forcing a way through their passages and melting them, and eliciting from them a union of fire and water which we call tears, being itself an opposite fire which comes to them from an opposite direction.

People wonder what he is talking about. It is why they discounted *Timaeus* as gobbledygook. Nonetheless, it is an alchemical language of certain qualities.

> The inner fire flashes forth like lightning, and the outer finds a way in and is extinguished in the moisture, and all sorts of colors are generated by the mixture. This affection is termed *dazzling*, and the object that produces it is called bright and flashing. There is another sort of fire that is intermediate, and that reaches and mingles with the moisture of the eye without flashing; and in this, the fire mingling with the ray of the moisture, produces a color like blood, to which we give the name of *red*.... White and bright meeting and falling upon a full black, become dark blue.

If you know a little about Goethe's color theory, this should be ringing some bells for you. This is the passage in *Timaeus* that caused Goethe to think he had a case against Newton.

Now we will consider the turbid medium. I am going to do a demonstration here of it. Color has four properties: value, temperature, hue, and intensity, or chroma. Value is light and dark; temperature is warm and cool; hue is the primary red, blue, and yellow and various mixes of those hues. Chroma is intensity, or the bright or dull quality of the hues. These are the four properties of color. Light and dark is the fundamental. In an earlier chapter, we looked at the fayum pictures and early art, which were mostly light and dark with color laid on top as a kind of mixing thing to separate those two out. Later artists began to explore color and the neutralizing of color and developed color circles and such. The first actual color circle was developed during the Renaissance. It was very simple and was developed as a result of "dynamic color." Goethe inherited this concept from a classical painter while still in his teens. His father arranged painting lessons for Goethe, because he was supposed

to be a lawyer, and lawyers were supposed to have classical training. He received his painting lessons from Friedrich Oeser, a classically trained painter in the town where Goethe lived, and such training at that time was all about dynamic color. There is an excellent book on the subject by Sir Charles Lock Eastlake, who was the head of the Royal Academy in the late 1800s.[1] He was supported by the Crown, and his job was to travel around Europe to monasteries and collect manuscripts on painting materials and techniques. It was also Eastlake who translated Goethe's theory of color into English.

Those masters understood that there is another level of color, or "dynamic color." When egg-oil developed into oil painting and sfumato came in the 1500s with da Vinci and the Renaissance painters, the old masters eventually noticed that certain things happened that created "atmosphere," which was used in the seventeenth to nineteenth centuries to develop very precise painting techniques of one color layered over another to create color effects that were not part of pigments themselves—that is, dynamic color. The principle of turbid medium drove the technique of dynamic color. Light and dark are simply light and dark, but to make gradients of light and dark and lay them over on top of each other, we begin to have the experience of a temperature change in the way the pigments interact. This is a kind of door to understanding color. When light and dark are layered, something new happens that is not physical, but we see it because we have a soul. Our soul requires us to see something that may not actually be present.

Speaking about the Rosicrucian path, Rudolf Steiner said that, when ancient people spoke of the element of warmth, they were referring to the hierarchies called Cherubim, Seraphim, and Thrones.[2] Warmth is the enthusiasm of being. It is the cosmic condition of ancient Saturn. Then there are the cosmically younger beings, the Kyriotetes, Dynamis, and Exusiai. They reveal themselves in the element of light. Penetration

1 Eastlake, *Methods and Materials of Painting of the Great Schools and Masters* (Mineola, NY: Dover, 2001).
2 Steiner, *The Secret Stream: Christian Rosenkreutz and Rosicrucianism*, p. 197.

of dark Saturn warmth indicates inner illumination of darkness. Meanwhile, the warmth becomes denser as a shadow of the light.[3] This is known in art and the psychology of color as *simultaneous contrast*. Light and the dark must speak to each other. The ancients called the shadow of light *air*—this is pure alchemy. Light reveals the path of beings moving through dark Saturn warmth. With the onset of light, shadow arises. Alchemically, air is the shadow of light—the dark that opposes the light on ancient Sun. After this a further evolution takes place through the workings of the Archai, Archangels and Angels on the Old Moon; they add a new element that is like our human desire—soul, astral body.[4]

This is our impulse to work toward something, to long or yearn for something, which I propose to you is *color*, which itself is something yearning to become something. Colors add a new element akin to human desire, like our impulse to strive or long for something. The Archangel, or Angelic being, enters a place of light from ancient Sun, and that entrance and that being's receptivity to light in the beings of the third hierarchy causes an urge for darkness to arise. The angelic being who carries light into the darkness is a regressive Angel, but one that still has a cosmic function to fulfill. These beings are mediators between darkness and light. As a result, the darkness of the air begins to shine in the play of color. Out of light and darkness the third hierarchy creates color through being in the darkness and wanting light or by being in the light and wanting darkness. It couldn't be clearer. When color is present, where it penetrates and flames up in a shadowy air, pressure and counterpressure arise, and a fluidic, the element of water comes out of the color.[5] Rudolf Steiner relates this picture to *An Outline of Esoteric Science* and the Fall of the hierarchies through sense perception. The agent of the Fall of the Archai on Old Saturn is the fact that they held onto a quality of sense perception instead of reflecting it back to the Creator. That is the core of the soul. From that, then, comes light and darkness.

3 Ibid., p. 198.
4 Ibid., pp. 198ff.
5 Ibid., pp. 202ff.

I have water, a medium thought of as transparent, meaning that light passes through it without being altered, other than being refracted. We can shine a little spotlight through the water in a gallon jug, and we see that the light passes through the water but stays the same color, because water is a transparent medium. However, if we drop a little bit of milk into the transparent medium, the medium remains transparent, but a milky area becomes turbid. Now we will mix the milk to diffuse the turbidity in the transparency. Now the medium becomes wholly turbid and there is a change in the "temperature" of the light. If you have a keen sense of vision, the change will be very evident. As we increase the turbidity, we make it so turbid that it becomes opaque. At this stage, light cannot pass through and we lose the color.

In this way, we can see that turbidity has a certain degree of light and dark in the mix, and we see by this that there is a change in the hue of the light. In the turbid medium, through which the light is passing, we see warmth in the center, and then it gets cooler on the periphery, in contrast to the color of the light through a transparent medium. The light shining through the turbid medium will have the appearance of a warm yellow. This is a warm color. Now shine the spotlight from the front of the jar toward the back, and the water that was just seen as yellow will now appear to be blue. This shift from yellow to blue is a change of hue.

We have moved from value (light and dark), because the turbidity is a mixture of darkness and something light scattering in there, through the beginning of temperature. Now, however, as the turbidity gets stronger, we start to see not just a temperature change but also a definite hue change. This is the action of a turbid medium. The question is this: What does this have to do with the prism work we did earlier? Do they have anything in common?

Now place the light so that it shines down into the top of the jar. We can see that, even in the jar itself, there is a hue change from one area to another. If the light shines from behind the jar through the turbid medium we see one color—darkness is in front of the light. When darkness is in front of the light, what do we see? The medium appears dark

in front of the light, and the appearance is one of warmth. With nothing added to the transparent medium, the light passed right through, but now the turbidity becomes a kind of darkness in front of the light. Compared to the light, it is dark. Recall what Steiner said about the archangels and the Angels—if they are in the light, they need a dark; and if they are in the dark, they are looking for the light. Darkness and light have a love–hate relationship.

There are lots of different kinds of darkness. There is darkness that moves and wants to have a relationship. There is darkness that doesn't move and doesn't want a relationship. There is light that moves and wants to have a relationship, and there is a light that doesn't move and doesn't want a relationship. Thus, when we have darkness such as our turbid medium and shine a light through it, we have a condition known as dark in front of light. This gives my soul an impression of warmth. My soul enters the turbidity and supplies a hue. There is no "color" there; it is only milk in water. Where is the color? Nor is there any color in the glass of the prism. These are interesting questions.

So we have the warm condition—dark in front of light giving an impression of warmth. Now place the light in front of the dark—light with the darkness is behind it. What do we see? It is cool. With the darkness behind, the light is cool. With darkness in front, the light is warm. This is what arose in Goethe's mind when he looked through the prism. We have a turbid medium that generates the impression of warm and cool. If we keep deepening by adding more milk to the medium, opacity will increase. Is this opacity what we would normally call color, or is opacity something else? A turbid medium simply means that the light encounters resistance. The light cannot just stream but has to bend or become diffused. Goethe calls it suffering of the light. When the light suffers, its suffering is revealed through its desire body, which we now know is the Angels working to make colors. That is our desire body—our astral body.

The astral body is filled with polarities. The astral body has "I like this" and "I don't like this" as its fundamental principle. Rudolf Steiner

calls it *sympathy* and *antipathy*. Sympathy is "That is me," and antipathy is "That is not me." The astral body is composed of infinite permutations of this polarity. Your shoes are you. If someone comes into your bedroom, takes your shoes, and start wearing them, you will have problems with that.

My desire body is made of colors that represent the force of "I can just go and do whatever I want." You know how it is when you are driving your car on the Golden Gate to San Francisco and heading for the plaza to pay your toll, and some guy in a little Fiat or Porsche comes up and cuts in front of you. You know how that is. Certain feelings arise. Now think of light streaming in from the cosmos and having to get caught in your gallbladder. It has issues with that. It is coming through the cosmos—maybe from Antares to be with you, and now it is in your gallbladder for a while. When light has to stop or change directions, what we call color arises. When you see my feelings change, we say that I show my true colors. Now you know where I am.

Where light goes over dark or dark goes over light, we get turbidity, even if it is just pigments spinning. Consider our earlier discussion of the prism. Was there color everywhere? No—only where light meets dark. But then we changed viewing sides and move things around, and we found some kind of logic to it. We tried to see what makes the prism work. Where did the blue show up—the blue side of the split spectrum? It is in the dark part. What is the relationship between light and dark in the blue part? Think about that. What is the relationship between the same light and dark in the warm part? This is an interesting question. If I look at the colors as they appeared, I have light going over the dark. What do I see? I see the cool colors. And if I have a dark going over the light, what do I see? The warm colors. What do I mean by "going over"? If you look through the bottom of the prism, you see this one way, and if you look through the top of the prism, then you see the opposite. That means that the prism, by bending the light, is casting one image of light and dark just in a little fringe across the other image. When they refract and cross each other, you get a condition of light over dark or dark over

light. Wherever that boundary of light and dark is, depending on where you look at it—through one side or the other of the prism—you will see the light over dark or the dark over light. The prism is casting, through its refraction, just the edge of one image of the light across the dark, or the dark across the light. Then the opposite; it is just very consistent. The prism is consistent. When we work with the idea of turbidity, or the turbid medium, we see that wherever light and dark cross each other there is going to be the potential for "temperature" to arise from the value structure of light and dark.

Let's approach this logically. I have a white field and my prism is casting the white field across the black bar. When I say "light" or "dark" I prefer to say that there are two kinds of darkness. This is a lot easier to understand. The darkness behind the light is blue, and the darkness in front of the light is warm. Otherwise, we say: Well, is this the light or the dark? To be clear, rather than saying it is light over dark or dark over light, try to say it is the darkness behind the light or the darkness in front of the light. When working with the prism, if I have the darkness behind the light, the white is being cast over the darkness—meaning I have darkness behind the light. It goes blue. If I have the darkness cast over the white, the darkness is in front of the light. It goes warm. It is the same medium and the same degree of turbidity, with either dark behind the light or dark in front of the light.

This is a great metaphor for the soul—is it good or is it not good? And the answer is yes. This is the metaphor of the soul. Are you warm for big government, or are you warm for small government? Are you warm for chocolate, or cool for chocolate? This is sympathy and antipathy. This is why our little jug of milky water is such an incredible metaphor or symbol. The light then changes the relationships between the light and the dark. In the prism, where the prism is casting the light field across the dark, I experience the dark behind the light, and I experience the blue spectrum. Where I am experiencing the dark field in front of the light, I experience the warm spectrum. The dark is cast across the light—that is, the dark in front of the light. It is warm. When I experience blue in the

91

turbid medium, the light is being cast in front of the dark; the dark is behind the light. It is cool.

Now we have the prisms tallying up with the turbid medium and we can answer Goethe's great question: Why is the sky blue, and why is the Sun yellow? Darkness behind the light is blue. What does that have to do with the sky? Where is the turbid medium? The atmosphere is a turbid medium. It is a turbid medium being illuminated by the Sun. When that turbid medium becomes light by diffusing the light of the Sun, the darkness of space behind it gives us the impression blue—the darkness behind the light.

Let's shift to looking at the Sun. What is that condition? The same turbid medium is now darkness in front of a light, so the Sun goes warm: yellow and reddish. Why does the Sun appear redder around sunset and sunrise? There is more medium acting as darkness between the Sun and the observer. At sunrise and sunset there is more medium between the light and us. We are seeing the whole range of colors unfold because of the depth of turbidity. The most beautiful sunsets have to do with particulates that don't particularly belong up there.

In reality, each color has a sympathy side we call a gift and an antipathy side we call a challenge, or an irritation. If you tried our previous color experiments, some of those colors were just part of your gift, and you were okay with that. But there may have been one of the colors where suddenly you felt your gallbladder become angry or somehow upset. This means that color, rather than being a gift, is experienced as an irritation. Magenta, for example, may be a gift that some people have in the soul, or it might be an irritation. This can also be the case for the Earth. Is climate change a gift to our consciousness or a challenge? It is both.

This work can get mystical very quickly, so what I want to do with you is ask: Can we think about this in a reasonable way? Can we put it on a foundation so that, when we do things with color, we can say we are doing this because...? It does not mean we will not make mistakes, but I would say that color is the medicine of the future. It is not the

surgery of the future, but certainly general medicine. This is where I want to go, but I want to put this on a foundation, so that when we do these studies you actually see a reason behind saying green does this or blue does that. When you do an experiment or test, the one that has the most irritation, the most negatives, that is your teacher. At some point, I will present the polarities of the color wheel from the perspective of homeopathic constitutional remedies. There are twelve homeopathic constitutions that homeopaths use as *polycrests*. These are the go-to remedies when you have an idea but not a specific *simillimum* for a person.[6] There are certain polycrests that we can go to (such as sulfur or silica) that cover a range of bases in a certain area, but are not necessarily specific to a particular symptom; rather, they have more of a general influence. We will look at this area in greater detail in terms of colors when we consider the work of Catherine Coulter, a brilliant homeopath. Before then, you should have enough color in you that, when I talk about green, you will be able to have an inner experience of why a green personality and a magenta personality have particular afflictions that can be healed in particular ways. Certain substances in the world are images of those colors.

In color therapeutic work, the color one experiences as the most negative is called an irritant. This, then, becomes the therapeutic remedy. If you have a hangover in the morning, you have to make friends with that color. It represents a whole nexus of feelings that you do not want to access. That is why it makes you reactive.

6 *Simillimum*: in homeopathy, the remedy indicated in a certain case because the same drug, when given to a healthy person, will produce the symptom complex most nearly approaching that of the disease in question (*The Free Dictionary by Farlex*).

6

Glory Sun

Let's begin by looking at Goethe's Temperamental Rose and power of the soul tetrahedron. The colored discs around the outside are just add-ons; the tetrahedron in the center, the triangle, is what he calls the powers of the soul as colors. The surrounding disk Goethe calls the Temperamental Rose. He had five books on the color theory, four of which were about physical color, optical color, chemical color, and so on. The last one was on psychological color. This was the 1800s in Europe, and Napoleon was running amok. Unfortunately for today's delicate sensibilities, therefore, Goethe based the psychological colors on the characteristics of national flags. Nonetheless, his basic idea was very profound, because it opened the door to exploring color in terms of psychology. In the evolution of art, post-impressionists were interested in the psychology and symbology of color, whereas the impressionists before them were more interested in the optical effects of the color. However, if you read impressionist manifestoes, the optical effects they were aiming at had to do with generating greater participation in the viewer. They wanted the viewer to participate in the actual becoming of their art, so they placed the colors from Chevreul and Delacroix next to each other in small patches so that viewers had to mix them in their soul. This was what they called an "impression." It was an impression of the color, requiring people to become more active in perceiving. They were trying to manipulate the inner soul so one could "create" a color that wasn't actually there. It was a kind of shamanic process.

Prior to the impressionists, the purpose of painting typically was to replicate sense reality. This was around the time that the camera had

been invented and was coming into use. Along with the use of photography, there was a controversy in France. It had to do with whether a horse is ever airborne while running or at least one foot is always touching the ground. With the development of the camera, one could now take photographs of a horse running and say that, yes, a horse does leave the ground while running. This seemed to do something to the national consciousness in relation to what we expect art to be. The impressionists and the post-impressionists said that we no longer have to act as cameras, because now we have photography. Painting to produce an image much like a photograph had been the goal of visual art from the time of Vermeer. Vermeer was an innkeeper, and in one of the rooms of the inn he had a pinhole lens in a wall that projected onto a sheet of frosted glass. He would have people sit on the other side of the room and on the sheet of frosted glass there would be an image that he wanted to duplicate. This is why his paintings look like photographs; his room was a camera obscura. To paint like a camera had been the goal in the early Flemish times; painters worked a lot with the camera obscura to flatten the image, making it easier to duplicate three-dimensional reality. All they had to do was copy the patterns of light and dark in their underpainting and they had it. Then they glazed over it—that was the fun part. Verisimilitude—photographic realism—was the goal from the time of Vermeer in the north until the time of the impressionists.

Suddenly, the camera was able to depict the outer appearances of nature better than any painter could. What is the purpose of painting? Color began to take precedence over form; instead of being concerned about form, painters began to concentrate on color. This was the inheritance of Rudolf Steiner—painting out of the color. Now color no longer had to serve outer appearance but could now become a vehicle of expression in its own right. This led to the impressionists, who wanted the impression to do something in you that goes beyond just using a picture as a metaphor for the life of Christ or some other important event. The great post-impressionist Paul Gauguin wanted people to feel the biliousness experience of being hung on a cross, so he painted *The*

Yellow Christ as a picture of the suffering, surrounded by the local peasantry in their rustic garb. He made a social comment about the Church. Color had been liberated to express feelings. There was Goethe in the late 1700s, already saying that color can be used to express feelings. The idea of the Temperamental Rose was that certain constitutions would have an affinity to particular colors. If you look at the Temperamental Rose, it is actually funny—poets such as Goethe are useful. Historians are common; poets are useful. Goethe was a curmudgeon and a radical guy.

I bring you the Temperamental Rose as an idea so that you can make your own Temperamental Rose based on the previous experiments. I place this in the context of a twelve, and then we will discover whether you are a poet or a historian in the way you live in your soul. This work has to do with the way your sensory organism operates. Thus, we have to understand a little about how the sensory world interacts with my life body. If I want to understand what I am feeling when I have a sense impression, I have to understand what my life body is trying to do at that moment. If I look at a red, my life body responds with an exact complement to the value, temperature, hue, and chroma of that color. I lack the space here to go fully into the experiments, but I have done them and I can tell you it is spooky how accurate our life body is. If we change the chroma of a color, the chroma of the afterimage changes; if you change the value of the color, the value of the afterimage changes. This is point for point. The reason is because our life body needs to keep us in the ballgame when we are in a room full of a color that we find irritating. Otherwise, we would leave. Our life body has to do something.

Your life body makes a complement to the color you are seeing. We will look at colored shadows and afterimages, and your life body will simply adjust to whatever sensory experience it is having. The life body has a repertoire of certain movements that will irritate it, and certain movements that will not irritate it. It builds a complement to the sensory impression; whatever it sees, hears, tastes, or whatever, it builds a complement so that the endocrine system can bring the person back to harmony. The life body is deeply embedded in our endocrine organization

and continuously balances what we eat, smell, see, hear, and touch. Our life body is always creating an inner condition that allows us to maintain ourselves in face of stimuli and the senses. Most of this takes place below the level of conscious awareness in the life body, to which we do not have access—and thank the Lord, or we would be kept very, very busy with each and every sensory input.

There is a little dog that lives next door to me. I call him Stupid. He was put into my life to teach me a lesson. He is definitely an irritant. Yap-yap, yap-yap, yap-yap for hours! Take out the trash—yap-yap, yap-yap. Over time, however, I have realized what goes on in me. It is an exact feeling. After I do my little meditation thing in the morning, I am feeling okay and I walk out the door to do some work, and yap-yap, yap-yap. Part of my body responds: Oh, my God! It took me about two years to realize this was the same feeling I had when my father would come home and yell at the dinner table—the same feeling. So, Stupid taught me something. I was spraying water over the fence at him from a hose. We had had a water war one evening when his master was gone for three hours. My wife came out and saw me spraying Stupid over the fence. She slapped her forehead wondering what's with this guy. I was crazy. I would soak him, and he'd run away and come back; I'd soak him, he'd run away and come back. He just kept coming back and I just kept soaking. Finally, he went away. But he would not leave me alone until I finally went to the neighbor. I wrote a letter to the neighbor and said this is what's going on in me, and it felt a little better, but it didn't really stop until I actually went and talked to the neighbor. I said, you know, I don't want to be a bad guy, but your dog is driving me nuts. Can you give me your phone number so I can call you if he is driving me crazy? She said, oh yeah sure, and gave me the phone number. Now I can tolerate him because I feel I can talk to someone. I can talk to my dad's (Stupid's) mom about how he is treating me badly. And I am okay with that. So if he wants to do his thing, I say, Oh, Stupid is having a bad day.

This is soul work—feelings. If you do this work with colors and sounds and so on, eventually it is an aesthetic experience of forms, sounds, and

colors. My sound work involves listening to Johann Sebastian Bach every day—all of his different works—to get my life body and my soul body harmonized by hearing. Then I sculpt, and then I work with color to give my soul forms that allow me to be lawful, to withstand the craziness, and to find out eventually why it is driving me crazy. As a person endowed with an "I"-being, I can actually go and talk with the neighbor instead of having a hose war with the dog. Once I felt this burden taken off of me, I realized it was me who was stupid. This work on the senses is really deep, healing stuff. Not directly, but it allows us the capacity to see what is irritating us and to talk to it. In the beginning, it will talk back to you in weird ways, but eventually it speaks to you about why it is irritating you. Then you can decide (or not) to do it.

The Temperamental Rose of Goethe and the powers of the soul seem to represent the first incursion of a mind into the idea that color has psychological effects. This is long before the idea of psychology. Color is not just something we put in a painting to make it look nice, which is okay, but it actually has meaning in the life of a soul. For me, Goethe's fifth book on color theory was the most important one, because, instead of refuting Newton's work he opened a whole new door that Newton wasn't even talking about. It is that door where I feel color has a huge future in the healing work. We have to understand that healing work with color is not random or just nice; it has laws like every other science. Those laws have to do with the feelings that arise in me when I am under the impact of a sense impression?

Our work with the test gives a picture of our soul configurations around an irritant. That irritant is something we cannot allow to remain in our soul—even though we need it. The irritant is in there, but when we are put into situations that begin to resonate with whatever that quality is, a part of our soul just shuts that off and rejects it. Thus, we have to compensate by trying to bring other things in to substitute for that color, which creates stress. If we want to get rid of the stress, we must speak to that color. Inwardly, that color represents a whole web of feelings about what is okay or not okay—what needs to happen in our life, where we

get satisfaction, where we do not get satisfaction, how we solve conflicts, ongoing male–female issues, our fight or flight responses, whether we act boldly or retreat into our shell, how do I work when I am near the irritant. We usually find that the particular irritant is part of an inheritance. It is the mood at the dinner table when you were five and your mother said, "You just wait until your father gets home!" But the irritant is not creative.

Rudolf Steiner connects the Epistles of Paul with the ancient Vedic philosophy having to do with sensation and cognition. The way he talks about this problem from the perspective of that philosophy is very interesting.

> Each separate sense is a means of becoming aware of a particular part of the external world. We open ourselves to it through these doors of being called the senses. But with each sense, we approach one limited area of the world.
>
> Something like a unifying principle in us combines these different areas of the outer world for us, as even our ordinary language shows. We speak, for instance, of warm and cold colors, although we know that this is only a manner of speaking and that in reality we become aware of cold and warmth through the organs of touch, and light and dark colors through the organ of sight. When we speak of warm and cold colors out of this feeling of inner relationship, we are using terms appropriate to one sense in describing the others. We express ourselves in this way because in our inner being there is a kind of intermingling between what we perceive through sight and what impresses us through the sense of warmth. [Warmth is enthusiasm for creation or it allows me to integrate a sensation and harmonize it with my life body.] More delicately sensitive people can inwardly form ideas of color upon hearing certain sounds. They may, for example, associate certain tones with red, others with blue. Some activity within us, therefore, holds together the separate senses and makes out of their separate activities a unity for the soul.[7]

Diagram 3 (page 100) shows what is called the Glory. The word *Glory* here refers to an optical phenomenon that appears when an area

[7] Steiner, *The Bhagavad Gita and the West*, p 21.

Diagram 3: Glory

of fog or mist is illuminated. Sometimes we can see a Glory from an airplane while looking at the sunlight shining on a bank of cirrus clouds made up of ice crystals. If you are walking in fog, and if the fog is white enough that the sun illuminates it from behind, you may see your shadow cast into the fog with a halo like the old saints. This is why it is called a "Glory." It is an archetypical color phenomenon. I have seen them a number of times.

Once while on a plane to Hawaii, a Glory accompanied us for three hours. It was a *glorious* Glory. It was rings and rings—a perfect ice bank with the Sun in a perfect spot, and the shadow of the plane created that

condition. I was in a window seat writing notes and thinking about it. Later, I wrote a little article about it, and this diagram about the sunrise is from that article. I experienced the Glory and then researched it. I realized that the Glory had another realm in which it existed.

A Glory is something made by casting a shadow (see the diagram). A light behind is casting a shadow into a turbid medium. The shadow is surrounded by a kind of umbra of light. It is very bright light that separates itself from the light of the fog or the cloud; it is a very brilliant light around the shadow. Sometimes from an airplane we see only the shadow and the light, even when there is some turbidity. To see the rainbow-like Glory, we have to be in a position whereby the Sun shines from directly behind us; then we can see light with a shadow cast into the turbid medium, and we are in the shadow. If we were somewhere else, we would be unable to see the Glory. We have to be *in* the shadow.

A light illuminates the space around the shadow, and around that light you see a range of yellow to orange to vermilion, which is a red—that should be familiar to you as one half of a split spectrum. Around the light you see colors of yellow, orange, and vermilion, as though half of the split spectrum around the light. Then, if the conditions are just right, you see a gap of white between the red—a very warm vermilion red—and outside of that gap a band of green, and then a band of beautiful magenta. If the conditions are just right, there is also a band of green that is a little darker, and then another band that would be a magenta but is actually a kind of violet, because it begins to go into a dark area on the outside.

This is what I saw on my way to Hawaii. There can actually be many bands of green, magenta, and magenta if it is really good. This was an ice phenomenon. Sometimes I think there were three or four bands going out—green, rose-magenta, green, and rose-violet; this is the Glory. Search online for images of the Glory, and you will find lots of pictures of Glories. It is not a rainbow, but one does see a very strong rainbow effect. If you are in Hawaii, you can see the rainbow, then you see a reverse rainbow, and then you see green and red and green and red and green

and red go out. This why Goethe says that the rainbows you normally see are not the primary phenomenon. There is something else going on outside of that that needs to be included; we see that principle clearly in the Glory and in other instances.

Using the diagram, we can make a little imagination. Using colored pencils or crayons, draw a horizontal line, and just above that draw a thin area of green with a dark rose-violet above that. If you happen to be up before sunrise on a clear morning, look to the east and you will see a dark-violet color in the sky. The night sky is actually a kind of dark rosy-violet, indigo-violet before sunrise. Around 4:00 a.m., we see a condition called *first light,* in which the first little possibility of the sunrise starts to appear. That first light makes a lighter kind of bluish-green band under that violet—the whole sky is violet-dark, but this little band of a greenish color appears underneath it.

In the diagram, the horizontal line represents the horizon, and a light green appears below a dark rosy violet. I saw this for the first time while on a camping trip when I couldn't sleep. I decided to research this phenomenon, so I got up at 4:00 in the morning for quite a while to watch this. I found that the Glory is a sequence of colors in the sunrise, but you have to watch the whole sunrise. It begins with a rosy kind of violet, warm dark night sky, and then at first light a kind of greenish color appears underneath the dark rosy violet—a kind of plum color. Then as the light grows stronger, the greenish color lifts higher and higher off the horizon, and the violet is pushed upward, and finally, if there are any clouds in the sky, you start to see the clouds go from dark to a very light magenta tint.

Now draw a new horizontal line. Above the line draw a larger area of light green and separate that green and the rosy magenta by drawing the rose magenta higher in the sky. The rose magenta is lighter than the plum color and appears higher in the sky. The rose magenta rises and the light green spreads out during the second phase of the sunrise. As the sunrise proceeds, the rosy magenta starts to fill the sky with a beautiful pink color, and under it comes a greenish color in the sky behind

magenta clouds. It is a blue-green. I call that part the "Rose Bloom," because the whole sky blooms with the rose color when there are clouds. The clouds become very magenta, while the sky behind them becomes a kind of greenish blue. However, as the magenta rises, the greenish blue turns more toward blue. The magenta rises where you get a cooler end of the spectrum. The blues start coming out, and the green disappears in the sky, leaving purples and magentas rising off the earth as a rosy predawn condition.

Now draw another horizontal line and above it a cobalt-blue band. Above that draw rosy magenta with a few wispy, magenta clouds. In a perfect atmosphere you will see a band of rose with a band of a deeper blue beneath it, rising and pushing the magenta up until the magenta is a hand-width above the horizon. Then all the clouds suddenly go dark or lose their color.

Then a strange thing happens; the sky becomes neutral. If you watch for this (see the diagram) another band of light appears in the middle of the Glory. This is when daylight is growing and reveals forms on the ground. As you begin to see things around you, when you look for the magenta it is no longer in the east, but if you look behind you, it will be seen in the west. The blue that was underneath is now pushing down from above, and you see a very deep blue-magenta in the west. At this point of the sunrise, the light in the east is neutral. If you keep watching, the light in the west, the magenta and dark blue, fade and go below the horizon. As those colors fade below the horizon, the light in the east, especially when there are clouds, turns vermilion.

Look at the diagram again. This is the third phase. The color on the horizon now is deep-red vermilion. The vermilion, orange, yellow, light, and dark are all connected; the green and rosy magenta are connected; the green and rosy violet are connected once the vermilion shows on the clouds. Color will appear on the horizon as a deep, almost carmine red that goes vermilion and then starts to spread as the Sun approaches the horizon from below. Draw a horizontal line and put carmine about a half inch above it in a band, below that an orange, and then just at the horizon

a yellow. That is this phase. It appears as though you had dropped red dye into water and it starts to dilute to orange and then to yellow. As the vermilion in the sky starts to dilute to yellow, the light of the Sun is nearing the horizon, and then suddenly the Sun comes over the horizon and everything is rendered into light and dark on the ground, and all the colors in the clouds dissipate and disappear. This is your sunrise.

And in the evening if you watch, starting at 4:00 in the afternoon or 5:00, depending on the season and the location in your time zone, you will start to see, as the Sun nears the horizon, first the light becomes yellow and then grows a little warmer, orange; then it becomes red; next there is a pause and suddenly, as the vermilion red goes deeper toward the horizon in the west, you start to see magenta rising on the eastern horizon. As the vermilion in the west touches the horizon, you see magenta sliding around the horizon and you see the reverse Glory. Sometimes, as orange and vermilion compress toward the horizon just as the sun is disappearing, one can see a green flash.

In the diagram there is light between the vermilion and the green. The sun is setting, and the reverse of the sunrise Glory is happening. First the light and dark weaken as the Sun touches the horizon. Then the yellow grows stronger and turns to orange. Finally, we see vermilion as the Sun drops below the horizon. At the peak of the vermilion sky, the last little sliver of the sunlight is the gap of light between the vermilion and the green, and then as that last sliver of light is about to disappear, a green flash may run across the horizon. But conditions have to be just right to see it. Then as the Sun goes below the horizon, there is the rose magenta and deep greenish blue polarity that finally leads to the deep rose violet of night. Whenever you look at the sunrise or sunset, you are looking at this archetypical phenomenon of the glory, but it takes place over time, not all at once. To see the separate parts as one thing is the action of this archetypal sense that Steiner talks about: this *manas* sense in us that puts all the senses together. Manas is the part of us that says "I." In Sanskrit, *manas* is the "I"-sayer that brings all the different senses together and gives them a conceptual framework to provide meaning, as

we just did with the rising and setting Sun. The concept of going from the Glory to the sunrise allows our "I"-being to live in the phenomena in a different way.

In the case of synesthesia, something in a person takes the myriad senses of the world and somehow brings them together in a way that allows us to hear or smell colors, see music, and so on. With synesthesia, the senses become synthesized. We could say that synesthesia is an aberration, but in a way it also represents an esoteric goal. Kandinsky, Klee, and others saw colors as music. Rudolf Steiner's eurythmy is visible speech and music. Something you do might mean blue or something else. That is the great œuvre of Wagner, his whole body of art. When I can work with my senses in such a way that I bring concepts to the disparate parts of the world, unite them, and see harmony in them, I am at this level of experiencing creative wisdom.

7

Colored Shadow

We are now about to make a turn. Thus far, I have been trying to keep our work with color on the exoteric side. Colored shadows, afterimages, physical properties that result in color, and turbid medium were a large part of Goethe's work. To me, however, it is not the most significant part of his work. I said earlier that it is the psychological aspects of color that have the most profound impact on healing, but we need to understand what we mean by the word *psychology*. What do we mean when we say that a color is a psychological experience? We have the name *psychology*, but it really doesn't do justice to the issue esoterically.

In his lecture course, *The Bhagavad Gita and the West*, Rudolf Steiner is, in a way, trying to explain his mission to the theosophists. He is trying to tell them that he inherited his place with them, but it was not the reason he was there. He would be heading in a different direction and it would be fine if they wanted to go with him. Steiner had been struggling with the theosophical worldview and what he saw as an outdated approach to esoteric practice. He was saying to theosophists that we can use the terminology but we have to adapt it to where he and his students would be going.

Excerpts from that lecture course will help us begin our work with colored shadows. Steiner stresses to the theosophists the issue of using *Sankhya*, a philosophy that deals with cognition. It is kind of a Vedanta. The question is: How do I know that I know? Search online for the word *Sankhya*, and you will be led to websites that give a parallel to Rudolf Steiner's *Outline of Esoteric Science*. In *The Bhagavad Gita and the West*, Steiner cherry-picks from the ancient world. Although he feels that

this particular philosophy must be adapted, it is in line with his *Outline of Esoteric Science,* which he had published earlier. He recognized that the theosophists were into this Eastern philosophy, but explains that they must understand its roots where they would have to change it. To me, the significant aspect is that it has to do with the issue of sensation and perception, which is why I keep returning to that theme; it was a turning point for Steiner. It was where he had to say they would to have to make a science of those mystical ideas; they would have to make a science of cognition and the constructs of feelings we have in response to sensory experiences. Steiner is trying to say that the Bhagavad Gita is a fundament to Paul's Epistles.

Paul had traveled all through the ancient world and was bringing ancient ideas. All his epistles to the churches are trying to remedy this issue. He writes to the Corinthians about speaking in tongues, because Corinth is just across the bay from the Oracle at Delphi. The whole tradition of religion in Corinth and surrounding area was about speaking in tongues and prophesying as the Delphic Oracle had done. This is why he said, "If I could speak all the languages of earth and of angels, but didn't love others, I would only be a noisy gong or a clanging cymbal" (1 Cor. 13:1). Paul represents a link between the ancient world and the Christ principle. Steiner was using that connection to tell the theosophists it was a new day.

I want to present the background to our turn toward color as primarily an inner experience. We have been working with color as an outer experience, and the work we did with color as an outer phenomenon will be a good underpinning to understand how color becomes and acts as inner experience. Rudolf Steiner gives us this example:

> There are people who may experience yellow upon entering a town. In another town, they may experience red, in others, white or blue. A great part of all our impressions expresses itself inwardly to us as color. The separate sense impressions are united inwardly in an overarching collective sense that does not belong to any one sense alone. It lives in our inner being and floods us with its quality of

wholeness by incorporating the individual sense impressions into it. It may be called the inner sense, all the more so because all the usual inner experiences of sorrow and joy, passions and emotions, are united again with what this inner sense offers us, so that we can also describe some emotions as dark and cold, others as warm and full of light. Thus we can also say that our inner life in turn has an effect upon what forms the inner sense.[1]

Steiner is talking here about clairvoyance—what he calls seeing of the aura. *How to Know Higher Worlds* includes sections on seeing an aura. He is very clear that seeing auras does not mean seeing colors outside. We do not see red and yellow floating around someone's liver. If you do, it might mean that your own liver is not working properly. When he says seeing the aura, he is very clear. When I am in the presence of a certain person, I can connect with an inner feeling similar to the way I would feel when looking at vermilion or carmine. This is what he calls *seeing the aura* or having an impression of a color. In the presence of this town or person, I go inside myself and have an inner feeling of seeing yellow. We have to be very clear about this, because it was a big issue for him. The theosophists would say something like, I see your aura, and it is ugly; it was almost spiritism. Steiner fought against that, because he is talking about clairvoyance, which is the whole issue of color. However, he was not saying that having an impression of yellow when entering a town is belly clairvoyance. Rather, "belly clairvoyance" refers to seeing colors floating around things when you enter the town. Head clairvoyance is the inner experience of looking at the color yellow when you enter the town. The quotation for this type of experience is, "In pure thinking you find the self that can hold itself in check."

Under the impression of a sensory experience such as entering a new town, a feeling arises that is connected to a thought one can identify as a *feeling* of looking at yellow. In this work, you change the sensory experience into an inner picture that you can identify as similar to another type of sensory impression, such as the color yellow. Essentially, you

1 Steiner, *The Bhagavad Gita and the West*, p. 21.

change the sense impression into a symbol. When you encounter another person, you can experience what is going on in that person in terms of what we could call, as Novalis said, the "speaking flame." A person is a speaking flame.

Steiner said that gut clairvoyants see a lot, but don't know what they are looking at. Thus they have to make up codes—they use pendulums or say, if the third seagull that goes by the porthole has a black spot on is wing, it means this or that. This is a code, and it leads to superstition, which in turn leads to black magic. If you don't know what you are doing, why are you doing it? That is his message to the seers in the theosophical movement. If you have ascended Masters and haven't checked their credentials, what are you doing? I don't care if they are on the violet ray or the blue ray or whatever. He is trying to say that those ways of clairvoyance come from a misalignment in the digestive system. A problem in the digestive system is projected out, because that is how the old clairvoyance worked. When people read your aura, they are simply reading old news with their old news. Two old news reports do not make new news.

The new form is head clairvoyance, and Steiner says that head clairvoyants see significantly less than gut clairvoyants do, but they know what they are seeing. They don't need a code, because they've already gone through the cognitive filtering to make sense of their sensation. To perceive how their sensation is acting on their organism, they go through the work to find the patterns of cosmic wisdom in their seeing. They don't see the colors outside, but get in touch with the feeling, as if they were seeing a certain color while with this person—or you can do it with plants, with animals, or with towns, as Steiner says. It is called a "green thumb" when you do this with plants. You can be with a certain plant and you can get an inner color experience.

We can take this even further; we can go into calcium and potassium and have the equivalent to a color sensation (later, we will look at Fraunhofer lines as objective examples of this). Color, to science, is the color of a metal being burned to produce a light. Alchemists called light aeriform metal. The new clairvoyance sees a lot less but knows a lot

more. The old clairvoyance was a lot of seeing, from which traditions formed to be passed on. It became the tradition of the mystery schools and other streams that were handed down. If you saw something different, your teacher would dismiss it as a fantasy—until you became the teacher and taught a different way. If your way was significantly different, your teaching became a splinter school and was excommunicated from the system as heretical. This is the history of the church—kill, fight, win. In the third fourth and fifth centuries, such people were beheaded or sent into the desert to become food for jackals because they believed in the Virgin birth, or not. In those days many were very serious about their religion, much the way it is in the Middle East today. By addressing the theosophists, Steiner is speaking to those who are trying to make a bridge to ancient wisdom; they were Europeans enamored with Asian shamanic practices. Basically, that is Theosophy. Steiner was telling them that something new is happening.

"There are those who may experience yellow upon entering a town. In another town, they may experience red, in others, white, or blue. A great part of all our impressions expresses itself inwardly to us as color." The sensory impression impresses us, and we experience it inwardly as color, but we think it is something else—a belief structure about how things are.

> A great part of all our impressions expresses itself inwardly to us as color. The separate sense impressions are united inwardly in an overarching collective sense that does not belong to any one sense alone.... It may be called the inner sense, all the more so because all the usual inner experiences of sorrow and joy, passions and emotions, are united again with what this inner sense offers us, so that we can also describe some emotions as dark and cold, others as warm and full of light. [He is talking about forming symbols to express inner experience. This is the new clairvoyance.] Thus we can also say that our inner life in turn has an effect upon what forms the inner sense.
>
> Therefore, in contradistinction to the several senses directed to different areas of the external world, we can speak of one sense that fills the soul. It is not connected with any single sense organ, but

uses the whole being as its instrument. To describe this inner sense as *manas* is quite in the spirit of Sankhya philosophy.[2]

A sense that fills the soul has all of the senses in it and all of the colors. All that manas, buddhi, and so on comes from his connection to Eastern philosophy. The inner sense he describes as manas is the transformed astral, or desire, body—the transformed soul. When the soul becomes transformed by cognition through an "I"-experience, there is a force created in the soul in the spiritual world called *manas*. That is this inner sense. He is describing now how it works. He says it comes from Sankhya. "According to it [Sankhya philosophy], what organizes this inner sense into substance develops out of *ahankara* [or 'I'-saying]." *Ahankara* is a Vedic term. There was a certain stage in evolution when evolution became ripe enough for beings to say "I"—"*ahankara,* as a later product in the world of forms."[3]

"It can be said that there was first the primal flood, then *buddhi,* then *ahankara* and then *manas,* found within us as our inner sense." In this philosophy the original creation was bliss, and the counterpoint to bliss was the need to make something. These were the two big aspects of creation. There was *Creation,* the Creator of the bliss of creation and creating, and the Creator. So we have *purusha,* or bliss consciousness, and *prakriti,* the phenomenal realm, and then *buddhi,* or discursiveness. *Buddhi* is our transformed life body; it is discursiveness. It is the ability to say I think this is different from that. This is what our life body does to keep us alive; if you are seeing red, let's make it green. The life body is discursive regarding value, temperature, hue, chroma, overtone, undertone—every aspect of the color. It balances it exactly, so that our endocrine system can keep us in the game. It is the function of our *buddhi* body to be discursive. "Then *ahankara* ["I"-saying] and then *manas,* found within us as our inner sense."[4]

2 Ibid., pp. 21–22.
3 Ibid., p. 22.
4 Ibid., p. 22.

There is a fall from bliss down through discursiveness to "I"-saying to manas, which is all falling apart, because everything is saying "I." I have to bring it back together again. That comes from Sankhya philosophy. Steiner bought this to the theosophists.

> ...and then *manas* [is] found within us as our inner sense. If we want to understand this inner sense today, we proceed by taking the individual senses and observing how they help us gain particular representations insofar as the sensations from the separate senses join in a common inner sense.[5]

Rudolf Steiner is saying here that manas is a common inner sense; it is a being in us that holds all of the sense impressions, especially the colors, as a wholeness. We could call it our "inner zodiac." And it is constantly active in balancing and integrating, and discursive with the action of my "I" as it encounters multiplicity. It is looking for unity, and it is continuously pulled apart by "me and that over there," which says there is no unity, just lots of stuff. However, I have something inside that allows me to monitor the discursive action of my buddhi, or life body. When I do so, I begin to see into my own physiology as symbolic patterns happening in the natural world.

Steiner goes on to describe what that would be. Red makes an attack on us; it thrusts us back. This is what you felt when you did the colored gel test. When I did red I felt attacked. Blue violet makes us want to run after it. Blue makes us want to run after it, deeper and deeper into the cosmos—or the cosmos of another person. We could say that the other person makes me feel blue. Colors are a world in themselves; the soul element in the world of color cannot exist without movement, and movement is the yearning for one color to be a different color. That is the movement. Steiner says,

> We ourselves, if we follow the colors with soul experience, must follow with movement. People gaze wide-eyed at a rainbow. But if you look at a rainbow with a little imagination, you may be able to

5 Ibid.

see elemental beings. They are full of activity and demonstrate that activity in a most remarkable way. Here (at yellow) you see some of them flowing from the rainbow, continually coming out of it. They move across, and the moment they reach the lower end of the green they feel drawn to it. You see them disappear at this point [yellow yearns to be a green]. On the other side they come out again.[6]

If they go from green to yellow, that is one movement and gesture; if they are moving from the yellow to green, that is another movement and gesture. Isn't it amazing? Steiner is saying this is the language of the soul. "[The rainbow] is, in fact, like a spiritual cylinder, wonderful to behold. And you may observe, too, how these spiritual beings come forth from the rainbow with extreme fear, and then how they go in with an absolutely invincible courage."[7] Whether they go out in fear and back in in courage or out in courage and back in in fear depends on what color they are. This is the same for us, because we are—our soul is—color. Steiner says, "When you look at the red-yellow, you see fear streaming out, and when you look at the blue-violet you have the feeling that there all is courage and bravery of heart."[8] It is bravery of heart if it is a gift that you have, and it is a pain in the neck if it is an irritation.

The big secret is this: Your gift is your irritation, and your irritation is your gift. You just have to claim it. "Imagine it [the rainbow] is there before you in all its colors—red, yellow, and so on—and it receives a certain density. You can easily imagine how this will give rise to the element of water. And in this watery element spiritual beings live, beings that are actually a kind of copy of the beings of the third hierarchy [the Angels]."[9] When colors become dense enough, they become water. That is, step down, down, down. Air is the shadow of light; water is the shadow of air. Water is the salt of air; there is oxygen and hydrogen that come together and fall down. Somewhere in there colors are *sal,* or salt.

6 Steiner, *The Secret Stream: Christian Rosenkreutz and Rosicrucianism,* "The Life of the Spirit in the Middle Ages," p. 201.
7 Ibid.
8 Ibid.
9 Ibid., pp. 201–202.

Salt is when something sensory appears from something non-sensory. With that alchemical term *salt,* water becomes the salt of color. This is said alchemically.

Now the last paragraph: "Your 'I' and astral body do not have life, yet they have being, *they are.* What is of the soul and spirit does not need life. Life begins with your etheric body."[10] They are spiritual entities that go into the spiritual world at night and have no need of your life body. This is called sleeping. Your astral body and "I" have excellent adventures somewhere, and they could not care less about what is happening to your life body. Your life body and physical body are in the hands of the hierarchies that govern our life forces, and they are sweeping the debris out of the trunk and freshening it for your morning. It has nothing to do with your astral body, except that there is a link; the link between them is what Rudolf Steiner calls the *sentient body.* That body is sensitive and connects the sentient soul, which is part of the astral body, and the ether, or life, body, which is not part of the soul. Both your physical body and life body belong to the physical world, along with all sensations, which happen as reactions in the physical body with the senses.

Sense impressions happen and the life body responds, all below the level of conscious understanding. However, there is a part of your soul designated to monitor and be sensitive to this—your sentient body. The sentient body, in Rudolf Steiner's code, is *Gemüt,* a German word meaning warm-heartedness, or even enthusiasm. *Gemüt* is a seed in the human being of what our whole spiritual life will become in the future, because *Gemüt* is where we have inherited the Fall, which we must pay for through understanding. *Gemüt* is what your dog feels for the dog dish. We have to move it from a kind of animal, or visceral, warm-heartedness to an ability to sacrifice ourselves to awake in someone else. It is this type of devotion.

This, then, will also be *Gemüt*—that is, a seed that will have to be developed over time by the "I" creating manas, buddhi, and atma. When this happens, we lift the part embedded most deeply in our physical

10 Ibid., pp. 202–203.

nature out of the soul. *Gemüt* is enthusiasm for our food, our appetite, and buying a new pair of shoes. It is everything for which we have enthusiasm and about which we feel warmhearted. The problem is that our warmheartedness at that level usually has an outcome in the physical world. We have to move that up into a spiritual condition, which we can do by developing clairvoyance.

Rudolf Steiner is saying that "Your 'I' and astral body do not have life, yet they have being, *they are*. What is of the soul and spirit does not need life. Life begins with your etheric body."[11] The link is the sentient body, which is a part of the soul below our consciousness, similar to what we might call *the collective*. "The etheric body is external, it is of the nature of a sheath."[12] Your ether body is on loan, and it has very little to do with your soul in particular. It is just a vehicle that gives you life. "Thus it is only after the Moon stage, only with the present Earth stage of existence, that life enters the evolution to which our Earth belongs. The world of moving, glancing color is quickened to life."[13] The important thing is that life is separate from our soul. The soul has sensory experiences, but we do not experience in the sensation the living nature of the beings behind the sensory world. We do not have what Rudolf Steiner calls *etheric vision*, whereby we could see the activities of elemental beings in the colors we see—not as little beings out there with funny hats, but inside as cognition. He makes a case here for the therapeutic work.

> The world of moving, glancing color is quickened to life. And now, not only do Angels, Archangels, and Archai experience a longing desire to carry darkness into light, and light into darkness, thereby calling forth the play of color in the planet—now a desire becomes manifest to experience this play of color as something inward, to feel it all inwardly.[14]

The Angels want their own soul.

11 Ibid., p. 203.
12 Ibid.
13 Ibid.
14 Ibid.

Aesthetic experience enlivens our sensory experience and ensouls our life body. I have to push my soul down into my sensation and cognize what happens in my life body when I have a sensation. I do this when I feel a need to adjust a color in a painting because it otherwise violates the key structure. I adjust it with my soul. When I do so, I feel this thing moving inwardly—a feeling of rightness determined by aesthetic experience. This is what Schiller, Goethe, and Steiner were talking about—aesthetic experience is the way human beings redeem the Earth's fallen condition; it is the new mystery path. It means we have to enter our own life body consciously. It means I have to look at my sentient body to find out what is going on there that prevents me from doing this. I formed my sentient body during adolescence, and during adolescence I am aware of my sentient body, because it is reacting to my hormonal changes in very strong ways. All of those change-of-life emotions happen because I am more conscious of my hormonal patterns. This is also a way to understand conditions such as Asperger's syndrome and autism. Because of brain lesions or abnormalities, a person cannot access certain hormonal patterns and start acting out. Healing work—especially the aesthetic experience of healing work—is a huge door into the future, and color is the key.

If we really get this, then we can enliven our senses. The senses are part of the physical organism. My eye is just a camera; it is built just like a camera. We build cameras because we have our eyes. And our eye is formed by the action of the light according to Goethe. The eye is light, and light is the eye. Hidden in the light is a great secret, a secret of the world—visible light. Invisible light is what my spirit is made out of, but that light does not cast a shadow. Later, during the Vulcan stage of cosmic evolution, we will all be made of that light—part of the light that must cast shadows, that will be a whole hierarchy carrying the Asuras, who will carry evil into the next evolution.

We are now reaching differentiations of light and dark, Lucifer and Ahriman, and these kinds of things. When we start to do that, the color moves from just being a substance out in the sensory world—I become aware of how my ether body responds to that, and my senses become

enlivened. With sensation, I begin to experience movement in my soul. We cry while listening to "The Passion of St. Matthew." The senses are moved by our astral body; our life body goes down into the senses. We become aware of how that is being moved. The more we practice art, the more sensitive we become to this. We become very sensitive to nuances of changing keys in a piece of music or subtle changes of color.

This is the story of Claude Monet late in his life. Many of his subjects in his later middle period of painting were gardens with ladies sitting around with roses and such. He was making salon paintings, and usually the subject was his dear beloved wife Camille. We get a portrait of Camille in the garden, for example. She passed away early, and he said in a letter that, as she was actually passing away, he was at her bedside and, instead of feeling sadness or grief, he found himself analyzing the color changes in her skin as she was leaving. He was deeply in love and connected with her, but he was trained to look at these things as they were happening and to be sensitive to the life in them.

There is also as story about Paul Cézanne late in life. He had become a bit of a curmudgeon, but he was also a deeply aware person who had overcome a very twisted astral body as a young man. Some of his early paintings are very strange—brothel scenes and such. Then he found religion. He went to church every day, and it helped him as a recovering alcoholic. As he was drying out, a kind of stability came into him along with an incredible ability to see nuance and change in color. He was in a meeting with the guys—all the Paris impressionists used to meet—and as they were sitting there he was in a kind of trance. Renoir asked him if he was okay, and Cézanne said, "Just look at how the light caresses that peach." There was a bowl of fruit there. This is manas. If you want to have an interesting experience, watch the color of a peach or nectarine ripening and then watch the glory in the sunrise. You might be surprised at the similarities. This is movement, and it is happening everywhere with us.

Now let's investigate something called colored shadows. Goethe did a lot of work with color, and the more we work with color, the more color we see. Recently, I was at a restaurant with my wife and talking,

and they had a mirror with bevel-cut edges. It created a rainbow on one whole side of the restaurant. As we work with color, we become much more sensitive to the fact that there is a yellow right there on the ceiling, little red streaks coming off a lamp over there, and green that goes to rosy violet over in the corner. Many people would see only white, but it is not white. The great question is this: Is a white iris in shadow still white? A realist would say, yes. If you are painter, you will probably say, absolutely not. This realm of fleeting colors is the object of our work with colored shadows.

A principle we have learned is that when I have a turbid medium, we can make color appear. It has to do with the two kinds of darkness—the darkness in front of the light, and the darkness behind the light, with the light in the center. When darkness is behind the light, it appears cool; when darkness is in front of the light, it appears warm. That is the principle. Now if I am in the warm darkness and start moving, gradually there is less darkness as I approach the light. If I turn in at the center of that red darkness and look, I will have the light behind me and darkness in front of me illuminating that darkness. Now I am going to experience that same thing I experienced as a red. I turn around and it becomes blue. The same turbid medium can be warm or cool, depending upon its relationship to the illumination and the viewer.

When we considered the Sun and the sky, the illuminated atmosphere as the turbid medium in front of dark space is blue; but that same atmosphere in front of the Sun as a source of light is a darkness that appears warm. Those colors are not actually part of the medium. Einstein tried to do this with dipole oscillations of electrons. In a way, there is a whole doorway to what a color really is. Is that color actually a color? Or does it show up because I need a color that reminds me of something I cannot remember—perhaps my incarnation process? Or my light moved into the darkness. Where is that color? Is that real? That is our question for now.

Goethe was at his writing desk one day and it was getting late. As he continued to write, the light coming through the window began to

Colored Shadow

Figure 1: Left-hand shadow of a pen cast by a white light on the right. The shadow has no color.

Figure 2: Right-hand shadow cast from red light on the left. Shadow has no color other than dark red.

Figure 3: The right-hand shadow cast from a red light on the left is now green where the white light from the right illuminates it. The left-hand shadow cast from the white light on the right is illuminated by the red light and has a reddish tone.

Figure 4: Left-hand shadow of a pen cast by a white light on the right. The shadow has no color.

Figure 5: Right-hand shadow cast from a green light on the left. Shadow has no color other than dark green.

Figure 6: The right-hand shadow cast from a green light on the left is now red where the white light from the right illuminates it. The left-hand shadow cast from the white light on the right is illuminated by the green light and has a greenish tone.

redden—we already know why—and cast a shadow from his pen onto his writing paper (figure 2). And he saw, since he had worked with color, that the light from the Sun appeared red, but the shadow appeared to have very little color. It appeared black. As he continued to write, he lit a candle (figure 3). After lighting the candle, he stepped back, because he saw something that seemed bizarre. What he saw in his book became a whole chapter on colored shadow. He saw the original shadow from the red light of the sunset (figure 2); then the additional shadow that the candlelight cast from his pen onto the red surface illuminated the red (figure 3). There was kind of a backfill where the shadow from the red light met a turbid medium in the air, with the light going across the shadow. When that happens, we see the complement arise.

Now, where is that complementary color? Is there pigment on the screen? This is the action of the life body, represented here as a kind of turbid medium in the soul—or the soul as a turbid medium between the body and the spirit. Within that turbid medium, astral beings and colors are present and allow us to balance and integrate things that are in "very great imbalance." Goethe asked: What if I put a green light in there (figure 5)? With the addition of a second, white light source, we see a total balance—the same two opposite colors, but reversed (figure 6). Where is this shadow color? Sunlight is coming from the candle and Goethe's writing with his pen and seeing this green shadow, but where is the green? Is it physical? No. Every time we look at the red, our soul goes green. When we enter a space where there is a turbid medium, we have to make choices. Is it warm, or is it cold?

Years ago, a woman pioneered color work as a mode of therapy at the Camphill Special School, Beaver Run, Pennsylvania. They had a whirlpool and a stage with southern exposure to the back wall of the stage. In the wall they had colored glass embedded with little shutters that they could open and shut allowing the colored windows to make combinations of colors like this. There is so much possibility in this.

In 1959, Edwin H. Land, who developed the Polaroid camera, performed an experiment based on Goethe:

Newton had shown that if one mixed colored lights (for example orange and yellow), one obtained something intermediate (an orange-yellow). Almost three-hundred years later, Land repeated this, but he used colored lights to project black-and-white transparencies of a still life taken through filters of these same colors. If only the yellow beam was used, one saw a monochromatic, yellow still life [because the filter was just filtering everything else out]; if only the orange beam was used, a similar orange monochrome. When both beams were turned on, the audience expected something intermediate, but what they saw instead was a sudden bursting into full color, with reds, blues, greens, purples, every color in the original still life.[15]

Land used a camera with filters on it to take a shot, to project black-and-white transparencies of a still life taken through filters. And he took a shot of it through a particular colored filter. A yellow beam and a red beam of the same shot were put together on the screen, and people expected to see a red and a yellow they expected to see the still life in orange. He took a shot of a still life with a red filter, and if you look at the picture, you would see a red monochrome with light and dark. If he took one with yellow, you would see a yellow monochrome with light and dark. So he had a monochrome yellow shot of the still life, a monochrome red shot of the still life. Then he decided: Now I am going to shine the yellow on there, and what would you think you will see? You will see orange. He had a yellow beam and a red beam. If only the orange beam is used, an orange monochrome picture would arise. When both beams were turned on, the audience expected something between the yellow and the orange, but what they saw instead was a sudden bursting of the image into full color, with reds, blues, greens, purples—every color in the original still life.

Land had taken two photographs of a group of different-colored objects. The photographs were taken using positive black-and-white film with a colored filter. One was taken with a light green filter, the other

15 Oliver Sacks, "Scotoma: Forgetting and Neglect in Science," in Silvers (ed.), *Hidden Histories of Science*, pp. 156–157.

through a yellow filter. Land then projected the black-and-white slides through the same colored filters used to take the pictures and superimposed the two projections on a screen. What they saw was a full-color picture of a bowl of fruit. It does not matter what filters you use. This is something that anyone can do. You can find a detailed description and discussion of Land's experiments on color in the May 1959 issue of *Scientific American*. His series of experiments cast doubt on existing theories of what color is and how we see it. But there is more to it than that. It tells us that much of what we believe about color and how we perceive it is probably not true. Even after more than fifty years, Land's remarkable series of experiments will not be found in physics texts on color. Why would such important work be ignored? I suspect that the reason is that it does not conform to the concepts that physicists currently accept about the nature of color.

Now, as we go into the work of Dinshah Ghadiali (1873–1966) and other color experimenters who have worked with color healing, we will find that the same thing happened to those researchers that happened to Goethe. If you search online for Goethe's Color Theory, you will get mostly the websites of critics and their belief that he didn't get it. In reality—and anthroposophists go crazy about this—he did not get it with his first four books on color. He tried unsuccessfully to refute Newton, but in Goethe's fifth book of color he surpassed Newton and broke new ground with his psychological color study.

Where does the color come from when I see a colored shadow? Where is it—is it out there? I can photograph it, but the camera and photo are designed to see like my eye. My question is: Is the color out here? When we had the jar with the milky water in it, was the color in the milk? No. Whenever I can take photographs of it, I look and see color in the photo, but how did it get into the photo? It is like the chicken-and-egg question. When we go into this realm and consider the Edwin Land experiment, we have two monochromatic photographs of a still life taken with yellow filters that have a yellow tint to them. But when you project them together, we see a full-color image.

Again, where is the color? It is out there as a sensation, or only in here as a perception. When I have it as a perception, I project it out into space where it almost does not exist but is ripe to become. The turbid medium is a picture of something. What does the turbid medium represent in the human being? It is the soul. The soul has requirements connected to the life body, and the senses come in, but there are also things streaming out. That was the brilliance of Goethe. I can take a picture of these color phenomena, but it doesn't solve the basic question. It does not tell me what it is or how it gets there.

The instruments we use to record color are based on the way my physical body works. It is probably impossible to make instruments that are not based on the way our physical body works, because that is the model we use. We take the lens of the eye and combine several of them to get a telescope or a microscope. Once we started to explore this realm and opened it up, color just pours out of things. There is a hue that is not perceptible unless a cloud blocks the Sun, or maybe it is a reflection of the sky coming off of a wall onto a flower. In reality, it gets crazy, but this is the true world of color. If we try to set up a still life of white objects, the color of the grass outside may be reflected on those objects as you are painting it. Every object in the still life picks up light from all the other surrounding objects, and so do we.

8

Color Intensification

> *Condensing feeling into light,*
> *you reveal forming strength.*
> *By embodying will in being,*
> *you create in world existence.*
>
> *In pure thinking you will find*
> *the self that can sustain itself.*
> *By transforming thought into image,*
> *experience living, creating wisdom.*[1]

These two pillars are on the side of a dark passage, where we go to meet the Guardian of the Threshold. That is the context. Boaz is "The Pole of Death into Life"; Jachin is the "Pole of Life into Death."

I meet the Lower Guardian at the threshold, and then within the threshold I come into contact with the Higher Guardian, who says that I am now free of karma. In Eastern tradition this implies having reached the stage of bodhisattva. In the abyss, you encounter the fact that your belief that you are bad and that other things are bad is a problem—actually, *the* problem. You have to change that belief, and then you have to intensify your feeling into light. You have to *cognize* your feeling. You have to make your feeling coherent to yourself to reveal the forming power present in your soul. That forming power in your soul is your gift as a member of humanity, the tenth hierarchy. You have the ability, through your feelings, to form a new world. This is what the Higher Guardian tells you.

[1] Steiner, *Finding the Greater Self: Meditations for Harmony and Healing* (tr. M. Barton), p. 59.

The Lower Guardian says that everything you think is happening *to* you actually comes from you. That is the first verse. The second verse says, now that you have realized this, what will you do? You have to intensify your feeling into light, meaning you have to shine your light of consciousness on them so you understand them. When you do this, you reveal the forming power of the cosmos within you. This allows you to concretize your will into a new being, the new Adam. Within you is the seed of an embryo that will continue on through the next cosmic evolutions until the final Vulcan stage. When you concretize your will into being, you will create a world being—a new world. That is the work of a bodhisattva.

These are the two pillars of red and blue. Red says you have all this life, and now everything dumps into it like arterial blood; then the venous blood carries this gunk, but because it is not drawing things in, it is open to the periphery. In Steiner's work the venous blood is where the healing force enters, not the arterial blood; the arterial blood receives all of the detritus of your cells. However, venous blood contains not only detritus, but also enzymes and signals, so to speak, of our struggle to incarnate, and it carries that toward the liver—and life. All the dead stuff now goes into life. These two verses are very deep mantras about your own physiology, seen from the perspective of your red and blue. I offer them as a kind of *leitmotif* for this whole book.

Returning to Edwin Land, inventor of the Polaroid camera, he was a person who used all kinds of equipment and optical systems to analyze frequencies and wavelengths as a scientist. These comments come from Land's "Experiments in Color Vision."[2] "The eye perceives color by comparing longer and shorter wavelengths." In color, there are long wavelengths (ultraviolet) and short wavelengths (infrared). These are the two ends of the visible spectrum, and the eye compares colors in the world in reference to those two poles. Land's conclusion is that "it must establish a balance point or fulcrum somewhere in between, so that all wavelengths on one side of it are taken as long and all on the other as short. From the

2 Land, "Experiments in Color Vision," *Scientific American,* May 1959.

evidence of the viewer, we can see that the fulcrum must shift, making sodium light long in one case and short in the other."

The balance point between infrared and ultraviolet is not fixed. This is where visible light goes out into these other worlds, and then suddenly between the two brackets of infrared and ultraviolet we have the visible spectrum. The eye needs a fulcrum point to say whether a color is on the long-wave or the short-wave side. However that fulcrum point is shifting for a particular reason. He explains why "we can see that the fulcrum must be able to shift.... From the dual-image experiments we learn that what the eye needs to see color is information about the long and short wavelengths in the scene it is viewing." It needs to find its place in the middle of where this spectrum is. It needs somehow to find the middle spot to say, is this cool or is this warm? Ultraviolet is cool; infrared is warm. It needs to find its place.

> It makes little difference on what particular bands the messages come in. The situation is somewhat similar to that in broadcasting: The same information can be conveyed by any of a number of different stations, using different carrier frequencies. But a radio must be tuned to the right frequency.[3]

The eye is in the middle of this sea of frequencies, some infrared; some hot, some cool—some red, some blue. It is the radio that must be tuned—what's the radio? Our eye via our "I." Land does not have the information to include the "I," but he has a lot of information about the eye. We have a kind of ace in the hole now when we read this—from Steiner about all of this stuff we have been doing. It is the radio that must be tuned to the right frequency. Our eyes are always ready to receive at any frequency and they have the miraculous ability to distinguish the shorter wavelengths from the longer.

In the retina of our eyes, the cones are tuned to red, green, and blue (RGB) and the rods to black and white. This is the difference—RGB is colored frequencies of all of our optical devices. And anything that is

3 Ibid.

in print is CMYK: cyan, magenta, yellow, and key (black). Our eyes are structured that way, and all our visual and optical technology is based on the eye. Different layers in our retina pick up the various frequencies and translate them into electrochemical responses. The eye transmits these phenomena; it is a receiver built to distinguish the shorter wavelengths from the longer ones. Somehow they establish the fulcrum that allows them to do this. The fulcrum is not in the eye; it is just a camera, and the camera is based on the structure of the eye, which distinguishes RGB from black and white. However, the eye does not establish the fulcrum of where the frequency is. Likewise, a camera records only what goes into it, because we have made an analog of our retina in silver that is embedded in something, which today we have digitized. Film is an analog of the way your retina is structured. The eyes establish the fulcrum that allows them to do this.

> The eye–brain computer establishes a fulcrum wavelength; then it averages together all the photographs on the long side of the fulcrum and all those on the short side. The two averaged pictures are compared, as real photographic images are compared in accordance with our coordinate system.... When we use a band of wavelengths for either or both of the records, we have light of many wavelengths coming from each point on the screen.[4]

Every point in your visual field is emitting huge numbers of frequencies at different wavelengths, because whether it is reflected, refracted, bounced light, ambient light, or whatever, all these different situations where you think you see red, there is a symphony of all these other frequencies that your eye is bathed in. And you have to find a fulcrum in that somehow. And he says it is in the "eye–brain computer." Land tells us that the eye can do almost everything it must to deal with random wavelengths. "Color in the natural image depends on the random interplay of longer and shorter wavelengths over the total visual field."[5]

4 Ibid.
5 Ibid.

Every point in everything you see radiates whole waves of interfering wavelengths. We have a term for that—*turbid medium.* When you stick your eyeball into a turbid medium, it tries to determine where the balance point is. If you stick a camera into a turbid medium, it will do the same thing, but a mechanism cannot provide the value of that. Value is not determined in your eye, nor is it in a camera. It is perceptible by your eye and perceptible by your camera, because they are based on the same model. Integrating of the fulcrum is somewhere in this "eye–brain computer," which I suggest is your soul. Your soul is the turbid medium between your body and spirit. Your soul is your astral body. It is the turbidity between the density of the physical body and the total transcendence in light of the spirit. We have this thing in between there called the soul, which is trying to establish a fulcrum point in the greatest turbid medium, life. It is the soul that finds where the fulcrum is located in the visual field. A honeybee sees ultraviolet and a rattlesnakes sees infrared. Why is that? This is what they need to find their food.

The white space we saw in the band of colors is the fog of all the frequencies. It is the great mystery of the Light becoming flesh—"The Light of the World" become flesh; it dies into that flesh to be resurrected. This stage of the drama is the Fall, where the turbidity is in the cosmos, where We have to establish a fulcrum somewhere in the middle of all this. That fulcrum has to be flexible, otherwise ideas become fixed and one has to go see a therapist. Our fulcrum is the focus of attention on whatever feelings arise in response to a sensory impression. The sense impression is at the dark end, and the spiritual side of my soul looks into the soul, wondering what feelings are arising in response to that sensory impression. Those feelings are the interaction between the sensation and one's cognition; *the result is perception.*

When I train myself to perceive the becoming of things, especially in the realm of color, I start to see the forming power of my own soul. I realize that, if I do not practice, it may still happen to me, my fulcrum-finding opens a door through which I begin to see into this realm and have experiences, but I cannot integrate them in myself. Therefore, I experience

them out in the world, mixed with the sensory experience. Rudolf Steiner talks about this: "Today, when an atavistic vision arises that the body cannot tolerate, it does not remain in the domain that brought it to life, which is where it should remain. A person becomes powerless when the physical body is too weak to stand up against the vision."[6] It becomes a hallucination. I see red stuff floating around your head. My body is too weak to deal with it, and my body is too weak because my life forces are affected adversely by my astral body so it cannot connect in the way it must to sustain my physical body. I am weakened physically, because my beliefs in my astral body will not allow my life body to gain access to my life organs. Imaginations come from the world and reflect off my life organs and arise in me as projections that I then project into the world. That is what a hallucination is. It happens if I fast and become too austere. I alter a life organ so that it cannot receive the imagination, which then has to reflect into consciousness. I see or hear it out in the world as a hallucination. That is belly, or gut, clairvoyance.

Belly clairvoyance is an anomaly, because life has caused my physical body to be so deeply stressed that my life organs cannot assimilate imaginations, which then appear to me as visual or audio hallucinations. Rudolf Steiner says this occurs because the physical body is not strong enough to damp down and contain it. "If the physical body is strong enough to stand up against it, the vision is weakened. Then the objects and events in it cease to appear—falsely—as if they belong in the world of the senses."[7] When I see red stuff around your head or when I hear voices speaking to me from a rock, it doesn't belong out there in the world; it belongs in me. However, when I remain awake for four days fasting and chanting, eventually my body gives up and says, Okay, whatever. Then I have a "vision." When that happens in this false way, visions appear as if they were part of the sensory world; this is how they appear to someone who is made ill by these imaginations.

6 Steiner, *The Riddle of Humanity*, lecture 9.
7 Ibid.

We are supposed to have the imaginations, but they are not supposed to appear as if they are out there in the sensory world. There should not be voices telling me what to do or colors floating around someone, but this is the way it has happened for millennia. This cannot happen unless I have to weaken my body through some austerity practice to the point where my body just gives up. "Thus, if physical body is strong enough to counter the falsifying tendencies of an atavistic vision, the following occurs; in such cases, a person relates to the world in a fashion that is similar to that of ancient Moon."[8] Steiner says we have to go halfway back to ancient Moon, because according to his spiritual-scientific research that kind of visioning was the way human sense organs were constructed then. It was just perfectly appropriate because we didn't have a physical body then that was strong enough to damp down the imaginations. We had a body with sense organs, but it wasn't packed with matter that damped down the imaginations. "In such cases, people relate to the world in a way similar to that of ancient Moon, and yet they are strong enough to reconcile that Moon mode of experience with the earthly organism in its present [material] state."[9] *This is the Fall.*

With the Fall, our eyes were opened to seeing the physical world as separate from us. Before that, imaginations would arise in us and we were one with the imaginations; this state of consciousness is living with the gods. That is the mode of consciousness during the evolutionary stage of ancient Moon. Now we want to go only halfway there for clairvoyance today.

> [We are] strong enough to reconcile the Moon mode of experience with the earthly organism in its present state. What does this imply? It implies that such individuals have somewhat altered their inner zodiac and its twelve sense zones. It is changed in such a way that what happens in that zodiac of the twelve senses is more like a life process than it is a sensory process.[10]

8 Ibid.
9 Ibid.
10 Ibid.

The life processes were more integrated than the sensory process, a field of random wavelengths. My inner life becomes more coherent, and I can find my fulcrum point in the middle of a sea of wavelengths. I damp down this overwhelming force coming in, and I learn to deal with it.

> Or, better expressed, one could say that the events in the regions of the senses, events which actually do impinge on the sense processes, are transformed into life processes—so that the sense processes are lifted out of their present, dead state and transformed into something living: you still see, but something lives in that seeing ; you hear, but simultaneously there is something living in that hearing.[11]

This is what happened before, when we started seeing red, yellow, and blue on a white ceiling. Your senses become alive. You could feel that suddenly there were colors everywhere, and yet it was not like seeing an aura but a cognition. Your cognition damps it down and allows you to go inside. If you think an Angel is coming through the venetian blinds and speaking, you might need to monitor that, because there are good Angels and there are not-so-good Angels, so you need to watch this.

> The sense processes are lifted out of their present, dead state and transformed into something alive. You still see, but something lives in your seeing. You hear, but there is something living simultaneously in that hearing. Something lives in the eyes or ears that otherwise lives only in your stomach or on the tongue.[12]

You have an inner perception of the quality of life. It happens when you put a piece of chocolate on your tongue.

> The sensory processes are truly brought into movement. Moreover, it is quite appropriate for that to happen, because our modern sense organs then acquire qualities that otherwise could be possessed in the same degree only by our life organs. The forces of sympathy and antipathy flow strongly through our life organs. Now just consider how much of our whole life depends on sympathy and antipathy toward what we accept and take up and what we reject. Now those

11 Ibid.
12 Ibid.

very powers of sympathy and antipathy, powers otherwise developed in the life organs, once again begin to pour into the sense organs.[13]

You look at something and consciously you can say inwardly what the sensation is doing to your life forces. But you have to develop a practice to do this. "The eye sees not only red; it also experiences sympathy or antipathy along with the color." You say this red is affecting me in a particular way.

> The sense organs regain the capacity to receive and be permeated by the life forces. Thus, we can say: *In this way the sense organs are brought once more into the sphere of life....* Truly, aesthetic human behavior consists of enlivening the sense organs and ensouling the life processes. This is an extremely important truth about humanity and explains much. The impetus for this enlivening of the sense organs and this new life in the areas of the senses is in the arts and the enjoyment of art. Something similar occurs with the vital processes, which are more ensouled in the enjoyment of art than they are in ordinary life. Today, it is impossible to understand the full significance of the changes we experience when we enter the artistic realm, because a materialistic approach is incapable of grasping facts in their complete reality. Today human beings are viewed as concrete and fixed, but to a certain degree people are actually unfixed.[14]

In other words, "Art in fact can heal people." This is the platform that Steiner suggests for redeeming and enlivening the senses, which is the role of aesthetic perception in Waldorf education. Aesthetic perception is not just a frill but also a doorway to shamanic practice of the future—to the new clairvoyance and building a new culture. We are not looking for pretty art; rather, art experience changes the human soul to become more flexible and tolerant and able to awaken in another person—able to have different modes because we can shift our fulcrum in the field of misunderstanding.

This is what I am doing in the sensory world, but if my senses are fixed into belief structures, I cannot access the ability of the fulcrum to

13 Ibid.
14 Ibid.

shift and to be more sensitive to the way everything is coming toward me. Is it red or is it blue? Is it Jachin or is it Boaz? Is it sympathy or is it antipathy? This is our work on the soul, and aesthetics—color, music, and movement—is the vehicle for transforming it. This is why Kandinsky and others were so concerned with the spiritual nature of art and so interested in how music, tone, movement, and color interact. They made paintings, and musicians would come and play the paintings, because they wanted to integrate the senses. When we do this kind of integration, we enliven the senses in a very profound way. It is the art of Wagner. It is the Goetheanum—the colored windows, the sculptural forms, the geometry, and so on. This is what Steiner brought to the world. His vision was that the arts offer the way back to sacred living.

Returning to Goethe's work, we see in the turbid medium two fundamental experiences: dark in front of the light and dark behind the light. Dark in front of the light gives a warm experience in the soul that Goethe called *yellow,* a primary color. Dark behind the light gives an inner experience of cool. He called the inner experience of cool *blue.* Blue and yellow, to him, are the two primary colors because of a very great mystery called *intensification.*

I have a yellow gel, and I take it to a sunlit window to see if it is actually yellow. I make it into a cone so that the yellow becomes deeper in the center of the cone. The color starts to intensify, and as it gets deeper the yellow begins moving toward red. Yellow, when it intensifies, turns into red. As yellow becomes less intensified and becomes lighter, it moves toward green. The great mystery of this is blue. Next I take a cobalt-blue gel and hold it up so that light shines through it. Now I add layers of the blue gels, and the blue quickly turns to purple. You actually have to look at the Sun through the gels. The blue shifts to magenta by the process of adding layers of blue gel. This is the process of intensification.

Thus, blue and yellow meet in magenta when they are intensified, and along the way from blue to magenta it goes through purple, and on the way from yellow to magenta it goes through orange. Yellow, orange, and red are on the warm side of the split spectrum. Blue, purple, indigo, and

violet are on the cool side of the split spectrum. Both ends meet in the magenta, which is what we observed in our prism experiment. These two primary colors, yellow and blue, meet in the magenta through intensification. Moreover, if I take blue and yellow and have them meet on the other side, I get green. Where they become less intense, they meet in green. Magenta and green are the two polarities—parrot green shows up in the prism experiment when turquoise and yellow cross each other; magenta shows up when red and violet cross each other.

All of this is totally consistent within the system Goethe based on his prism experiments. This is how he arrived at the yellow-blue-green-magenta picture of primary colors. However, since magenta and green are derived through a process, they are not primary colors but what we might call secondary. As yellow deepens, it goes through orange and then orange-red, or vermilion, which is a deepening; vermilion is a deepening of yellow through orange, a deepening of orange into a very warm red-vermilion, which becomes deeper by darkening and intensifying into carnelian, a brownish red.

Now look at the color wheel on page 235. Green is at the bottom and red at the top. It shows yellow to orange to vermilion to carmine to magenta. In this progression, after vermilion to carmine, the hues turn away from warm red to a cooler red and to an even cooler red in magenta. As it intensifies, it moves through layers of darkness, and magenta is the great mystery color that arises from the greatest darkness. If I move blue toward magenta, the closest to magenta is purple. Purple still has some red quality of the magenta, but if I go back a little toward blue, I get a cooler purple, which is violet. Now, if I take another step toward blue, back toward green, I move into a mysterious vibration that seems to neutralize everything; that is indigo, a very interesting color. It represents turning away from red and toward the blue—it is a kind of death process. Somewhere between red and blue is a doorway. Here we see our scheme of Jachin and Boaz. We could place indigo between these colors and meet, so to speak, the upper Guardian in the indigo room.

Color Intensification

Goethe Temperamental Rose and power of the soul tetrahedron.

135

In some schemes, we find cobalt blue and in others ultramarine. Paint manufacturers take a substance called smalt, from pulverizing glass containing cobalt. Alkalis pull pigment out of stone, which is placed in a vat to settle. The lowest part of the vat is where Prussian blue shows up. Above that, deep ultramarine shows up, and at the top cobalt blue. The kind of blue is determined by the amount of impurities in the color. Cobalt blue could be ultramarine blue, a slightly deeper variation of cobalt. In the ultramarine is a red tone connected with the purple–violet–indigo–red top tone. Suddenly we have another blue going toward the green, the green that turns away from red toward green and yellow, and this is turquoise. Or it could be cerulean, because the turquoise is moving toward yellow. It is coming out of the reds and going toward yellow through green, and we get lemon, which has one hand in green and one hand in yellow, and now we have a yellow with one hand in lemon and the other in orange, and then orange, and then finally we are back to the reds. This is a complete twelve-tone scale.

Indigo is the great manufacturer's playground. If you go into the watercolor section of an art supply store and buy indigo from six different manufacturers, you will get six different colors, from almost a kind of plum to red, or a violet having a blue-green quality. The label will say "indigo." Indigo is a color where all bets are off. I have heard it called the color of lead, the color of old congealed blood, and the back of a catfish, depending on the manufacturer. The beauty of the indigo is that it blends with everything because it is everything. It is a person who has received a deep wound and has stopped in their life. That is an indigo person. "Just let me rest." When we get to personality structures, we will look at soul moods as colors.

This is the twelve-tone color scheme. I first heard about it in graduate school, and then a couple of years later, I was doing a lot of painting and it came to me again in the work of the painter Liane Collot d'Herbois. She was brilliant and gifted and known as a harmonist. There are two kinds of color painters—colorists and harmonists. A colorist uses very pure colors in many different places to make them

appear different. Matisse was a colorist. By contrast, a harmonist tries to use colors in such a way that nothing pops out; everything speaks to everything else. There is a kind of totality of the mood. In music, the colorist is a soprano who loves trills and flashy vibrating notes, whereas the alto carries the weight; she is the harmonist. She brings the harmony. Liane Collot d'Herbois was a brilliant harmonist. When we view her style of veil painting and integrating colors it seems impossible to look at the colors; rather, we have to look *into the colors,* which pull us into a "color space."

Color space comes out of the work of artists such as William Turner, who developed "atmospheric perspective," in which the blues recede and warm colors advance, with yellows in the middle. A Turner landscape will have warm tones in the foliage and everything in front, with a yellow area in between, and the blues behind. That might even have been inherited from the Flemish painters. The technique creates atmospheric perspective, or color space. If you color a flat sheet with red at the bottom, yellow in the middle, and blue at the top, you are already giving an impression of a space. If you have blue at the bottom, a red at the top, and a yellow in the middle, you will not give the impression of a space.

These qualities of color—advancing and retreating colors—in the work of Collot d'Herbois allowed her to have a perception of these twelve colors as a kind of space to live in. She used color in her paintings to create a cupola of color that we go into, and we live in the movements of the color, while the colors in the foreground—the darkness in front of the light—try to move behind the light, whereas the darkness behind the light tries to move in front of the light. The darks in front of the light are the warm and trying to go toward and behind the light. The darks behind the light, the blues, the cool and yearn to come forward toward warm. We can think of this in terms of weather; cold goes to warm; warm goes to cold. As in human relationships, hot and cold are mutually attracted and things happen. Those qualities led Liane Collot d'Herbois to design a teaching device for painters called "The Grotto."

9

The Grotto

Liane Collot d'Herbois's "Grotto" is intended to help painters understand the interaction between "dark in front of light" and "dark behind light." It depicts a profound imagination that enables artists to comprehend and use the twelve-tone color scheme. The diagram shows an imagination in which there is a grotto filled with darkness, with an opening above through which a shaft of light shines into the center, and we enter the grotto from the right and perceive the darkness in front of the light at the center of the grotto. The darkness of the grotto is between the viewer and the light in the center. As we enter, we experience the maximum darkness in the grotto. The light we see here will appear as magenta, because the farthest point from the center produces magenta as the color shining through the darkness. There is a kind of magical power in the magenta raying through all that darkness.

Imagine that the room in which you are sitting is the grotto. The shaft of light is coming down, and you are on one side of the grotto, and you are at the point of maximum darkness. You therefore see the shaft of light as magenta colored, even though it is dim. You might see something like this when you look through magenta gels. They are dense, but when you look through them at a strong light or the blue sky, everything appears black or dark magenta. Now imagine that your room is the grotto and you are at the edge. In this position, you experience magenta. Now take one step toward the center. In essence, you peel away one layer of the darkness. You are now standing in the layer of darkness first seen as magenta, but now you are within that layer and the color of the light at the center of the grotto changes from magenta to carmine—one layer

The Grotto

dark behind light	light	dark before light
M magenta	G green	L lemon
P purple		Y yellow
V violet		O orange
I indigo		V vermilion
C cobalt		C carmine
T turquoise		M magenta

The "Grotto" of Liane Collot d'Herbois

less of the dark. The experience is now carmine, or blue–red. This is shown in the diagram. You are moving toward the light. With one more step and fewer layers of the darkness, the light becomes stronger and you experience yellow-red, or vermilion.

At this point, light and darkness are becoming more balanced with each other. Red is beginning to have a yellow cast as the light grows stronger in the darkness. The fulcrum is changing. With another step we are in orange, with vermilion, carmine, and magenta behind us. Yellow, lemon, and green are still ahead, and we are at a kind of threshold in the orange—halfway in or halfway out. This is the conflict or tension in the nature of orange. It exhibits a strong tension between light in dark, and

this is also true of orange personalities; they are perfectionists, always looking for the perfect balance and afraid of moving too far one way or the other. Are we in the light or in the dark with orange? When the Sun rises, the vermilion red is up and things are getting hot; this is the quality of orange. We forget all about the dark, but those with an orange personality remember the darkness they went through since they are in a kind of balance between the light and the dark. The orange personality yearns to be indigo, but they are the polar opposite.

Now remove one more layer of darkness and instead of orange, which is still conflicted about light and dark, we are in yellow. We feel we are now moving into the light. We have peeled away a lot of darkness and have much less to go through. I take one more step and peel off one more layer of darkness, and we are in a kind of lemon color, with just one layer of darkness between the ultimate light and us. The lemon personality is profoundly interested in the tiniest details of what might go wrong or right—what is not quite perfect and not quite the true light. Here we leave all the darkness and stand in the light. The role of the light is to be the agent that has to interact with the darkness. Suddenly, standing in the light, we realize that we cannot be all light; there would be no soul.

Rudolf Steiner said that the light *"greens"* itself. It has no darkness with which to work—only the *inevitable* darkness. Without the cosmic darkness, I am in the light with nothing to worry about, and suddenly I realize that, if I don't have any darkness, I don't have any me. This is the dilemma of green. We are in the light and realize we have to serve everything else that has fallen. This is the green man of the Celts. This is the Christ who came to Earth to be crucified. The light dies into the green. We are at the center of the grotto, but we are also drawn irresistibly to continue our journey. We take one step out of the light into the first layer of darkness, and now the light is behind and a vast field of darkness is before us. As we move away from the light toward the dark, we experience turquoise. In this first layer of darkness, the light is behind us and shining into the darkness, we feel we are going into a dark place, but still need to hold onto the light behind us. The inner nature of the

turquoise personality is the truth teller. Turquoise personalities know all confusion in darkness, but hold to the light. They are not in the light but remember what it was like to be in the light. The lemon personality is on the other side and still yearns for the light. If we are in a lemon space, we are irritated because we are not yet in the light. If we have a turquoise personality, we are irritated because we recall being in the light and are facing darkness. This is a kind of symbolic soul language.

In the turquoise, we are irresistibly drawn toward the deepening darkness before us, because our impulse is to be all of the colors, and we have to find our fulcrum. Our next step into the darkness places us in ultramarine, or cobalt—a kind of royal blue. It is the color of the Madonna's outer mantle. We could call it the "mom color." The never-ending courage to keep going because you feel good about it is the positive side of ultramarine. The negative side is our regret over leaving the light; it was really good back there. Negative cobalt is the personality living in the past. Positive cobalt is courage, remembering the good time and having no reason to believe there will not be a good time in the future. It is the eternal child, or embryo, with great potential for development. The gift of people with this personality is that they always bring positivity, courage, harmony, and acceptance to life's situations. Their problem is that the darkness always overwhelms, making them want to retreat into the past and memories of the light.

We take another step, and now we have left the light. We are faced with darkness but still have light over it. We are clear, though, that darkness envelops us again. This experience is indigo. Is it light or is it dark? We don't know if it is a light or dark indigo; we don't know if it is a light or dark orange. They are polar opposites. Orange represents going toward the light from the darkness; indigo represents going from the light toward darkness, but on the other side of the light. Indigo and orange are two thresholds, or turns. We go into indigo, a kind of death process. Something seems to be changing and happening, but we are not sure what it is. This quality is violet. The violet soul feels happier on the other side of the threshold. They have a great gift for perceiving the

other side, but they spend so much time on the other side that this side is a bit of a bother.

Then, we take one more step and find ourselves in purple. In the ancient world, it was the royal purple. The light and the darkness grow so intense that the purple has a kind of insulating quality in the darkness. To survive the darkness, they need an inner experience of remembering the light so strongly that, regardless of the darkness, they will be okay. They form such royal opinions about themselves that no matter what happens, they stay on course. These are people like Bill Clinton; no matter what happens, I am on message. They are in contact with so much darkness that they form an invincible buffer in themselves against it. They hold onto that memory of the light so intensely that when they are covered by darkness, they remain true to themselves. Nonetheless, they also have feet of clay, because they are continually drawn irresistibly to follow the same path into darkness.

Now we take one final step and find ourselves in the deepest darkness again. So, do we find our fulcrum? We are now in the deepest darkness and turn around, and there is the magenta again, but now it is on this other side. If we step back, we are in carmine. But wasn't that purple just a moment ago? Next we are in vermilion—wasn't that violet? And so on. As we go through the grotto, whatever the color, we are on a track to another one. But I have to turn my soul, and the problem with the magenta is turning—we are in the deepest darkness and have to turn our soul consciously. This is the suffering of creative genius. This is the deed of the Elohim in creating the world. This is the reason it is magenta. We are in the deepest darkness and have to find the most intense light to break through it. When we do, it falls from the deepest darkness into the light—into green.

Liane Collot d'Herbois's picture of the grotto gives us a brilliant synthesis of a way of thinking and imagining these colors and living in them. It is a meditation. Where is your grotto? Imagine your grotto. You come through the doorway and find the deepest darkness, and the light is in the center. Try to call up magenta in your imagination and then take a

The Grotto

step forward and peel off one layer. The magenta changes into the carmine, of scarlet, the color of the "blue" blood. Now another step, and we peel off another layer of darkness; we are in the vermilion, the bright, warm-red blood of the arteries. With the next step inward, peel off one more layer of darkness; you are in orange. Feel the threshold of darkness behind you and the light in front of you in the orange.

Now, as an exercise, turn around and look back; you are now in indigo. Turn around and look at the light and you are in orange. One more step and peel off the darkness; the light becomes stronger. Now you are in the yellow. Another step and the light becomes even stronger, but one layer of darkness remains—lemon. Finally, you step into the light. At first it is a white light, but then it slowly descends to become green. Now a step from green toward the darkness, and the light behind you illuminates darkness. The darkness is now behind the light, and your experience is turquoise. One more step and darkness grows—cobalt. One more step, the light fades and the darkness grows—indigo. Step through the indigo into the spiritual world—violet. One more step and you start to turn again toward the red in purple. The last step is again into the deepest darkness and the utter lack of color. Now feel your need for the light, and then turn and see the magenta arise. Go back through carmine, vermilion, orange, yellow, lemon, green, turquoise, cobalt, indigo, violet, purple, and deep darkness, and then turn, magenta....

This is a color meditation working with the grotto. I think that this imagination could do something to help in developing one's soul to become more sensitive to the forces of light and dark present in each color, and the yearning of the colors in front of the light to become those behind the light and vice versa. It is based on what we call the complements. In color charts based on this concept, we start by describing magenta and green as having an archetypical polarity. Going from the deepest dark to the light, those two are complements to each other. Indigo and orange are the second set of complements and a kind of threshold between the colors that are on the magenta side and those on the green side, relating to the balance between light and dark as shown in the grotto.

Each color has a "modulation." If I go toward yellow from the green, I get lemon. I modulate it toward the warm side. If I go from green toward the blues, I get turquoise, the cool side. Thus green has a warm side and a cool side—two different hues. Lemon has the cool side as a green; as it gets greener, it gets cooler. But it has a warmer side in the yellow. Yellow modulates to the green side, which is cooler, and to orange, which is warmer. Orange modulates to yellow, which is cooler than orange, and to vermilion, which is warmer. Vermilion modulates to orange on the warm side and to carmine on the cool side. These modulations build a kind of template for the complements.

In the chart [number 4] you can find your irritant, the complement for the irritant you may have married...or avoided marrying. Finding our irritant makes it possible to make a construct very similar to what you would call a natal chart. It represents certain forces operating in your soul, with squares, trines, and oppositions. We frequently work with oppositions, and turquoise is opposite carmine, with turquoise on the warm side going toward green, and on the cool side going toward cobalt, a complement to vermilion. Lemon is a complement to purple. And yellow is a complement of violet, with the achromat in the center. You find your irritant and then you have a structure of tensions, relationships, and dynamics you can use when you want to do soul work. Or, you may want to paint your way out of a bad mood.

Later on, we will consider how to set up a series of paintings with which you challenge yourself concerning the irritant. By looking at squares, trines, or oppositions and choosing color schemes that add colors to other colors, you observe your responses. Diagram 4 can become a way of taking our meditation and tuning it in to your own biography.

10

Dinshah Color Therapy

How do we interpret the color gel test discussed earlier? Why, for instance, is a homeopathic silica connected to the color green? Why is that a particular constitution, or soul attribute? To segue from outer phenomena to healing work, I present the following. First is the work of Dinshah Ghadiali (1873–1966).[1] (See diagram on page 146.)

There is a little book called *Discover Color Therapy* by Helen Graham, which I chose at random—there are numerous books on color healing. I am using this one here because of the way she does things. I want to point out some of what she says to show that the work of healing with color is filled with contradictions. Your soul has to find your fulcrum in a field of turbidity, so there is bound to be conflict, paradox, and conflicting statements. However, when you work with color, you always have to find the complement. Is there an opposite? I will paraphrase a couple of Helen Graham's points and cited research from other people.

A man named Max Lüscher (1923–2017) developed the well-known Lüscher Color Test and wrote a little book about it, with removable colored chips in the back.[2] During the 1960s, it led to a kind of party game. Someone would put out the little chips and people would choose colored chips and put them in little piles that they would then count. In the back of the book is a "filter" that indicates personality traits based on people's color choices. This is the Lüscher Color Chip. Some people were very inspired by this, because it opens a way to a valid means of working

[1] See, for example, Darius Dinshah, *Let There Be Light: Practical Manual for Spectro-Chrome Therapy*.

[2] See his book, *The Lüscher Color Test: The Remarkable Test that Reveals Your Personality through Color*; also, http://www.luscher-color.com.

```
                    balances
         calms      heart and    stimulates
         hyper     adrenals      hypo
       conditions                conditions
                weak      kidney
               spleen    genitals
               heart            liver
                pain            stomach
                                    lung
relieves pressure  thyroid        stomach     heals paralysis
arrests discharge                              penetrates and
soothes inflammation  indigo      orange      activates tissues
relieves pain         deep                lymph
                    immune                intestines

                    builds               gall
                    vitality    skin     thymus
                             disorders  pituitary
           acute alterative               chronic
                           balances       alterative
                         musculature
                        aids purification
```

Dinshah's system of "Spectro-Chrome" therapy

with color. However, the way Lüscher did it was a little odd. Research scientists began using the Lüscher Color Chip Test and concluded that the red stimulates the sympathetic nervous system (SNS), part of the autonomic nervous system, and that blue stimulates the parasympathetic nervous system (PNS). The SNS is related to "fight or flight," and the PNS is related to "rest and digest." These are the two main aspects of our autonomic responses, and we need both. It was concluded that the sympathetic nervous system is stimulated by red and the parasympathetic is stimulated by blue.

Robert Gerard confirmed these findings in 1958.[3] He found that red produces feelings of arousal and is disturbing to anxious and tense

3 See http://healthpsych.psy.vanderbilt.edu/color_therapy.htm.

persons, and that blue generates feelings of tranquility and wellbeing and has a calming effect. He also discovered that blood pressure increases under the red light and decreases under blue light. Dr. Harry Wohlfarth, based on Lüscher's work, also showed that certain colors have measurable and predictable effects on the autonomic nervous system.[4] In numerous studies he found that blood pressure, pulse, and respiration rates increase under yellow light, increase moderately under orange, and increase minimally under red. Wohlfarth's research showed that blood pressure is minimally influenced by red, but Dr. Gerard's research showed that blood pressure is increased under red. We have to take the results of such color research with a grain of salt, understanding that there is a polarity in the soul seeking the fulcrum. You will have a physiological response one way or the other, depending on what you like or dislike, or depending on what does or does not irritate you. We should not make blanket statements, especially about color, unless we also include the opposite conditions. This is exactly what color does and what our life body does in relation to color.

This research found that blue light was used successfully in the treatment of neonatal jaundice and rheumatoid arthritis. Others found that blue light was helpful in pain relief. Conventional medicine today considers light therapy to be junk science because it cannot be replicated a hundred percent of the time. But it has to be considered in relation to the different soul configurations of those who are being treated in this way. We need a different rationale when we assess color healing.

> Color is also used therapeutically in a variety of nonmedical settings. In some cases, its effects have been quite accidental, as in a report to me by the governor of a newly built prison in which each of the four wings have been painted a different color.
>
> Both he and his staff found that the behavior of the prisoners varied significantly, depending on which wing they lived in, although their allocation to each had been random. Those in red and yellow wings were more inclined to violence than those in the blue and the green wings.

4 See https://sites.ualberta.ca/ALUMNI/history/peoplep-z/86winwohlfarth.htm.

> By comparison, pink has been found to have a tranquilizing and calming effect within minutes of exposure; and it suppresses hostile, aggressive, and anxious behavior. Interesting given its tradition associated with women in Western culture.
>
> Pink holding cells are now widely seen to reduce violent and aggressive behavior among prisoners. And some sources have reported a reduction of muscle strength in inmates within 2.7 seconds. It appears that when in pink surroundings, people cannot be as aggressive even if they want to, because the color saps their energy.[5]

Pink is very close to magenta—a tint of magenta. Maybe there is something to this. Again, we have to take it with a grain of salt.

This points to something in my own life. I had a student years ago who was blind from around ten to twelve years old, when he was blinded by an accident with a chemistry set. He wanted to enroll in my Goethean studies course on color. I said, "Well, John, correct me if I am wrong, but what can I do to teach you about color?" He told me that his profession dealt with color healing. He had a little device with colored glass rods as a diagnostic tool. He would take a rod of a particular color and hold it on the middle of someone's forehead. When he turned on the light and put his hand on the soles of the patient's feet, he could feel a difference in the hue as the color moved through the body. Based on this, he would make a diagnosis. I said, "John, I think you can take the course." He had the most precise and nuanced sense of color of anyone in the course. He felt it through his hands.

> Until recently the function of light was thought to relate largely to sight. However, it is now well established that color need not actually be seen for it to have definite psychological and physiological effects. Blind, colorblind, and blindfolded subjects can also distinguish it. This phenomenon, referred to as eyeless sight, dermo-optic Vision, or bio-intrascopy, has been researched since the 1920s, when it was established that hypnotized blindfolded subjects could recognize colors and shapes with their foreheads, and that non-hypnotized,

5 "The Benefits of Color Therapy – Part II" (http://www.natural-holistic-health.com/benefits-color-therapy-part-ii/).

blindfolded subjects could precisely describe colors and shapes presented under glass.

Research in Russia during the 1960s was stimulated by studies by Roza Kulesheva, who, when blindfolded, could distinguish color and shape with her fingertips, and could also read this way. Other experiments showed that Kulesheva was not exceptional. One in six experimental subjects could recognize color with their fingertips after only twenty or thirty minutes of training.[6]

This is similar to what happened last night when everyone started to see color in the white ceiling. When you become aware of this dimension, other parts of your soul are grateful.

Blind people develop this sensitivity even more quickly. Some subjects could distinguish color correctly by holding their fingers twenty to eighty centimeters above colored cards and described experiencing sensations varying from needle pricks to faint breezes, depending on the color. Even when heat differences, structural differences, and dyestuffs, and other variables were controlled, people were still able to distinguish colors accurately, whether they were put under glass, tracing paper, aluminum foil, brass or copper plates. This phenomenon remains something of a puzzle.[7]

What is color, and what does it have to do with healing? The little chart (on page 146) is related to the work of Dinshah Ghadiali, a medical doctor and researcher with connections to the work of physicists. Ghadiali was interested in the healing properties of red and blue light in connection with the work of Edwin Babbitt in the late 1800s.[8] Babbitt had published a controversial book on esoteric principles of light, and his work opened the door to research on how color and light can be used as healing modalities.

Dr. Seth Pancoast (1823–1889), a theistic mystic, kabbalist, and alchemist, published a book called *Red and Blue Light*, using Babbitt's work

6 Graham, *Discover Color Therapy*, p. 14.
7 Ibid., p. 15.
8 Babbitt (1828–1905), *The Principles of Light and Color: The Healing Power of Color*.

as a basis. There were also numerous experiments dealing with ways to accelerate plant growth, as well as how to heal inflammations by having a person sit in a room with windows of blue glass interspersed with white glass and a room with red and white glass. Although many of the results could not be replicated, there was a huge interest in it, because it seemed as though something was happening.

Ghadiali inherited much of this controversial research, but he was a good researcher and medical doctor, so he was able to gather data at a clinic. He began his experiments with color and found a modality of working with certain colors that could enhance or suppress inflammation, which is a fundamental issue in healing. Do we allow inflammation or suppress it? Ghadiali developed a system. In the diagram on page 146, you see green, turquois, cobalt, and indigo. You see the color circle inside, with vermilion, orange, and yellow on the right as healing to cases of paralysis; those colors penetrate and activate tissues. He was looking at broader symptomatology rather than specifics and found that, in general, yellow, orange, and vermilion heal paralysis. In other words, those colors allow for a kind of movement, because they penetrate and activate tissues.

This is totally in keeping with Goethe's conclusions. Ghadiali's book is *Spectro-Chrome Metry Encyclopedia*. His color theory included active and recessive colors. Clinically, Ghadiali found that, when he wanted to stimulate, he could use vermilion, orange, and yellow. On the opposite side of the diagram we see that cobalt, indigo, and violet relieve pressure. Yellow, orange, and vermilion increase pressure, and sometimes we need to increase pressure to overcome paralysis; we need to push. On the cool side, cobalt, indigo, and violet relieve pressure; they arrest discharge, whereas the warm colors stimulate discharge and soothe inflammation, and the cool ones activate inflammation and relieve pain. The warm ones stimulate, until inflammation lets you know something is not right. These are the two polarities, or split spectrum. Ghadiali tested this numerous times, usually with colored glass in kerosene lanterns. He called his process "toning" and considered it effective in dealing, for instance, with burns. A bad burn is on the red, inflammation side. He would put people

with a burn in blue light for fifteen minutes, then stop, then fifteen more minutes, then stop, and so on. The process was a rhythmic pulsing. The pain diminishes, with much less scarring after healing. Ghadiali had lists and various categories in his book for toning, including the timing for using colored light.

In the diagram on page 146, you see that lung, stomach, lymph, and intestines are often healed with the warm colors, whereas the thyroid, deep immune system, and endocrine glands are healed by the cooler colors. Ghadiali also found relationships between the inner and the outer aspects. The life organs are connected to the warm side; the thyroid and deep immune responses of the deeper endocrine system are connected with the cool colors. This was his fundamental discovery. Magenta balances heart and adrenals. Green, the other side, balances musculature and aids in purification. Magenta and green balance. The lemon side of green is an alterative for a chronic situation. In the case of an acute situation, turquoise cools it down. Purple calms hyper conditions by cooling them down. Carmine, on the warm side, stimulates hypo conditions. This is a rational way of looking at color in terms of its therapeutic qualities. However—and here is where we go into an interesting place—if you start reading down below:

"In an indictment in Buffalo, New York in 1931 the AMA charged that Dinshah feloniously defrauded a purchaser by falsely representing Spectro-Chrome as a healing system."[9] He brought in three doctors to testify.

> Dr. Kate Baldwin, MD, FACS, was Senior Surgeon at the Women's Hospital of Philadelphia, and had been using the Spectro-Chrome system for ten years. When the prosecution asked her if Spectro-Chrome could cure cancer, Dr. Baldwin stated that in many cases it would. She testified that she had used it to cure gonorrhea, syphilis, breast tumors, cataracts, gastric ulcers, and severe third-degree burns.
>
> In fact, in an article printed in the *Atlantic Medical Journal* of April 1927, Dr. Baldwin stated that after thirty-seven years of active

9 Cited at http://www.wrf.org/men-women-medicine/spectrochrome-dinshah-ghadiali.php.

hospital and private practice in medicine and surgery, she produced quicker and more accurate results using Spectro-Chrome than with any other methods, and there was less strain on the patient.

Urging the medical profession to investigate the effect of color light on burns, she cited the following case history, "In very extensive burns in a child of eight years of age, there was almost complete suppression of urine for more than 48 hours, with a temperature of 105 to 106 degrees. Fluids were forced with no effect, and a more hopeless (condition) is seldom seen. Scarlet was applied just over the kidneys at a distance of eighteen inches for twenty minutes, all other areas being covered. Two hours later the child voided 8 ounces of urine."

Dr. Martha Peebles also gave sworn testimony at the trial. Dr. Peebles was a doctor of medicine for twenty-four years, including twenty years working for the Department of Health of the City of New York. She was a physician for New York Life Insurance, and was a physician to the American Expeditionary Forces during World War I. During the war, she would attend up to sixty-one operations daily. She stated that she had been forced to retire due to ill health, but using the Spectro-Chrome system she had restored her health. She had used seventeen color machines over ten years, and had treated cancer, hypertrophic arthritis, poliomyelitis, mastoiditis, and many other medical conditions.[10]

Then the third doctor testified:

Dr. Welcome Hanor, a medical doctor for over thirty years, provided sworn testimony that he had treated cancer, diabetes, gonorrhea, syphilis, ulcers, hemorrhage, neuritis, spinal meningitis, heart disorders, uremic poisoning, and other medical conditions. The jury did not find Dinshah's healing system "preposterous." Ninety minutes of deliberation resulted in a verdict of "Not Guilty."

In 1947, Dinshah was tried in court for "mislabeling." Dinshah was found guilty and was forced to surrender all of the books, magazine articles, and papers he had written on Spectro-Chrome to be burned! The estimated worth of the material that the government destroyed was $250,000. Dinshah was placed on five years' probation, ordered to disassociate himself from Spectro-Chrome, and to close his institute.[11]

10 Ibid.
11 Ibid.

Dinshah Ghadiali died in obscurity as a pauper. The mainstream allopathic medical establishment claims that color healing is ineffective.

Recalling our code word, the *fulcrum* is in the soul. Homeopathy is effective all the time for only thirty-five percent of those who use it, and for thirty-five percent of the people it is *never* effective. For the other thirty percent, it may or may not be effective. The souls of thirty-five percent of the people are sensitive enough to homeopathic remedies that they will have a healing effect. Homeopathy is used with horses, and for some it works and for others not. Healing involves a certain sensitivity.

During the late 1800s, most of the hospitals in the United States used homeopathic practices. Homeopathy was touted as the coming new age, the age when people would no longer be sick. Then Matthias Schleiden and Theodor Schwan proposed their germ theory and pathology, leading to what would become the continuous warfare of allopathic medicine. Homeopathy became quackery for most of today's medical profession—a money-making scheme based on ten-dollar sugar pills. However, if you work with homeopathy you see that it works. The realm of healing is very delicate. This is the current context of homeopathic medicine and flower essences. Color is a spiritual substance that has a particular action on the soul, just as a homeopathic remedy or a flower essence does. It is pretty clear when they work. This is clearly not a placebo effect, since you can give a homeopathic remedy to one-year-olds having a tantrum, and ten minutes later they are usually fine.

In graduate school I studied Goethe's color theory, did a lot of painting, color keying, and research into the subject of color. Over the years, there has been this other, healing side that interests me. I couldn't quite get it. Then I encountered the work of Liane Collot d'Herbois and her grotto imagination. I took a course from her in San Francisco and realized that she knew something she did not know. She was a very gifted artist and not such a gifted teacher. In a certain sense, she could not express what she knew. When I was with her, I had to get it by osmosis. I had to read between the lines. Nonetheless, there was something in her

twelve-colors system that my efforts as a painter told me is in fact there, but I could never quite say what it is. Then I discovered *Portraits of the Homeopathic Remedies* by Catherine Coulter.

There was a time in my work at Rudolf Steiner College when homeopaths were taking my course, and we would end up discussing homeopathy. At one point, I aspired to take a year off to study and become a registered homeopath. I was studying hard, and one of the homeopaths suggested the book by Catherine Coulter. Her thesis is that certain substances are archetypes for a homeopathic *polycrest,* meaning many crests, or points. A polycrest is a remedy that touches many points in a particular constitutional archetype. We might say (now that we have some color language) that a polycrest has access to a broader field of wavelengths, but it is a fulcrum in a modulated field of archetypal constitutional patterns—a bad liver, bad lung, nerve or skin disorder, and so on. Certain patterns of these problems constitute what Coulter saw as a constitutional polycrest. Coulter's book helped me to understand the broad aspect of the work with these twelve constitutions. As I read Coulter, all I could think of was Collot d'Herbois, because her book on color describes the movement of colors much the same way that Coulter talks about homeopathic substances. I kept thinking, this is too simple, but as I continued to read, I could see the similarities.

Then someone suggested I read Dinshah. So I got started reading his work and he, too, uses a twelve-tone system. Liane Collot d'Herbois has a twelve-tone system; Catherine Coulter has a twelve-tone system; and Dr. Edward Bach's flower essences have the twelve healers. Suddenly things started to gel for me—this is a healing system! This is not just random. I looked at Dinshah and at Coulter's polycrests and saw a close connection. By combining of all of these, I am sure we could probably move on to the twelve-tone musical system and find something there, as well. People try to tell me it is the zodiac, too. I'm from Missouri, so show me. When I discovered that the Dinshah system had become the system for the Roscolux theater gels, the light went on.

For my first year of classes, I spent a couple of days making little pairs of glasses out of pipe cleaners with red and green colored gels glued to them, so that people could wear them in classes. I asked the students to put on the green glasses, and as I did my lecture, people started leaving. Then I had them wear the red glasses, and a whole other group of people started leaving. They were feeling nauseous. I realized that I would have to take a different approach. Then I found that theater suppliers had gel collections made up especially for healing.

There is something in those colors and their frequencies that seem to stimulate a homeopathic constitutional response. When looking through a gel, your system responds on the basis of homeopathy, which in Hahnemann's work is called the *miasm*. Samuel Hahnemann (1755–1843) worked as a homeopath and found certain constitutional patterns he called *miasms* (Greek = stain). His book, *Organon der Heilkunst* (*Organon of Medicine*), states that all disease arises from a fundamental stain in the soul. The stain enters your bodily constitution through the belief structures of your grandparents and their unresolved issues. These cause tendencies that need to be dealt with if you are to be free of the miasm. This stain in your soul is inherited through a certain somatic tendency, and has to do with unrecognized traits such as guilt, anger, shame, and so on. It presents a miasm in you that, when you entered this life, acts as a kind of cloud, or stain, in the tincture of the relationship between your spirit and your body. It is turbidity in your turbidity.

Briefly, Hahnemann discovered homeopathy by exploring the substance sulfur and a process called potentization. At the time, the idea of "vital force," or vitalism, was widespread. Vital force involves a certain pattern of forces in the life body. Your life has been carried to you as a kind of inheritance, and Hahnemann explored the gesture of people such as Paracelsus, the alchemist. Paracelsus had his patients sip the dew of flowers as a medicine. Hahnemann said that this represents what he called *attenuation*. The dew on a flower itself is a rarefication of the plant's medicinal aspect. Whatever is present as a substantial process in the plant is than summarized and rarefed in the flower and, especially, in

dew on the flower. Such rarefication is made even more rare in the morning when dew settles on the flower.

Alchemists see dew as a condensed reflection of overnight planetary movements in relation to the fixed stars. They call it the sacred dew. Light becomes air becomes water: movement—light, air, water. Alchemists collect dew to make remedies. There is a whole cosmology behind Paracelsus' suggestion to sip the dew off a flower. The unification of the plant's process reaches up to the cosmos, and the cosmos reaches down in the morning. They would come together in a highly attenuated light—what comes from the Earth marries what comes from the cosmos.

Hahnemann refers back to Paracelsus and wonders what would happen if he took some sulfur, put it in water, loosened it up by shaking it, poured that into the same amount of water, shook it up to loosen it, and so on numerous times. This reverses the dew process by moving a substance back to attenuation. When you get a substance that is very attenuated, it still carries the imprint of the original coarse substance, but it is far more effective because it acts as if the body is not even there. If you are familiar with alchemy and spagyric processes you can see the potential of this. Paracelsus worked his whole life to make a spagyric process, so that the physical body barely exists and it goes directly into the energy body and through that into the soul. This is alchemical work.

Hahnemann said that the real issue of the fundamental miasm; he called it *psora,* the basis of the word *psoriasis.* He called it the itch, or irritation. According to Hahnemann, all chronic diseases begin as some form of irritation, which builds on itself. Depending on the constitutional direction, it becomes cancer if it is on the blue side or diabetes if it is on the red side. These diseases have their root in being irritated and if the irritation is connected to the patterning in the miasm. Not everyone is irritated by the same things; rather, it depends on what one has inherited as a somatic inheritance and a predisposition for a particular constitution.

While I was reading Coulter's book, I was also studying Hahnemann. I had discussions with homeopaths in my classes and was reading Collot

d'Herbois's work when I realized that color is the most attenuated substance. It turns out that color has a very deep connection to particular miasmatic patterns constitutionally. Our experience with the colored gels was meant to discover our irritant. What makes you irritated? The list of the words we used is from Dr. Bach's twelve healers. The color stimulates the irritant in you, and the way you collate that is to look at the chart and find the color that has the most negatives. The color that has the most negatives indicates your irritant.

Now the issue is this: We—our elemental body, or *manas*—are supposed to have access in a healthy zodiac to a full pallet of twelve and then modulated colors, so that when I get into a given situation and I am forced into a polarity, I can compensate. I can shift my fulcrum and be able to fill in where there is turbidity, match colors, and find out where they are. The miasm makes it difficult for me to include a particular hue in my emotional hue band. When I am in a situation with a particular kind of person and I need to go into that irritant color to compensate for what's coming, I am unable to go there because that is my irritant. When I try to go there, I am trying to find the fulcrum so that I can give an authentic response. However, that authentic response is my problem, my irritant, but it is also an overlay on my gift. That is the problem with miasm. I chose my grandparents so that I could have that miasm as the burr in my saddle; there is no blame in this. I chose that long before my grandparents were gleams in their parents' eye, through karma. It might help to paint a picture of grandpa and grandma in the colors of your irritation. Move it into the art and aesthetic realm, where you feel you can breathe with it. You have chosen everything. You've chosen them, even if you have not known them. Some people chose not to know their birth parents and then spend their whole life trying to find them.

When Rupert Sheldrake came out with his book *Morphic Resonance: The Nature of Formative Causation,* anthroposophists were saying, "See?" But no one ever claimed that prize. Someone could devise a seventh-grade-level experiment to prove that inherited characteristics can be seen physically—in other words, karma could be identified by a simple

physical experiment. This seems to be a great idea, but no one could devise such an experiment, because the inheritance of body types has a lot to do with somatic issues, and there are problems with this. With respect to color, the experience is in the soul, not in the soma. The miasm is actually in the soul and projected onto the soma through the life body.

With the color test, the irritant that came out as the most negative is not permanent. It may last for only a day, but your soul is like an onion. Maybe you are on the edge of a breakthrough. You might work with it, maybe do some paintings, and in the process paint your way out of it. I have seen people do this; they get to the middle of the series of the seven paintings, get sick to their stomach, lie down, and think, someday I will get back to that. They get right up to the edge of knowing that, with the next painting, they would have to change. They might have a dream, and something would shift, and they could no longer blame anyone else for their problems. They are having so much fun suffering and blaming that it is not worth it to be rid of the miasm. Who would I be if I couldn't blame someone? Maybe a bodhisattva.

So the work here is, when you find that irritant it is not just a random thing. It is polar to something. It is also squared to something. It is part of the gift structure when it is triangulated. There are ways to work around this by setting up color keys—using your irritant as what we used to call "the hammer" in painting. You take the three other colors; if you're irritant is green, you have a relationship between orange, magenta, indigo, and green, or what we call a *square,* and there is tension in that. If my irritant is a green, I cannot include green in my repertoire of responses. Green is *uber-adequate* and very practical. If I think being practical means getting a job or doing my taxes, and if green is an irritant to me, then doing my taxes is a copout. Getting a job is a copout. Paying my bills is a cop-out. Picking up my laundry from the floor of the bathroom is a cop-out. That is all green, because green means everything has to be in its place or I am not happy. Maybe the green I grew up with was so green that I couldn't put the wrong fork on the table for dinner. I am up to here with green—when I go near a green or someone gets me

to do green, I rebel because I believe that I don't do green. Basically, my miasm is preventing me from actually giving an authentic response, and that drives me crazy.

Therefore, if I want to paint my way out of it, I don't start with my irritant, green, or I will paint the first one and think, this is stupid. Instead, I go to the opposite color and start with the veil of magenta. I don't have to pay my bills. I can be creative. I am magenta. I am going to break through all this and dissolve it all with the heat of my rosy light, magenta. But I want to approach the green. If I make a frontal assault, paint a magenta veil, and paint a green over it, this is not going to work. Maybe I will sneak up on it—paint with orange, indigo, and magenta, with a little green in the corner.

Now I do the same thing but add green a little closer to the beginning of the process, rather than saving it for the end. If you keep a journal as you go, you see your responses to sensory experience. In pure thinking you find the self that can hold itself in check. If you have a problem with green, transform your thought into a picture and experience creative wisdom. Concentrate the feelings into light and bring them into consciousness. You reveal the forming power of...what? Green—it is something you want to avoid. You put that green in the first painting and get the forming power of the green. As a result, you might need to lie down because now you have a stomachache and your gallbladder is acting up. This process is a way to explore the miasm through art. Along with color keying, you can use this kind of diagram to paint images of your journey into yourself.

Colors are symbols of the challenges of constitutional beings and who we are. If we could understand their totality, our "I"-being could hold the whole together. This is the essence of this whole process.

11

Circle of Color

The next couple of chapters will deal with the color polarities in the diagram on page 162 as homeopathic remedies and the colors on page 163 as flower essences. We will see how homeopathic constitutions reflect what we now know about color. The forces of color are yearning. What is that yearning about? Being green is the light, and light in consciousness is thinking. In thinking, the ineffable manifests as a thing. That is what we call the formation of a thought. Thinking is a verb; it is an activity, not a thing. A thought is a thing that precipitates out of the thinking. Greening of the light is the light falling into matter, or substance. This is called photosynthesis—carbon, hydrogen, and oxygen in the presence of sunlight becomes a pigment.

Green represents a quality of light as a pole of thinking. I can put thinking as representing the color green in our soul life. The opposite pole in the soul is the will. I can designate will as the darkest dark, magenta—or the least conscious soul force. We have found that the mystery of the darkest dark begins in magenta and goes to the green, and then through green to the darkest dark on the other side of the light, where I have to turn around or be lost in space. When I turn around I am in magenta again, a great mystery. If we think about thinking as light and the will as dark, all the other colors are our feelings of yearning between light and dark. Yearning for what? Thinking is yearning for the will, and will is yearning for thinking. The will yearns for freedom. Thinking has freedom, but it has to engage matter. That is part of the great resurrection of what has fallen. There is this struggle in the soul among the tensions of thinking, feeling, and willing. Our color circle can be used to describe

soul qualities of relationships among the yearning for resolution between the separation of thinking and the will. Rudolf Steiner's great mantra is:

> Willing my thinking is freedom.
> Thinking into my will is love.

Willing my thinking is freedom means that in pure thinking we find the self that can hold itself in check, leaving us free to do what we need to do. To do this, we have to will our thinking—we have to control it by applying our thinking to specific things so that it doesn't go off into old thought habits. Willing our thinking means applying the will to create and dissolve thoughts through our own volition. When we do this, we free ourselves of compulsively repeating and automatic thoughts. This is the basis of meditative practice.

Once we do this and gain some control of our thinking, we step into the realm of power and the problem of power, because we have feeling responses to willed thinking; we become attracted to power because we can now control our thinking and, consequently, what we do with our freedom. This can get us and others into trouble or lead to the degradation of the mysteries. The downfall of the mysteries means that people are free to think; once we learn how to use that tool, we tend to go overboard with it. It is a great temptation to pursue power through freedom. The temptation of *power through freedom* also shows that there is a limit to human power and, with this, the moral impulse that along with willing my thinking I have to *think into my will*.

Thinking into my will is love means we begin to see the motives for *why* we will our thinking; those motives are usually less than noble. Cleaning up our motivations is the path to love. According to Rudolf Steiner, love means becoming so secure in myself that I can become vulnerable to others. These two poles are present in this twelve-tone spectrum. If you have a green constitution, you experience living in the light, but you also have to watch the light die into phenomena. You experience being one with the light and living in it. You are even transparent to it.

Color Wheel of Homeopathic Remedies

magenta — staphysagria
+ creative, inspired, charismatic, committed
− indignant, incised, wounded, fears the practical life, martyr, self-destructive

purple — lycopodium
+ tactful, benevolent, tolerant, charming, magnanimous
− a free mind with a fixed soul, habitual denial, aversion to change, supports underdog but undermines equals

carmine — pulsatilla
+ devoted peacemaker, seeks beauty, self-sacrificing
− easily crushed, fears anger, needs noticing, guilty conscience when angry

violet — sepia
+ transcendent soul life, deep spiritual roots, devotion to causes especially in the arts, self-reliant, candid
− estranged from life, avoids affection, soul sore, complaining

vermilion — sulfur
+ thorough, prolific, learned, direct
− self-centered, caustic, overwhelming, inflated

indigo — ignatia
+ highly intuitive, perseveres through obstacles, patient
− exaggerates inner drama, grieves unknowingly, numb to life

orange — arsenicum
+ very enthusiastic, loyal, organized, perfectionist
− driven, domineering, nervous, excitable

cobalt — calc carb
+ mystical, intuitive, loyal, deep self-knowledge, true believer, supports causes
− stubborn, brooding, afraid to act, fantasist, lives in the past

yellow — phosphorus
+ witty, high energy, learns easily, many ideas
− scattered, absent-minded, confused about identity, multiple personalities

turquoise — natrum mur
+ truth seeker, keen intellect, fair, just
− opinionated, bitter, relentless, loner, absolutist, unapologetic

green — silica
+ sensitive, rich inner life, capable, self-limiting, meticulous, practical
− apprehensive, anxiety attacks, seeks recognition but fears being seen

lemon — lachesis–nux vomica
+ competent, high ideals, diligent, organized, insightful
− spiteful when betrayed, aggressive to others, closet anarchist, irritable, conflicted over morals especially sex

Spokes:
- staphysagria / noble sufferer / Prometheus
- lycopodium/ driven detached/ politician
- sepia/ fisherman's wife/ sore soul
- ignatia/hidden grief/Romeo and Juliet
- calc carb/ 3rd son/eternal embryo
- Nat mur / truth teller/ Martin Luther
- silica/ sensitive server/princess pea
- lachesis/manager/ Jacob and angel
- phosphorus/actor/ Peter Pan
- arsenic/bulldozer/thoroughbred
- sulfur/philosopher/collector
- pulsatilla /Cinderella/ devoted soul

	green	lemon	yellow	orang	vermil	carmin	magen	purple	violet	indigo	cobalt	turquo
calm	+											
nervous	−											
happy	+											
sad	−											
confident	+											
fearful	−											
serene	+											
anxious	−											
relaxed	+											
tense	−											
centered	+											
restless	−											
pleasant	+											
unpleasant	−											
secure	+											
doubtful	−											
strengthened	+											
weakened	−											
positive	+											
negative	−											
total	+											
total	−											

magenta
star of bethlehem - emotional shock and physical trauma or loss. the world is threatening
larch - fear of failure - with great anxiety, inner life threatens

purple
water violet- aloof, arrogant, detached
chestnutbud-repeats mistakes, compulsive
beech-grumbler, satirical fault-finding, sarcastic

carmine
centaury-too devoted
holly-anger,suspicion, jealousy, revenge **pine**-guilty conscience and extreme self-blame

violet
gentian-pessimist /skeptical/ worrier
willow- bitterness/high expectations from life
wild rose-chronic boredom, indifference lethargy

vermilion
cerato-collects opinions, indecisive
vine - domineering,highly opinionated
wild oat - depressed, unsatisfied, restless

indigo
rockrose-terror of death /panic attacks
agrimony- hiding problems / enabler
cherry plum-terrified of losing self-control, suicidal

orange
vervain-idealist,perfectionist, missionary **hornbeam**-exhausted, distracted
white chestnut- compulsive/obsessive

cobalt
chicory- manipulative/ silent resentment
red chestnut- projects self-fear on others
honeysuckle-yearns for the good old days

yellow
clematis-daydreamer
impatiens-impatient
mustard-burned out, life is empty and senseless

turquoise
agrimony-hides fears behind cheerful mask
vervain, overly enthusiastic, hides alienation
sweet chestnut-absolute despair, debating with death

green
mimulus-sensitive,phobic anxious about specifics
heather-look at me dance hypochondria / interrupts
mustard-unexplained sadness/moody

lemon
scleranthus-talkative, superficial, inner conflict
rock water- ascetic idealist, dogmas rule
crabapple-obsessively clean, sees self as soiled

Wedge labels (clockwise from top):
- staphysagria / noble sufferer/ Prometheus
- pulsatilla /Cinderella/ devoted soul
- sulfur/philosopher/collector
- arsenic/bulldozer/thoroughbred
- phosphorus/actor/Peter Pan
- lachesis/manager/ Jacob and angel
- silica/ sensitive server/princess pea
- nat. mur / truth teller/ Martin Luther
- calc carb/ 3rd son/eternal embryo
- ignatia/hidden grief/Romeo and Juliet
- sepia/ fisherman's wife/ sore soul
- lycopodium/ driven detached/ politician

Welcome difficulty.
Learn the alchemy
True human beings know:
The moment you accept what trouble you've been given, the door opens.
(Rumi)

The heart is the key to the world and to life.
One lives in this helpless state in order to love and to be indebted to others. Through imperfection one becomes susceptible to influences of others.
And this alien influence is THE GOOD.
(Novalis)

Roscolux colored gels replace the old Roscolene series and are more durable than the older gels

Roscolux colors
14 straw
34 flesh pink
25 orange red
50 mauve
90 dk yellow green
383 sapphire blue
342 rose pink
49 medium purple
80 primary blue
83 medium blue

crimson / carmine 14 + 25 + 80
scarlet / vermilion 25 + 50
orange 50 + 14
warm yellow 14
lemon 14 + 90
green 90
turquoise 90 + 80
cobalt 383
indigo 383 + 49 + 83
violet (2) 383 + 25
purple 383 + 25 + 34
magenta 383 + 25 + 342

163

Homeopathically, green is silica—window glass. If you look into the edge of a piece of window glass, it will appear green. Silica is transparent, and silica people are somewhat transparent and very sensitive to light. As a result, they feel vulnerable to the light of their own consciousness and tend to build walls around it. However, those walls are invisible because they want to make walls that you may not be able to see, because they don't want to be seen; they don't want to stand out—they want to be like the grass. Silica people are very sensitive and willing to serve through their sensitivity, but if you try to get too close you will hit an invisible wall. Moreover, if you are a green person and try to get out of your green, you also bump into an invisible wall. Green personalities always bump into invisible walls, but they find it difficult to realize that they are the ones who made the transparent walls in the soul.

Think of a cricket in a glass jar. It tries to get out, but instead of jumping up and out, it keeps banging its head against the invisible wall. That is a picture of silica people solving a problem. When they hit the wall, they wonder what happened. They are living in the light of consciousness, so they are willing to serve others and don't have grand ambitions. However, they have an Achilles' heel because they are so sensitive; they are highly aware of the gaze of others. They spend a lot of time making themselves look good, well dressed, fashionable, and well coordinated because they want to be looked at but not seen. They are capable, detail-oriented people who love to keep things ordered. Silica is a crystal structure. If you want to see this fear of vulnerability and being seen in nature, look at blades of grass; individual blades are sleek and well composed, but they exist only as a collective.

Green personalities have a kind of crystalline beauty; their inner nature is to serve, to be competent, pretty, and nice, but inwardly they want walls to keep people at a distance. Paradoxically, however, they also want to be looked at and admired for their simplicity and elegance. This creates a conflict in the soul. They don't look outward, and don't even look inward, but *look at*. Their circle is where the light is, so they are very good at detailed organizing in their specialized realm. They make

excellent accountants and office secretaries. Their dilemma is seeing the light repeatedly dying into facts, so they satisfy themselves by organizing those facts. In homeopathy this constitution is "the angel." Serving, sensitive, and beautiful, but not very sensuous.

Green personalities have striking, fine features and are well dressed, but we never know where we are with them. They are not timid and are somehow in control. They are mysterious, but in a cool way. They have an aura of mystery because they are so open inwardly. They are so sensitive inside that they have to ward off anything that would turn them green, make them fall into commitment, so they can be obsessive about details, order, and structure. Silica is related to the skin, so they are prone to skin difficulties. They tend to get boils and sties and calluses on the feet or corns on the toes.

Silica, as a homeopathic remedy, is known as the homeopathic surgeon. If you have a stubborn splinter under the skin, place a couple of silica pills in a little hot water, hold your finger over the hot water, and let the steam from the silica pills penetrate. If you do that in the evening and cover it with a small bandage, it will be out in the morning.

Silica people tend to form "indurations"—little hardened areas of the skin that seal off because that is their nature. When this becomes chronic you get things like warts. When this manifests in a positive way, they do the work and serve; they are beautiful angels. However, when it becomes a problem in life, it becomes an irritation—it "gets under their skin." Silica types develop hard spots on their elbows, problems with their hair or fingernails, or sclera of the eyes—anywhere there are outer membranes. As a result, they can begin to act in negative ways. Your secretary starts plotting your downfall by "forgetting" things. They live in the light, but they also experience the light falling.

I am describing a delicate constitution and the color that these qualities represent is green. These personalities don't want to be out in front, because they know it will not end well. A typical homeopath would say that they might have offensive foot sweat. It is always in the shoes and no one will notice. They might have rippled nails. Fingernails are, in a way,

extensions of one's hair. Their conscience is troubled over trifles; they obsess over details. They have a yielding disposition, which sometimes leads to a faint heart. Homeopaths sometimes call them "oat straw." They will yield, but if they yield too much they become fainthearted and overly sensitive to outer stimuli. They may be prone to sleepwalking, during which they have anxious dreams.

These people live in the light, and the boundary between them and the spiritual world is ordered in layers. They have a deep yearning to get out of their prison of light and do wild things in the dark, but never will because they fear the results. Nonetheless, they have a yearning inside to do that. They can either go to the cold side or go to the warm side of magenta, becoming so "creative" that they forget to pay the bills. But magenta people are insanely interesting, because they continuously bring things out of the darkness that no one else is thinking about. We can follow this process on the yearning wheel of the diagram on page 163.

The next color, lemon, does not live in the light. The lemon personality has taken a step into darkness, which a green personality would never take. The consciousness of lemon personalities is about thinking, the light of thinking, but because they are living in one degree of darkness they want their thinking to be a reflection for everyone else. In a sense, they are trapped in the idea that there is something not quite right about the light of thinking in them, whereas the green personality understands this is just a cosmic thing—it is going to fall anyway, but if they protect themselves, they will be okay. The lemon personality, by contrast, has stepped away from the light into the darkness, and they never know whether their thinking is light or dark. Inwardly they suspect that their thinking is something to feel guilty about. They don't know what it is, but they know it is not quite right and experience a thin veil of darkness that only they can see. Green personalities have their transparent wall, whereas the wall of the lemon personality has a darkness that interferes with the light. Their tendency, or yearning, is that this darkness should be the way everything is. Green doesn't care whether everyone thinks the way they do or not, but for the lemon personality it is a problem. They

want everyone to use their thinking process as the model, and if everyone does this it means that their suspicion about the darkness is okay.

If we take another step into the darkness, we come to yellow. The yellow personality feels inwardly that they are so connected to the power of the light in thinking that they find joy in the fact that darkness actually creates this hue, because yellow is a primary color. However, they experience a double inner darkness. They have a hue, but yellow is the most vulnerable hue. If it is touched by any other color, it immediately begins to go green, orange, neutral, and so on. It is extremely vulnerable, but it is also very brilliant. Green personalities want to remain in the background, but yellow wants to be on the stage, to shine, and to radiate. They are comfortable with the darkness, but they want to gather a certain kind of knowledge, and once they get it they want to spread that knowledge to everyone who will listen. Thus we get this radiating energy of yellow as a color and as a personality.

The thinking of yellow personalities penetrates the darkness. They can take in knowledge, assimilate it, and shoot it out to others. Unfortunately, they cannot hold onto knowledge very long. They love to absorb new things and adopt them as their own, and then radiate it out. They take joy in the act of knowing but lack the capacity to organize that knowledge. There is little depth to their knowledge—no darkness or will in it. Their kind of knowledge is only a reflective light of thinking that reflects outward.

Taking one more step into the darkness, we enter a kind of balance, or fulcrum, point, with green at the beginning and magenta as our goal. We are now in the will, at orange. We saw that the yellow personality is interested in the experience of knowing and sharing that. For the orange personality, thinking and the will are in a push–pull situation with each other; knowing is about effort. It is not knowledge that is so important to orange consciousness but the effort to gain knowledge that satisfies. These people expect knowledge won at great cost will continue to exist and be correct. Orange does not collect knowledge but takes pride in the effort expended to attain perfect knowledge. Orange personalities rank

other people according to their ability to gain knowledge; they are like editors and copyeditors. "I think you made a mistake there, so why don't you go back and work it through." Orange editors are not interested in what you are writing about, but only about whether you used a semicolon in the right way. Orange personalities have a kind of split between their thinking and their will, and when they get it right, it is just great. They are very enthusiastic about things, because they have a kind of balance in them between their thinking and their volition. You can rely on them, because they understand effort of knowing.

Those who consider knowledge to be a commodity (our next step into the darkness) tend to hoard it. This is the vermilion personality. The vermilion person has made a commitment to the darkness and to the will. It is not so much the act of knowing but what happens in the act of knowing. The vermilion personality wants to get and hold on to knowledge as a commodity. Goethe refers to the vermilion constitution as scholars in his wheel of temperaments; they take great pride in their knowledge. However, they become trapped in the knowledge they have acquired. They become inflated, and a kind of darkness settles on them. They feel compelled to collect more and more knowledge. They might write an encyclopedia just to keep handy when they go out to dinner. Actually, they care less about the entries in the encyclopedia and more about their name on the encyclopedia as the one who collected the information. They do a very good job with the research and are proud of the fact that they collected facts and put them in the right order. They love databases. They are getting deeper into the darkness; they yearn to own knowledge, because they are getting more into the realm of the will, which is dark, and moving away from the realm of the thinking, which is light. Vermilion is losing contact with the light of the consciousness as it moves into the dark unconsciousness of the deed.

Now we take one more step into the darkness, the darkness grows so intense that we have shifted from radiating, as the previous colors do in varying degrees. Lemon radiates, whereas vermilion radiates much less, and actually pulls in to a certain extent.

With the next step, carmine first holds in and then rays out. Carmine lives in darkness but wants to radiate. The carmine personality is turning toward magenta, the very dark, and they have the quality in their will of being inwardly ardent. They are deep idealists and not concerned so much about knowledge. Carmine consciousness understands the need for people in the world who serve the greater good, even if there is no sign of gratitude for their service. They are at a kind of turning point in the deepest darkness. The cosmos is saying, We need a failsafe; we need people who live in this dark who can connect with that and resurrect it through idealism and humility. Because they are in contact with how the light of thinking lives in their blood, such people are inwardly beautiful and devoted. Carmine personalities are the "imitation of Christ" in a certain sense. They tend to sacrifice themselves, because they are inwardly ardent and yearn deeply for goodness in the world. This is a carmine, the color of blue–red venous blood that has absorbed all and is now returning to the heart.

The next step into darkness is magenta; here we are overwhelmed by the darkness. Magenta consciousness, if it is balanced and harmonized, is the new dawn. It is the harbinger of things far in the future that will come as a burst of creativity after a long incubation. This is the magenta ray before dawn in the clouds. Magenta people have the vision of the eagle; they are the "seeing-far people." They bring the greatest ideas to the world. They are very creative and gifted people. Well...we would call them gifted, but their gifts are narrowly defined. They may be virtuosi, for example, practicing the same Bach fugue every day for fifteen hours. They are having an inner experience that, when they do this on stage, their magenta light will become a religious experience for the audience. They will suffer, but they suffer nobly. If it is in balance and they can get in contact with the true nature of magenta and use it in the right way, they will bring great gifts into the world. The magentas are always on the cutting edge; they are the rosy fingers of dawn. However, if it gets clogged and the darkness they experience does not move when they create, they become indignant that they have suffered so much and critics are

panning their performance. When this happens, the magenta can become corrosive. They yearn to break through the darkness and will do so at any cost. They take great risks, usually because they have a vision that if they do not, nothing great will happen. A good picture of the magenta personality is Prometheus. His job was to create humans, but his brother Epimetheus used up all the attributes. *Prometheus* means forethought; *Epimetheus* means afterthought. Zeus gave the Metheus brothers the task of creating human beings. Epimetheus, the afterthought, used all the qualities to make the animals. Prometheus' task was to make humans, and when he reached into the bag there was nothing left. The only thing that remained was fire, which was taboo because it had to stay in Olympus. But Prometheus was a magenta personality, so he was willing to approach Zeus to get the fire. As a result, Prometheus was chained to a rock, where an eagle came each day to dine on his liver. "Eagle" is a thought—the thinking. Prometheus is a strong archetype of this creative magenta constitution, a noble sufferer.

Magenta suffers great injustices and great indignities, and if it is balanced you get a Martin Luther King, Jr. They push and are willing to go over the edge, willing to go to Selma, willing to go to jail. Magenta people bring cultural changes; they have fire in their belly and in their will that burns through the darkness. Martin Luther King had a lot of issues, especially with women. He was not just a preacher; he was a preacher man. On the other hand, he was bringing something in that had to come, and he paid the ultimate price for it. That is the magenta.

The homeopathic remedy for the magenta is *Staphysagria,* the delphinium flower. The delphinium has a corolla with a very long tube-like spur that goes into a little bulb at the end, where the nectar is. This is such a picture. The insect comes and has to go down the long tube to get the sweet. Insects need a long proboscis to do this, which bees do not have. When bees visit a delphinium, they have to hang upside down, make a little slit, and sip nectar through that. That is a Promethean image; let's be creative and make this work. The delphinium gesture is great penetration for a successful harvest.

Staphysagria — Very peevish. Easily wounded. Becomes indignant. Considers the least offence to be a premeditated insult. Hypochondriacal or apathetic mood, prefers solitude. Self-absorption. Thoughts vanish while speaking or thinking. Uneasy sleep and obsessive dreams of the previous day's works.

Staphysagria is often given as a homeopathic remedy for people who have had procedures in which an orifice has been violated medically—for example, a speculum used somewhere uncomfortable; an orifice dilated in an uncomfortable way; or surgery in which something has been incised and stitched up. The indignity of an incision and the stitches leaves a kind of trauma in the soul. This is especially true of extremely invasive events such as heart surgery or sexual penetration against one's will. The image is light that has been pushed all the way down to the bottom of darkness, and the darkness seals it over. You have to look through all the darkness to see beautiful, intense light out there; you have to squeeze the violet and the red together to make it come out. The quality of the Staphysagria is indignation at being violated. A homeopath would describe Staphysagria as a remedy for people whose constitution is easily wounded, because they already have an inner pressure yearning to break out. If you get close or hit the area that needs work, they are easily irritated or wounded. They might take everything as a personal slight. This is magenta.

+ **The Noble Sufferer,** Staphysagria — Creative breakthroughs are the gift of these intense souls to society. They are the "canaries" in the social coal mines. Great capacities enable these souls to intuit changes and trends far in advance. They produce groundbreaking works.

− **The Noble Sufferer** — The thoughts of these soul are intensely focused on a particular interest. Their will is to make a unique and selfless contribution to humanity. Conversely, they feel indignation at having to take the hit for the unappreciative masses.

Magenta personalities sleep easy, but sleep is also easily interrupted by obsessive dreams of the day's events. Inwardly, they are continuously

turning over their life, because they see their life being sacrificed for the greater good. They picture themselves as the "noble sufferers" for everyone, though they also feel that their suffering is unappreciated by most people. When their magenta personality is in balance, they hold onto creativity, do the work, and get it done. They also have lots of charisma—like Mother Teresa. You wouldn't have wanted to get in her way, because she would get it done no matter what. People who have charisma have a force pushing their rosy light out through the darkness, which is irresistible to others. When they have it under control, it can be transformational; if it isn't under control, it eats them up. That was Friedrich Nietzsche, the brilliant philosopher who started life on track. Rudolf Steiner became very interested in Nietzsche's work while working on his *Philosophy of Freedom*.[1] Nietzsche, however, got caught up in his own magenta energy, pushing the envelope philosophically and making increasingly radical statements. That is a magenta gesture—feeling violated and needing to lance the wound. They are charismatic and dream of saving the collective through the power of their inner life, but it sometimes overwhelms them.

Magenta personalities often need a green personality to accomplish what they need to do. Likewise, green personalities enjoy being in the aura of a magenta personality, because they then do not have to be the one out front but the power behind the throne. When Sergei Prokofieff[2] and his wife were visiting Rudolf Steiner College, I kept thinking magenta and green. He could hardly tie his own shoelace but he gave brilliant lectures, after which she would take him by the arm and walk him out the door and to their car. He was a great author and lecturer, and she protected and took care of him in daily life. That is the gesture of magenta and green in balance and working together in a positive way.

1 Steiner, *Intuitive Thinking as a Spiritual Path: A Philosophy of Freedom*.
2 Sergei O. Prokofieff (1954–2014) was a Russian anthroposophist, prolific author, and member of the executive council of the Anthroposophical Society in Dornach, Switzerland.

Circle of Color

We can see these personalities and combinations as pathologies, as gifts, or as challenges. When you have green or magenta as an irritant, you want to look to a personality of the opposite color as a complement. If your irritant is green, your complement is magenta. You are comfortable with people who are creative and unconventional, but people who want to stay in the shadow and avoid attention irritate you. Whatever your story is, look back to see whether someone in your biography had this kind of complementary gesture. You can even find old black-and-white photos of people in your past and hand tint them. It might seem odd, but can also be a release—a way of bringing a symbolic gesture to a photo of someone with whom you had difficulties.

Very often we have feelings that are not of our own making, and these colors represent ways to look at our lives. We can look at people in current or past-life situations as colors and opportunities. Even periods of our life may have included passing through magenta or another color. Picasso went through a rose period, followed by a blue period, then a black-and-white period, and then red, yellow, and blue periods. Is this random? He was burning through karma and casting off skins. Everyone around him, however, was collateral damage. Once Picasso had exhausted his process, he just wanted to be the grand old man of art history. In the works of artists, look at the color choices to see symbolic pictures of biographical gestures and their yearnings they had. Art allows us to see ourselves and heal. This is a useful way of looking at our biography.

For now, we will remain with green and magenta as two polarities. Thus, we return to green at the center of Liane Collot d'Herbois's grotto (page 139). We have the light of thinking—we are in the light. We take a step into the darkness on the blue, cool side. The yellow–red side is the warm side, which gives our inner life passion, enthusiasm, and joy. It is the way our will in the body works. The cool side represents the way our will in thinking works in the spirit. The qualities of the cool side, going toward deeper darkness, have to do with the gesture of turning inward. The quality of the warm side is yellow trying to radiate. Blue is at the periphery, holding in. Yellow is the sound "ee"; the blue is the sound "O."

The colors around the light are the sound "Ah." We have O on the cool side going to the periphery of the spiritual world and into the darkness. Red goes through the body into its deep darkness.

I am still trying to go to will, but there are two different paths. I start with light in the green and move a step into the darkness, into the turquoise. Those who have a turquoise constitution strive to align their thinking with pure, universal truth. They need to align with the truth because they experience the darkness of the light and want to make sure their thinking connects them with absolute truth. The color on the other side of the greening light is moving toward warmth. That color is lemon. Lemon personalities experience this darkness, but they want their thinking to be mirrored by everyone. Whether it is true is not important; they just want everyone to buy into their way of thinking. We all know people like that—it doesn't matter if it is true, but it is what I think, so we all need to think this way.

Turquoise personalities, on the other hand, in the darkness on the cool side of the light do not want people to mirror them; unless they are certain their thinking is absolutely true, they are actually somewhat of afraid of that. When turquoise personalities go into the cool darkness behind the light, they penetrate the spiritual ground of thinking as a universal truth. The lemon personality working in the warm dark in front of the light comes into thinking as a social phenomenon. They have no problem promoting their thought as the basis for what everyone else should be thinking. "I am the manager. Here are the rules for the way we do things." The turquoise person, by contrast, is not concerned about the rules—except that any existing rule had better be absolutely and forever true. Turquoise personalities will go to the end of the earth to find out whether something is true; they want to be certain that whatever they say will not be found false. This is their deep fear, because the light is darkening and they need certainty.

Recall how we entered the grotto through the warm side and moved toward the light. Once we moved through the light, we entered a mysterious space out in the dark. In our movement through the atmosphere

of the grotto, the blue side carries a different mood. We begin thinking as turquoise on the cool dark, behind the light side, and the first veil is turquoise. Now we take a step deeper and find ourselves in cobalt, a deeper layer of darkness. In cobalt, it is getting very dark. Now it is not about truth, but about having to align with the larger picture. We have to align our thinking with the forces of the periphery—all the things I know and believe in. They allow me to forget the scary part of being a human and believe that there is a purpose to life's craziness. Cobalt people are really interested in beliefs; turquoise people are interested in truth. Belief and truth are not the same. Cobalt people are interested in beliefs, and they find beliefs in what they learned in the past. When they go into the past, they feel secure in their beliefs, because they are certain that it is what happened to them. So cobalt people have a kind of childlike quality in the way they feel secure in a belief. Turquoise people are always on edge, because they want to know whether their belief is true or not? Cobalt people don't worry about truth, but about whether they can be true to their belief structures, so they value loyalty, for instance, over truth. They are very loyal people. We say they are true blue.

From cobalt we go another step into the dark, behind the light and toward indigo. In indigo we have the complement to orange, where knowing requires effort, but indigo does not wish to make any effort at knowing but wants only peace of mind. If this peace of mind is positive in the soul, indigo people can enter a room and, suddenly, everything there is touched by indigo's sober composure. When in balance, indigo people help to harmonize everything. They are deep, peacemaking people, but they do so unconsciously. Because they are inwardly ardent and idealistic, carmine people are peacemakers, but they don't do it consciously. In their experience, they have surrendered to a kind of death of the light in the deepening darkness. There is a kind of death force in indigo people. They are going deeper into a darkness and don't know where they are going. There is a constant mood of surrender to the inevitable. When balanced this is sober and soothing, but can be morose and depressing when not in balance.

With a step deeper into the darkness we find the violet people. They have been through a kind of death process in their yearning and are no longer concerned about worldly things. They have left the world behind and are living in a spiritual mood. They are deeply concerned about issues of the spirit. They live on the other side of the indigo death process. They live in darkness, and the light from the green in the center of the grotto shines only a little. The violet personality can see movements in the darkness without fear. They can read invisible movements of the spirit. They have capacity. This is H. P. Blavatsky, for example. They can look into the darkness and be very comfortable there, divining shapes and movements. However, they have a difficult time when they come into the world, because people don't understand what they have to relate. Thus, they tend to seek out people who will value what can be found only in the spiritual world. The violet personality seeks little groups that can discuss the spiritual life. Here we get Theosophy. It is the little violet berets people wear in certain spiritual communities.

Next, we step into purple, and now we are returning to the red realm. As violet turns away from the blue toward magenta, there is a kind of reversal in the purple. Purple personalities are not generally big thinkers but more interested in getting things done. They are connoisseurs of the will and have a nose for where the will is moving. They are networkers looking for recognition and connections, though they don't really want to do anything too physical to get it, because that approach takes too much time. Nonetheless, they know where the power people are, because they can sense the dark power of the will. Purple personalities go into the power realm to meet others, and suddenly everyone is onboard. The purple gesture is heightened awareness of how will travels through organizations and power. Purple personalities know just where to make connections, with whom to talk, and when to talk to them. It is all about connections and recognizing how one's will can be joined with the will of others to "get it done."

I am just making a general outline, but people and situations you know will pop into your head. I have given you the green–magenta polarity.

Circle of Color

This is archetypical; I come from the dark periphery and break into the light; I fall into green and move through it into the darkness beyond and meet magenta. Green and magenta form an archetypical polarity. That is why the split spectral colors meet in those two colors; they represent a kind of archetype of a becoming, whether incarnating or excarnating. That is our axis.

Later we will start with the square of our axis. We will explore indigo and orange, a square of green and magenta. In astrology, a square indicates tension. The way you work with your chart is to find your irritant and then you go to the opposite one. If it is positive and you are okay with that, you look at the squares to see if you know people who have issues with that. You know you're irritant is where you have difficulties, so you don't want to just wallow in it. Rather, it is a kind of focal point to find the tension in your life and the kind of people with whom you experience tension. That is a square. However, if green is my irritant it forms a trine with vermilion and violet, and those are the people likely to value your gifts and are most likely to be of help in life. You can make a map of the people most likely to challenge or to complement your irritant with gifts. This can happen because it is the great law of the soul that your irritant is also your gift.

People who have worked with this will say they like a certain color, but then when they look through the colored gels they become nauseous or angry and say that maybe they didn't actually like that color after all. Or they might find it is their irritant and hate that color, but then they eventually start working with it and come to accept it as a part of their learning in life. In the process of painting, you might start out being very irritated by a color, but through the process you can eventually go out the other side and it becomes a favorite color. Then a new color will become your irritant, because the human soul is like an onion. As we peel off one layer, another appears. There is always going to be an irritant. If we are ready for a change, we might have a physical reaction when we look at it, which usually means we are ready. We have pent-up energy. With painting we can work through the sequence. It might

actually be a physical body response—a rash or an old physical challenge that returns, but we are actually working it out, because the color acts as a homeopathic remedy, but at a very high attenuation. There are many ways to work with this.

12

Indigo

This and the next few chapters will discuss the remaining hues in the color circle as homeopathic constitutions. The test we worked with earlier is designed to trigger a response to one's miasmatic constitution. That is the purpose of the gels we use. We can accomplish the same with painting. However, we need to understand that, with painting, the hues may vary slightly according to the manufacturer. They are trying to make colors that look different from any other color on display. When we find watercolors similar to the gels, they are healing and useful for our purposes. For example, Windsor Newton makes the most healing colors in the range of cobalt, turquoise, magenta, rose, and the cooler colors of the gels. We could even do some testing and make our own tuned healing pallet. We would use little five-by-seven-inch watercolor cards to lay down veils of a color, and then look on the test and ask: Am I tired? Am I energized? Am I sad? Am I happy? Does it give me the same response? If the yellow we are working with doesn't do the same thing, then search for another one and see if that one does it.

With time and research, one can make a pallet that fits a personal healing modality. It becomes a pallet with which to explore one's soul. The color may give you a stomachache or a headache because your yearning was already at the maximum in that color. Maybe life has given you lessons that moved you toward an emotional need for catharsis with that constitution. If you look at the color for a while and someone asks you questions, it might cause you to recall something that triggers a response. That would probably eliminate that color for you as a powerful constitutional remedy if you were ripe. If you weren't ripe—if you recently had a

sickness or an event, then maybe that event, sickness, relationship loss, or someone passing away, or you lost a lot in the stock market—you might have a response that is not quite as strong or maybe a little mixed.

This is not cast in concrete. It is color. But if you use this as a research tool in your own life, you can construct a pallet for painting that leads to healing. Every time you decide you want to do a painting, your pallet is already speaking to you. This is the difference between Beethoven and Mozart in their pallet choice. What key did they favor? What is in the soul? Those feelings are the basis of your painting; you are pushing them around. That is what happens when you listen to or play music. You are adjusting the field of the turbid medium of all tonal wavelengths of sound, touch, color, and so on. If you are a gourmet chef, you use tastes adjusted for inner states. Thus, the presentation is a big deal; the reds and the greens need to be balanced; the plate needs a certain shape that matches, for example, the cut of meat. This is aesthetic experience. And if you are a wine guy, it has to have a nose, a smooth finish, and so on. So it is not just color, but I could say all of those have a colorful something to them that has to do with the most fundamental experience of color—light and dark.

Light is clarity; dark is the question. Between the two is the gray stuff of life. That is our soul. There is a hidden energy source in this, and it has to do with this idea in Land's experiment of finding the fulcrum between the short waves, the warm, the sympathy side, and the long waves, the cool, antipathetic side of the soul. The major–minor contrast has to do with finding the fulcrum between antipathy and sympathy. Antipathy is a kind of coldness, and sympathy is a feeling of warmth.

Let's start with magenta (page 181), the maximum darkness in front of the light. I become progressively warmer as I break through magenta and go through to the light, and then I become cooler until I reach magenta again. Is magenta warm or cool? Look at this from the perspective of sympathy and antipathy. Purple is cooler than magenta because it represents a movement toward the blue side. Carmine is warmer than magenta because it moves toward the warm side. Magenta is in the center.

```
                              light
  M    P    V   I   C    T    G    L   Y   O   V    C    M      enter
 max              next next                   next next max
 dark             layer layer                 layer layer dark
```

 dark behind light dark before
 light light

However, if we move to carmine, magenta is cooler than carmine, but vermilion is warmer than carmine, but carmine is warmer than magenta. So what is the truth? In human terms, magenta is a creative-will person, and that magenta person meets a carmine person, who is inwardly ardent. The creative magenta person meets a carmine person, who will interact more warmly, since the carmine person has a thread of devotion in the soul, while the magenta just pushes through the darkness almost in an aggressive way.

Purple in the context of magenta is cooler. Magenta works from a kind of Elohim consciousness that creates a whole new world. Purple wonders about the sort of connections that can be made to create something more useful than this new world, which is a little cooler than simply wishing to create. If purple, which is cooler than the magenta, then meets violet, then violet is questioning whether or not one really wants to make those connections. What's the motive for doing that? Purple is basically a politician. Is purple cool or warm? In connection with magenta, it is cool. In connection to violet, it is warm. Warm is sympathy; cool is antipathy. Antipathy does not mean hating or disliking something, but rather this is not for me. Sympathy, on the other hand, is a feeling of

warmth and openness. Thus, no matter how cool a color is, it is always warmer or cooler than the adjacent colors.

Now we will play a game. I am experiencing a kind of blue in your question. Now you are experiencing a blue. You are wondering what I mean by that. It is antipathy. It doesn't mean you hate what I said. Or perhaps you really get what I'm saying. That is sympathy. Antipathy is "I don't get it." I have to find out where the warm and cool is in the exchange. If we have known each other for years, I feel safe in playing a little game with you, but with someone I just met for the first time, I would answer this question in a whole different way. This is the soul.

I have had a great gift given to my life—having spent twenty-some years in the best laboratory I could ever have, watching adults interact in social contexts around esoteric questions. The work I am presenting here is the way I have survived. I have been able to enter a context in which all kinds of things are happening with a person and been able to listen and attempt an answer. Years ago, through my work, I started a little practice so I could make sense of an inner experience building in me. I started a little booklet made up of a collection of colored flames representing different persons. As I got to know those people, I would go into myself, taking them into meditation, and ask their Angel to give me a picture of how they would look if they were a flame? What colors would they have in their flame? I would make a picture in colored pencils of what a person might look like as a flame. What colors would be on the outside of the flame and what colors would be on the inside of the flame. When you look at a flame, you see that it goes from blue to red in the different parts of the flame, so I just made a drawing of the colors they might be if they were a flame. This was my practice for a while. Finally, I got it; the penny dropped. I started putting the colors around and making little lines connecting them, and that is what led me to the chart based on the earlier test we used. It started out as a collection of colored flames. If this person were a flame, what colors would it contain?

Astronomers use a spectrograph, a device that analyzes the wavelengths of the light from the star. Each wavelength in that spectrum

represents a metal that has been combusted and produces a particular frequency of color in a spectrum. This is the way scientists analyze the light of stars. The light of stars is what alchemists would call an aeriform metal. The light comes in from the stars, and the spectrograph shows it as a spectrum. Each substance produces its own color vibration when burned. When you get starlight from a star, there are all these colors, but they mix and match, because the light coming in is in a plasma form; it is an aeriform metal—a metal that has been vaporized to the degree that it ignites into light. That light travels through space, and our spectrograph tells us that star contains hydrogen, sodium, helium, or whatever. When those substances burn, they burn with characteristic colors. The secret of alchemy is that *metal* is a code word for sensory experience. When we transform metals in alchemy, it means we transform our senses, which is what I have been talking about in this book.

The warm and the cool of something are always relative. To determine this, I have to match it to the person I meet. Sometimes I do it by saying something shocking, and other times I just try to be nice. If I am in contact with and in control of my soul, I can choose which approach to use, because I have access to my full pallet. Sometimes I would first need to work out the right color through painting or working with color in some other way, because that is where we become adept at this. If you use it intellectually, it could be problematic. You can do a series of paintings and watch yourself resist your irritation. Your true self that lives in pure thinking will eventually provide pictures from dreams that will tell you why you have a color difficulty. You will be given pictures of it, and usually those pictures have to do with an opposition or square in your chart. The opposition usually occurs when your irritation is across from something you feel really good about. If you want to work with this and you start painting with your irritation color, you will not get very far, because it will look terrible to you. Now you go to the opposite one. You make a few veils of color and think that is great. Then you add the irritant as a veil at the end and watch it die a miserable death as it neutralizes, just as you thought it would. Then you write about it. What am I feeling

when I watch this color die? What does it represent in me? This is what you take into sleep. What is the one thin veil of your irritant doing in me? What feelings are rising in me under the impression of this sensation? You try to find a feeling for that and take that into sleep. It is like throwing a rock into the pond, which starts spreading ripples. You take it into sleep again and again, and this steers your soul toward that issue. The captain is on board, so it is not just chaos; you are watching your soul go toward the reef. The captain knows where the passage is. Pictures of relationships will come to you and feelings that remind you of your irritation color. Interesting physiological events might even happen, and suddenly colors arise from them or on your body that you never thought you'd see there. These are pictures of feelings surrounding that issue.

This is our polarity between dark and light, between magenta and green; maximum darkness is magenta, the will, and then the light is green. This is what we explored earlier with the grotto of Liane Collot d'Herbois. That axis is squared to the horizontal axis: indigo and orange. If I am in the light of green and moving on the blue side, then indigo represents a kind of flipside. As I am coming out of this warm side of the reds, I go through a kind of a green in the turquoise; green is starting to go toward blue. I reach cobalt, which has a kind of red note, and suddenly there is a flip and I am in darkness, because I am turning toward the red side away from the green side. I am moving away from the colors around the light. The colors around the light are lemon and turquoise, and the light is green. The colors around the dark are carmine and purple around the magenta. The colors around the light have their own kind of relationship, while the colors around the dark have their own relationship.

You may have an incarnation in which you are modulating your soul around the colors of the light, and for a while you were turquoise, and then you became lemon and then green. That other side of the spectrum is terra incognita to you, because you reincarnated to work that out. Alternatively, you spend all your time in the purple, carmine, magenta realm of creativity, running the political pack for some big shot as a

creative political analyst, because you are devoted to the party with no real notion of serving and truth. You live your whole life circling in the darkness.

That is our polarity in this chapter—a square of the one in the previous chapter. Squares have tension. Our axis with magenta and green is an archetype, but now we are going to square that: magenta, indigo, green, and orange. Those four colors create tension with one another. If you did a painting with them, it would feel uneasy; we would find it difficult to control a painting with a magenta, green, indigo, and orange color scheme. This square axis; indigo and orange form a kind of midpoint between these two polarities of the maximum darkness and the maximum light. We have transitions in indigo and in orange. In orange and in indigo we have a contrast between the light and the dark that creates a balance. In indigo, however, I am moving through the cool side, and in orange I am moving through the warm side. They are opposite each other. These kinds of transition lead to a lot of tension in life.

For orange people, their whole life is about enthusiastic efforts to make the world perfect. If you get in the way, you are going to be neutralized. Their enthusiasm for the world arises from the tremendous power they have between the light in the dark, between thinking and the will, which they bring together. These are people with a cause and a mission. If you want something done and want it done right, find an orange person. They are development people. They take on projects for causes, and their life revolves around them. They are idealists and get a tremendous amount done in a short time. However, they also lose energy in long-term projects and become frustrated. With short-term projects, they will be up day and night for a whole week for a cause, but then they collapse because of the tension of the light and dark. Their enthusiasm cannot be doled out in little bits; it comes in torrents, as very short bursts of very intense energy. Homeopaths call them the thoroughbred. The gate opens, they run a mile and a quarter, and they are happy. That is the picture of the orange person—the power of the red, the darkness, but also yellow, which is flighty.

On one side of orange is vermilion, the will side of orange. The yellow side, the radiating side, handles situations that require slogging through the many small imperfections, especially in the face of incompetence or focus on the wrong details. Ask me a question, and I will blow up and say crazy things, because I have exhausted my psychic energy by making things perfect. We can feel the orange as this kind of light–dark oscillation. When orange is in balance, it is perfect. It is the greatest enthusiasm in the spectrum, which is its great gift. When things get tough and have to be slogged through and this personality has to experience the chronic side of life, they would really prefer to deal with acute situations. Orange personalities just want to deal quickly with the issue and then go rest for a while. That is the orange.

Look at the homeopathic qualities—Arsenicum album, which is essentially arsenic.

> \+ The Perfectionist—Arsenicum album. This soul brings the gift of perfection into the realm of the will. Projects undertaken by this highly idealistic soul are sure to be accomplished with dexterity and integrity. These souls make dedicated editors and development persons.

> – The Perfectionist—Arsenicum album. This soul couples intensely focused thoughts with a will that seeks complete control. With a withering verbal barrage they can make it clear that they do not tolerate less than perfection. Their feelings often cycle around control issues.

If you make a homeopathic remedy out of arsenic, a virulent poison, and give it to someone, that person will have a kind of photophobia, meaning the light of idealism becomes a little too exciting. There is so much energy in these individuals that light gives them a headache. Light makes them start to cycle, so they prefer to work in spaces that are a little dark. They are prone to sneezing and may complain about the quality of seaside light. They are very sensitive to light and are restless. They are finely tuned to what is not perfect. They make fierce, exacting copyeditors. Their digestion can be compromised by their

great restlessness. When in balance, their enthusiasm carries them and everyone else. In a meeting, this person is the gusher; when you come to this person, you get the whole story—volume up with enthusiasm for the cause. They have intense anxiety and great restlessness and are the restless-leg people at night. They cannot settle down. They fear being left alone and crave having someone to go to. When they are left alone, they become anxious and want someone to check on them, because their great fear is getting caught in a mistake. If they make a mistake and that brochure goes out with a typo, it's the "end of the world." They tend to break out in cold sweat when afraid. They are very hot, but then go cold, with hot–cold extremes. Women at a certain period of life—during menopause—experience hot–cold swings and experience restlessness. When they are on, they are totally on; when they are off, they are totally off. These are the orange personalities. Looking at where they are in the color circle, we get a picture; they are caught between light and dark.

On the opposite side we have the indigo personality. Orange is all about effort, but the indigo is into peace: Just let me be. The indigo has lost enthusiasm for trying to reach perfection. the Homeopathically, the indigo personality is frequently Ignatia Amara:

> **+ The Broken-hearted Lover,** Ignatia — This soul tone is a temporary condition brought on by unrecognized grief. It is often a soul block that masks the true constitution.
>
> **− The Broken-hearted Lover** — The feeling mood of this soul is unconscious and inconsolable great loss. Confused thoughts revolve around a blow of destiny that seems beyond their capacity. This is a temporary combination of sorrow, loss, and shock.

Sometimes a person experiences a loss that comes as a surprise. The surprise catches the person off-guard, whose constitution then moves from irritant to the shock of loss. Such individuals experience the loss but don't understand why it happened; they don't have the capacity to understand why it happened, so it just gets buried and layered over with many

other colors. But it becomes an irritant hidden very deeply—a chunk of something down in the soul so that, when they try to get on with life, they cannot muster the forces of the life body. There is a kind of veil over their life. They cannot remember when life became so gray, but they know it did. Their family has become something to bear instead of a source of soul nourishment. Their work becomes an uninspiring and dreaded chore. Whether caused by a loss of face, money, partner, or position—whatever it is, their enthusiasm is replaced by a hollow feeling. Life becomes a lacuna of unresolved grief over the loss of what life "should have been." I thought we were going to be together forever. I thought I would have money forever. I thought I was going to have this position forever. People retire and suddenly feel irrelevant. But people have to grieve the loss to find the new.

The indigo represents a kind of veil that comes over life and the homeopath looks at Ignatia as a kind of temporary replacement of one's characteristic disposition. Now, if the indigo soul is balanced, these are the people about whom others say, "Oh my God, I don't know how they survive!" They lost three children, or they lost husbands; they went from living in a mansion to living in a mobile home. People in the community go to their home to talk to them, because when they go in that house they leave feeling great. Why? The indigo person does not judge. These are the balanced, beautiful indigo people who serve the community because they have seen so much loss in their own lives. And you wonder how it happens.

Indigo represents grief that may be unconscious and unresolved and acts as a kind of veil over one's true constitution. A good picture of how this works is the story of Romeo and Juliet. Everyone is dying because each thinks everyone else is dead. No one is actually dead, but then everyone dies anyway. There is an indigo mood in that story. If they had only realized the truth in time, they could have healed. That is indigo. Ignatia is the effects of grief and worry. Those in need of Ignatia have extreme mood swings, but they are very underplayed—unlike the volcanic vermilion. The changeable moods swing between worse and a little

better. They experience twitching facial muscles. They have insomnia. They yawn because of tension in the musculature. There is tension in the body because energy is being blocked by their inability to grieve the loss of which they are unaware. They think they have already grieved, but they haven't actually released it.

So they have this kind of stuck quality—they yawn; they have spasmodic, unproductive, and nervous coughing spasms. In the middle of conversations they have to clear their throat with nervous coughs. Their intense though suppressed grief gives them a feeling of anxiety, as if they had somehow committed a crime. If it is not in balance, they have the feeling that they did something evil, though they don't quite know what it might be. In the middle of going through something, they will ask, "Am I a bad person? Did I do something wrong in my life?" They don't quite know whether they did or not. Grief following loss, grief of children being punished by parents for things that the child doesn't understand—this can start very early. Perhaps your parents were extreme with you and you never knew why—for instance, being punished for bedwetting or nail biting. Or after a beating the child, the parent says, "Now look what you made me do." This leads to an indigo mood, because such children never feel they can use their energies in the right way. It clouds their will and they grow up feeling they are always wrong. It is the expression of unrealized, ongoing grief. If they realized it, they could say, "This is not my problem; it is your problem." But they cannot do this because something won't allow them to turn their will in the right direction. So they are sad, quiet, and melancholy. The homeopath would say, they weep tears inwardly. You can sometimes hear it in their voice; when they speak to you, it is almost like they are crying. They are grieving, but do not realize it. They just think they are to blame, and they may find people in the world who are very willing to cast blame on them.

These two poles now represent a square to magenta and green. If you take those four colors and make a painting, you would experience the effect of a square, which means that nothing is quite settled. As an

experiment, we might put those four colors on a pallet and use them to make a painting. We will become a little frustrated, because they just don't want to talk to each other in the right way. That is what we call the mood of a square. There is a tension in the soul.

13

Turquoise

We have the idea of a square. When you want to work with your chart, you go to the color you like least. If there are two colors you dislike equally, the one opposite the color you like neutralizes that one, so go to the worst one with no positives. You are looking for the absolutely worst color for you. If you dislike turquoise and yellow, and for both you had seven negatives, but from the yellow the opposite color would be violet where you had some positives. That means you already have some neutralization of yellow. If you have a positive on the opposite color, it means you have done some work. But you may have some neutralization and yellow is still mathematically the one with the most negatives. You want to get the one with the most negatives.

People come to me and say, "This is the color I really love." And I say, "I don't care what color you love; I want to know which one you cannot tolerate." The one you cannot tolerate is the representative of the miasmatic risk. This is all risk–reward; how much am I willing to risk to get a reward? Risk–reward is the basis of the limbic structure of my feeling life. My reward is sympathy, and my risk is antipathy. How long can I stay in a relationship before that transforms into something else? How long can I keep doing something before the law of diminishing returns kicks in? That's when I am no longer willing to take that risk. That is color. That is the antipathy–sympathy: cool and warm. Reward is warm; risk is cool. When I look at my chart, I want to find the color that represents for me the greatest risk with the least reward. If you have the highest risk in the lowest reward, it represents an issue you are working on in your life. Look at your chart to see if there is another color that

is very negative. Do you have anything positive on that one? If so, but not as much, then that is probably the most negative. The most negative is where the itch is. What I am describing is a process for constructing a healing painting protocol.

The process involves seven five-by-seven-inch pieces of watercolor block. We will work with turquoise and carmine for this painting process; this is our new polarity. Supposed turquoise was your irritant, perhaps because you grew up with a turquoise person who drives you crazy and you vowed you'd never be that, and now you are finding you are. It is probably your gift, but it is also driving you crazy. Or it might not be your gift at all, but you married one because you grew up with one. Now you wonder: *Why did I do this?* It is not your gift or issue but an irritant in your life because it reminds you of someone you grew up with. Or maybe you got a job and your boss is like one that you grew up with and your relationship is fine. Or your job reminds you of a task you thought was onerous for someone else. There are lots of ways to analyze where the irritant is. It usually shows up as the most negative, and it may be your irritant *du jour,* depending on whether you work things out.

This has to do with turbid medium; your soul is trying to find the fulcrum in a sea of wavelengths. In the experiment we want to find out, if I put my bait in the water, am I going to get the big fish or just a nibble? If I pull it up and it has fourteen eyes on it and it starts to sink my boat, am I going to just cut the line? If I find that turquoise is my irritant for some reason that day in the colored gel test, I don't want to start my regimen of painting with a veil of that irritant color. I don't want to start with that irritant color because I want to watch that color intrude into my settled color scheme. I want to be able to watch the feelings that arise in me under the impression of a sensory response to something I have identified as my irritant. I want to watch myself respond when my irritant enters an established schema. I want to create in myself a meditative mood in which I feel sympathy and harmony, and then add one veil of the irritant at the very end, giving myself all of the support of the opposite.

If turquoise is a negative and carmine was indifferent, I didn't feel good or bad about carmine. You don't have any issues around devotion or people who are idealistic; that is carmine. People who are turquoise are realistic and pragmatic; those who are carmine, the opposite color, couldn't care less about pragmatism; they just want everything to be nice. They want everything to have the aura of devotion, because they are in contact with their blood, whereas turquoise people are in contact with their nerve. So if turquoise was my issue and carmine was neutral—I had a couple of hits but not the same number—I would start with six veils of carmine on a five-by-seven-inch sheet. We use these sheets for this exercise because we don't want to get lost in a larger sheet of watercolor paper to do an exercise. We are merely fishing to see if the irritant really is an irritant. Later, if you find the color is an irritant for you, then make a big painting out of it; explore it as an inner landscape and work with it therapeutically. What I am suggesting is not art, but it is aesthetics; you are using aesthetic judgment to watch how these colors speak to each other, but this is not about art.

Start with six veils of carmine, and then add turquoise over them. Watch turquoise interact with the carmine. Then write about it. Duplicate the painting before you go to sleep in an inner picture process. Watch yourself paint six veils of carmine and then add number seven, the turquoise. Observe what happens and take that into sleep. You are putting a seed into your dream life. The seed goes from you and into the spiritual realm where the color beings live. The great color beings live in the cosmos as a blueprint of processes in my soul life. Cosmic color beings take the will force of my inner picture making, make dew out of it, and give it back to me as a dream, which leaves a feeling of Gestalt in the morning.

At some point, we will use another five-by-seven-inch card to paint five veils of the carmine, one veil of turquoise, and then another of carmine. In this way, we will embed the turquoise into the carmine. Rudolf Steiner spoke of the different levels of elemental activity that occur when we embed colors within other colors. They interact in a different way. Five of the carmine, one of turquoise (that is six), and another of

carmine, and then we will write about that. We are embedding the turquoise, the irritant, into the color we tolerate. It is like getting an allergy test in which something is embedded under your skin and you are asked to return in a week. After you write about it, you take it into sleep. In our third session, we paint four veils of carmine, one of turquoise, one of carmine, and another of turquoise. Turquoise is layered into the carmine, so you are "inoculating" yourself with the irritant and watching it interact with a color that you normally think is okay. Embedding the irritant this way might bring up feelings you experienced around the dinner table when you were three years old. Colored layering brings on memories of a mood similar to those when the irritant was first settling into your soul life. Whether four, five, six, seven layers; you are just starting. You always start with the color that is okay. We started with six and one, and then we buried it and kept burying it until the intrusive color is where we start and the accepted color now begins to seem intrusive. That comes at the end. Let's begin with three or four veils of turquoise and then add carmine. Just cover the whole card with the color; you want to swim in it.

I have a doctor friend who is a real curmudgeon. I was doing a color course years ago and he was there. Throughout the course, he would come to me and say it was just bull. I said okay and asked him to try it. I threw down the glove. I said you are a doctor, and this is a healing modality, so give it a try and prove me wrong. It was the holiday season, and over Christmas holidays, the Twelve Holy Nights, he decided that he would do me one better. He would do a series of twelve paintings using this process. He was going to modify this. I told him to go for it. He got about halfway through the first one, and he came down with serious flu symptoms—vomiting and headache. He was down for four days, and then he returned and tried to paint that next one. He couldn't do it. He couldn't paint that next one. He returned the next year for the course. He wanted to know what was going on. I asked if he'd had an event, and he certainly had. I told him that he would have to work his way through it. He is a person with a lot of will, so during the next Holy Nights

he worked his way through that one and started to get sick again, but worked through the middle and out the other side. He experienced all of his feelings about the death of his mother; he had thought there was no problem. He went into the process and came back with a huge explosion of color. He became a fanatical painter. Every year at that conference, he would come with all his paintings he'd done during the Holy Nights with such amazing colors. He was a gifted colorist, but he had a lid on it for a long time.

What I am describing here is a little like jazz. You start out in a certain key, and then you wind up in a whole different place. So what I am describing will get you to the middle. If you get there and it becomes an issue for you, just practice layering one veil of the nice color, one veil of the irritant, one of the nice color, and then another of the irritant. That is the middle. You build yourself up slowly. But in the middle you just keep doing it until you can feel these two colors pushing at each other. Put twenty veils on there if you have to. Do that and keep writing about it and keep taking it into sleep. Somewhere along the line, pictures will start to come to you. Your thought will be made into pictures, and you will experience creative wisdom. You will experience the wisdom of what the colors and processes mean to you. You will begin to have insight into why that color was an irritant. Your irritant is hiding your irritation about your irritant; it is hiding its gift. Your wound is your gift, but you have to free it from belief structures before you can take the energy hidden in it.

Start with the turquoise and add the carmine to it, and see if it doesn't act as an intrusion. The whole issue is that the intrusion comes into the established situation. You think of it as an intrusion because it threatens the lid you keep on the irritant. It threatens the way you have your soul structured, causing you to shift your fulcrum, but you don't want to shift your fulcrum because you know you are going to have to include that wavelength. You don't want to do that, because you've already decided why you need the pathology. But maybe you do, and maybe you don't, but that is the technique of the painting.

This is research; it is not fixed. There are many ways to do this—it is cool compared to the warm, but warm compared to the cool. The reason I am bringing this in the way I am is that this is just a research idea. I have been able to work this out for some twenty years with people and have seen how these things operate. If you take a homeopathic remedy while you are doing this, you get more bang for your buck from the homeopathy. If you know a eurythmist who practices tone and color eurythmy, that can work as a complementary modality, too. You can also take different colored foods and arrange them in a certain way. Painting is not the only means, but with painting you are fishing to see if your irritant actually is the one. If you get in the middle of the painting sequence and issues start rising to the surface, you know you've hooked something and you have to work. Maybe you can find food to work with or a homeopathic remedy. Later, we will discuss flower essences, which is a whole different way to do this process.

Let's look at turquoise and carmine as a polarity. Turquoise is one of the colors closest to the light in the grotto diagram. The light is thinking. With lemon, the other color closest to the light, the mood is: "I want everyone else to think as I do." This constitutes a veil of darkness over the light of thinking. It is, in a sense, a veil of egoism. With lemon, one's personal thinking needs to be mirrored by everyone else. Lemon is on the warm side of the light. On the cool side of the light is something similar, but it is not one's personal thinking that needs to be shared by everyone; with turquoise everyone needs to think the absolute truth, even if this is unattainable. It is a shadow over the free light of thinking. With the lemon personality, on the other side of the light, thinking is not about truth but about social beliefs.

A reporter interviewed a recently elected Republican member of congress. The reporter asked him about his agenda now that he had been elected. He said that his agenda was to make Democrats think properly. The reporter said, "Well, what is that?" He responded, "To think like Republicans." That is a lemon personality. Everyone is going to think like me, and then we will have it all solved. On the other side is the person

who has an issue related to thinking, but it is not about everyone thinking as I do. Rather, everyone needs to think the truth. With the turquoise it is not just about what I think; turquoise personalities go to great lengths to think only thoughts that can be proved true. If they find the truth on which to base their thinking, it doesn't matter to them if everyone else thinks as they do, but if they find themselves confronted by untruth they can be counted on to correct that untruth directly according to painstaking research. It is not as if everyone has to be a truth seeker. If you want to be ignorant that is your business, but if you are going to work with a turquoise person you need to get to the truth. That is a turquoise.

The movie *The Tree of Life* (2011) is turquoise–carmine story. The father (played by Brad Pitt) is turquoise; the mother (played by Jessica Chastain) is the carmine. The mother is a beautiful, very delicate, sweet mom who has three boys and lives in Texas. She holds them, plays tag in the yard with them, and is totally in love with them. But she is very delicate and inward and holds her children in a kind of ideal world—she wants to keep them as children. The father is an engineer who designs airplanes and equipment. A turquoise, he takes his oldest son across the lawn. The boy is supposed to be pulling dandelions out of the lawn, and the father has him by the neck; they are walking, and he goes, "huh- huh- huh," while pointing to the dandelions the kid missed. They reach the edge of the lawn, where there is an invisible line between their property and the neighbor's. He lets go of the boy, who crosses the line, and the dad gets upset—"That is the line!" That is turquoise. If you are a turquoise person, you will probably not like that movie, because there is little indication of what is happening other than innuendo and symbolic nuance. We were walking out of the theater, and the person in front of us said, "My God, I feel like I have been to church!" And the guy behind us says, "I'm getting my money back; that was a complete waste of time!"

For the turquoise nature, the homeopathic remedy is Natrum Muriaticum (or Nat Mur), table salt. The Nat Mur constitution is like a pile of salt. The remedy is made by taking table salt and running it through the homeopathic process to make a dilution. There are implications for

the Nat Mur, or turquoise, personality that gets embedded in this world of truth. The persistent angst over truth eventually creates what I usually call "the ice prison." There is something in the Natrum Muriaticum person that is very interesting to me. I have known many, and they all have a relationship to music. In the film, the father plays the piano, and the son has to turn the pages in church for the father.

I once knew a woman who had perhaps the most natural clear, silver soprano voice I had ever heard. When she was a student, she would walk around campus in a turquoise sweatshirt, turquoise sweatpants, turquoise sneakers, and turquoise earrings. I used to say to her, "You know, a little pink would be kinda nice," and she would give me a go-to-hell gesture. One day she came to me and had the tiniest imaginable pink ear studs. I said, "I like your earrings," and she said, "Shut up!" That made me think something was going on. Then, a handsome young guy came and put his arm around her and said, "Hey, good morning." Suddenly she was coming out of her tower and down into the carmine world, the other side of herself. Breaking away from one's belief that truth is the only important thing can be a potent challenge. Her turquoise quality prevented her from being *in* life. She was so turquoise that she could not tolerate any aberration in life—and she knew it; we talked about it. She was somewhat brittle. That is what happens to the father in *The Tree of Life*—he is incredibly brittle, but you can tell he feels for the kids, but part of him cannot allow things to cross the line into carmine devotion. This is the turquoise prison. Nonetheless, if you want someone who is the paragon of truth—someone who can design a perfect airplane—you look for turquoise people, because they take great pains to keep their inner life in order. When they give you an answer, it will not be arbitrary or random. It will be true.

14

Carmine

> Jachin, *The Pole of Life into Death:*
> thought–salt–wisdom–the descending forces–autumn
>
>> In pure thinking you find
>> The self that can hold itself.
>> Transform to picture the thought
>> So you experience the creative wisdom.
>
> Boaz, *The Pole of Death into Life:*
> life–sulfur–love–surrender–the ascending forces–spring
>
>> Intensify feeling into light
>> So you reveal the forming power.
>> Concretize the will to being
>> So you create in world being.
>> (Rudolf Steiner)

The turquoise personality, or turquoise constitution, is salt and has a tendency to want to salt the world. Alchemically, salt means to make a precipitate, a crystal. The consciousness of the turquoise is a crystalline truth-centered consciousness; everything in the salt has to think and act according to what we could almost say is an obsession with what is true or not true. Facts are a big issue to turquoise types. The lemon personality, by contrast, is not so interested in facts. Lemon personalities are near the light, so the issue (in common with the turquoise personality) is about the light of thinking. However, in the lemon soul it is about the power of what I know and what you don't know. Thinking takes on the mood of a

social issue, because in the warm colors the soul is radiating outward. In the cool colors, the soul is raying inward.

The veil of darkness for a lemon person becomes belief structures. They don't care if they are right or wrong; they just want to feel the power of the belief and who the belief will be able to move around and what kind of group they can join, in which the power of shared lemon beliefs can forcefully move others. This is Tea Party and its mood of political dialogue. For the lemon personality, one's personal thinking must be accepted by everyone. They don't care if their opinions are true or not, so they feel empowered to twist them in any way that makes things happen so that more people think as they do. It is the mood of a single veil around the light—the same level of irritation, but the lemon personality is worlds apart from the lemon personality regarding facts and truth. This is why music is so interesting to turquoise personalities; to them it is simply mathematics, the ultimate arbiter of truth. That is the consciousness of the turquoise. The cycles per second of a B-flat are different from B-natural.

By contrast, a lemon soul would look for the right song for emotional use at a propaganda rally. When a turquoise personality is balanced, you can go to them and they will give you the truth. When turquoise is not balanced, you can go to them and they give you the truth. They'll give you the truth no matter what, even if it hurts you. I overheard a Christian Community priest say something to another priest that caused the other priest to respond that he couldn't talk to another person that way because it would be hurtful. The first priest said, "I don't mind being hurtful as long as they get the truth." That is a turquoise sentiment. I will tell you the truth, even if it hurts you, because truth is what it is about.

We considered the lemon personality in context of the turquoise. Now let's look at the personality opposite to the turquoise—the carmine personality. Turquoise is concerned with truth; carmine is concerned with beauty and goodness and will hold truth in abeyance if it makes things good. Carmine personalities have a connection with their blood. The

turquoise is connected with their nerve. In the blood, it might be this and it might be that. What is most harmonious and beautiful? They are both idealistic, but the idealism of the carmine is a kind of social idealism, whereas the idealism of the turquoise is more philosophical. The carmine persons, in their social idealism, are very willing to sacrifice themselves in extreme ways so that the good prevails—harmony shall prevail; beauty shall prevail. These are the soccer moms who volunteer to drive the kids wherever they need to go; they bake the cookies, handle the money at the gate, collect the chairs, and clean up afterward. Then they go home and cook dinner. Why? It needs to be done. Carmine personalities are the engines in the social realm of devotion to goodness. Their homeopathic remedy is Pulsatilla, the windflower. Look at the homeopathic qualities:

> + **The Peacemaker**, Pulsatilla — Society owes many thanks to souls with this constitution. They seek blessedness and harmony as a self-evident native state for all humanity. Diplomats, legislators, and humanitarians of all kinds are among the peacemakers.
>
> − **The Peacemaker** — This soul's thoughts focus on the highest ideals. Their feelings oscillate between elation and frustration. These souls are willing to make any effort for reconciliation where there is conflict. Their will becomes self-condemning when their efforts fail.

The peacemaker—these are Mothers against/for some cause. It is peace, no matter what. My son lives in Berkeley, and after a mountain lion mauled a jogger on a running trail the authorities tracked it down and shot the lion. That triggered a week of mountain-lion-equality protests at the university. It is very carmine there, and carmine personalities are willing to put their guts on a rock for the sake of beauty, peace, and harmony. When they do this, they have an inexhaustible source of devotion, because they hold the ideal and believe that holding their ideal and devoting themselves to it will eventually win out. Because their ideal carries truth at a high level of heart thinking, they may have to rearrange facts a little to make things happen. This is not philosophical truth but a kind of emotional truth. It is big-picture truth.

Pulsatilla is called the windflower, an "oscillator." In its environment, it blows this way and that. It lives in mountain passes where there is a lot of wind, and to survive it has to be able to bend in any direction, thus the name windflower, meaning it will go in whatever direction the wind is blowing. The characteristic of Pulsatilla personalities is this: when they are out of sorts and experience pains, they call the doctor to explain the problem, and the doctor says I'll see you tomorrow. They get up the next morning and the pain is somewhere else. It is just as severe, but one day it is in the head and the next day it is in the little toe. The pain varies and changes, because it moves through their body along what acupuncturists call *meridians*. Pulsatilla–carmine personalities are very sensitive to change and are willing to go with change because it is the way they get things done. When carmine is out of balance, radical change dominates, and it is difficult to gain stability. Taste in the mouth changes; menses are intermittent and changeable; pains in the body shift; moods are changeable and contradictory; they experience sleeplessness in the first half of night and then sleep soundly and cannot wake up in the morning.

These are Pulsatilla persons. They have a very delicate digestion, especially for things like fat, because the fat requires the gallbladder to do extra duty. Nonetheless, when they feel out of sorts they still say yes to driving the soccer kids for the next three months and, when they get tired, they get upset that they are tired, because people might think they are not carrying the weight of their idealism. Maybe they are the ones who harangued everyone into having a soccer league, and then no one wants to drive. Carmine idealism pushed the issue, so now they overcommit themselves to carry through. Then they get tired or maybe something little changes in their life, but that little change requires greater oscillation. Then they start to feel resentful and angry, but that is not beautiful, so they become resentful and angry at themselves for being resentful and angry... and on it goes. They remain inwardly ardent until that inwardness becomes so contracted and overwrought that they just have to shut it off and/or break down.

Now the turquoise and the carmine, these two types, are everywhere in anthroposophic circles, especially in Waldorf schools, because esoteric work is a path of devotion and cognition. So these polar opposite paths somehow need to come together. When they are out of balance—we see husbands and wives in these situations; everything is happy when they come together, but if something has to change, Pulsatilla can go overnight from sweetness and light to venomous. One wonders what happened—when did all this idealism suddenly become conflict. Turquoise personalities get conflicted out of the truth, because with their experience of truth, they start hurting people and they have to build up a kind of wall of belief, saying this hurts me more than it hurts you. I am sorry I have to tell you the truth, but eventually you will thank me. That is turquoise consciousness.

Now go to the square of that polarity—violet and yellow. Turquoise, yellow, carmine, and violet are squared to one another. Tension is in the squared aspects. The violet soul is on the spiritual side, the blue side, the cosmic side, the inward side, and the soul movement has gone through the indigo (out through from the green colors around the light through a kind of death process in the indigo) and is now beginning to turn toward the red that is the magenta in the deepest darkness. However, it is still in a kind of blue mood coming out of indigo. The violet soul carries a deep inwardness of how it is to live in darkness without fear. That is more or less their native state. Violet personalities are also "cause" people, but it is not a question of devotion as it is for carmine personalities. The violet cause arises from a very high spiritual perspective—violet persons are probably the most removed of souls from the daily grind. They have spiritual capacities; they read and feel movements and feeling life in the human atmosphere—they have a good barometer. Violet personalities usually have a dark or swarthy complexion and dark hair and eyes. They also have a kind of regal, aloof power.

Years ago I was in some airport and there was a flight attendant in the terminal. She had dark hair and a swarthy appearance. She was near

a crowd of people chatting in the mezzanine, and she just came walking through. She had a huge glow of being present, but not here; "here" is just a focal point of a huge, powerful vortex. She walked into the crowd and just stopped and stood there, and everyone else also stopped and did one of those "Wow, look at that!" gestures. The whole crowd just moved around her in a certain way. By the way she was holding herself, I thought, *There is a violet.*

It is difficult to describe, but the part that is here on Earth is deeply connected to the part on the other side. Violet people tend to have a sixth sense about things. They sense things in a room and in the people around them. The causes they support are usually spiritually oriented. They could be artistic or religious in nature. They do not want to be someone who is out front, but they are so completely self-contained that, when they join an organization, people defer to them, because they carry something the organization needs. And they will go out and lobby people, but it is never for themselves or for show. If you ask them about it, it is always about a spiritual or higher cause.

An orange personality can have an in-your-face cause. Carmine can support a cause and be ardent about it, but not in your face; they just volunteer for everything. The violet people have a cause, and you might not even know about it until you ask, and then they speak about it in a way that a charismatic force of the spirit comes into them. You sense they are in contact with something of another dimension. That quality is violet. They meditate; they live in the world on the other side and are familiar with it; they can draw things from it down to Earth. Their difficulty as violet personalities is that they are happier over there than they are here on Earth. They have worked things out and are continuously in an excarnated state, but not in a pathological sense. Oddly, they tend to withdraw and become deeply involved.

Christian Rosenkreuz was always in the background when dealing with Marie Antoinette—a world player trying to change things. He had the ear of emperors, presidents, generals, and whatever, but was never out in front. That is a violet person—highly spiritual with deep

capacities, never in the front but instrumental to change. It is a picture of the reticence they have for incarnation itself. He could be a volcano, too. He was sulfur, a knowledge person. He had his own business here in the green world. The higher the initiate, the greater access they have, but that particular aspect of Christian Rosenkreuz was as the violet. However, he was not acting as a violet when he would hold a jewel in his hand and remove a flaw through concentration. When bringing the Rosicrucians together, he was not just a violet; he had a deep turquoise nature to him, as well. Initiation means I have access to many colors.

The image I like to use is this: You are going to play a piano, but someone comes in at night and cuts three strings out of it with wire cutters. In the morning, someone comes and asks, "Can you play this song?" So you sit down and you play the song and it is great, because it is in a key that doesn't need those three strings. Then someone asks, "Can you play this other song for us?" Now you play that song, but it is in a key that needs those strings. You play what is still a piano, but you don't have access to something you need to play the song. This image is a perfect analog of this work with soul. You are in one situation with a person, and you have all your firepower in your soul aura, and that person requires a certain color in your aura; you meet and match them and everyone is good. Then you go to a different person, and from the very beginning you are not getting the same color message. It is because, to find that person's fulcrum, you have to bring colors into your aura that you don't want there, so you cannot play that song with them. It is that kind of picture. An initiate has all the strings.

The spiritual insight of violet personalities is their gift; however, if it is unbalanced, the gift of seeing our visible world from the perspective of the spiritual world gives them a feeling that somehow a curtain has drawn between their life in the spirit and their life here. Rudolf Steiner talks about watching your vehicle do stuff, and in that moment you actually have to think yourself back into your life consciously. The struggle of violet souls is staying engaged in life when they really want to be in the spiritual world. The remedy is Sepia:

+ **The Proud Sufferer**, Sepia — This soul brings an intense idealism to life that is often focused on high spiritual causes or the struggles of the underdog. Advocates and supporters of the arts, religious movements, animal rights, and similar causes often have this soul tone.

− **The Proud Sufferer** — These souls crave freedom from attachments. Affection requiring reciprocation is felt to be a burden. Thoughts are focused on the ideal. Feelings oscillate through degrees of indifference. Will impulses seek vigorous movement or release.

Sepia is the ink of cuttlefish, a predator of the deep ocean. The little cuttlebone, the backbone of the cuttlefish, is sold in pet shops for the parakeets to nibble on in the cage. It is a little flat mollusk with little tentacles that look like fingers. It has a little jet nozzle near the mouth like a squid, and it can steer the animal in any direction. When it feels threatened, cuttlefish uses the chromatophores in its skin to change its color. It can become more or less invisible and then squirt a jet of ink that resembles a cuttlefish in the water. Then it quickly moves away. That is Sepia. The violet constitution, when out of balance, works that way; it puts a little model of itself out there to interact with people as it hold back and watches the interaction. That is where the veil comes down between my life and me. Sepia is especially characteristic of women as they approach menopause. They oscillate between Sepia and Lachesis, which we will consider with the lemon constitution. For the women reaching menopause, the sepia gesture is the need to release congestion. Things become irritating owing to a kind of congestion. During a menstrual cycle, the buildup creates congestion and pressure in the ovary and then the little egg comes out. Before the egg emerges, the pressure builds in the follicle and causes congestion that is irritating.

Sepia — Bearing-down sensation. Weakness of back. Hot flashes at menopause. Indifference to friends and relatives. Sensitive and sad but aloof. Much inclined to weep. At times apathetic and indifferent. Fretful and easily offended. Dread of being alone. Apprehensive of the future with great fears over health. Sleepy or dull during the daytime and early in the evening. Awakes at 3 a.m. and cannot sleep again. Talks in sleep. Sleepless from rush of thoughts. Awakes at night, with palpitation and anxiety over things that happened years ago.

The sepia constitution is inclined to be apathetic and indifferent because they are in the spirit. Homeopaths say, especially about women, that the children of Sepias are the most organized, because the Sepia mother will give the kids space; they are not helicopter moms. They are somewhat on the cool side, but not cold. There is a quality in the Sepia of aloofness and other-worldliness, and in this violet they feel a little uncomfortable when affection is expressed toward them. They feel that if they get affection they have to reciprocate, and they are not sure whether such reciprocation is real affection or just repaying a debt. They are in the spirit watching this drama of affection, and their affection is calculated in a certain sense. They can give affection, and the kids grow up knowing mom is always there but not smothering.

Sepia/violet personalities don't trust spontaneity, especially overly sentimental spontaneity. Theirs is a no-frills consciousness, living in the spirit, so everything has a purpose and the cause will move forward; no one needs praise. Today we see the remnants of the recent praise-everything generation; everyone in the class got a trophy for "trying." Such tactics to build children's self-esteem with false praise is not for Sepia moms, and the kids grow up not expecting praise for every little thing. They can work hard and be on their own, and they don't move back in with Mom when they are in their thirties.

Sepia personalities on the "shadow side" are apprehensive of the future and have great fears over their health. With time, they have pulled away from physical reality, and they feel as if their body belongs to some one else. Their body is this thing "out there," because really they live in

another world; their body is something with which they lose contact in a certain sense. They fear that the body is not going to be okay and tend toward a kind of inner drama in which the body is taken over by things.

Looking at the color violet, we see that the color itself is quite ambiguous. Is violet on the red or the blue side? It is a little like indigo—violet on the verge of becoming indigo and indigo going to violet. When you are in purple, you are a purple, but violet is somewhere on the way to indigo, and indigo is on the way to violet. There is, in a sense, an atmosphere of the other side of the threshold. In purple we are already turning toward red. In violet we haven't yet done that, so it is the most inward. Nonetheless, it is a great gift because it involves spiritual capacities. The violet person can intuit things in an accurate and clear way. A polarity to the inward mood of violet is the radiating mood of yellow. Violet is the most inward of the inward moods; the yellow radiates into the world. That gesture is the actor. Violet is the spiritual side; yellow wants to be on stage. Violet wants to remain in the background. Yellow wants to be in the footlights with the lead in the play. The yellow gesture is to radiate and push outward from the center. The violet gesture is to pull back and enclose from the periphery.

Those are the two polar gestures in the colors. Yellow, as a homeopathic remedy, is phosphorus.

> **Phosphorus** — Fatty degenerations. Scurvy. Vertigo of the aged. Dandruff. Falling hair. Hemorrhages. Cirrhosis of liver. Glaucoma. Vomiting soon after taking water. Hoarseness. Various respiratory problems. General apathy and indifference. Very low spirits. Dread of death when alone. Indisposition to mental or physical exertion (also Nux Vomica and Sulphur). Ideas slow in evolution. Inability to think. Occasionally nervous, fearful, and hysterical. Sleepless before midnight. Falls asleep, but easily and frequently awakes during the night.

Phosphorus is a mineral that doesn't actually occur in nature as a pure element. It occurs only in combination with other substances, and this is the phosphorus personality type. These people are the most social

and interactive people in a group. When a phosphorus person arrives at a party, the party starts. They tell jokes, shake hands, and schmooze, and the energy starts to flow. That is phosphorus. The function of phosphorus in plants is to move the growing tip toward the Sun. It is the energy charger; it just keeps things moving. That is the role of phosphorus in the plant.

Science has found a way to condense phosphorus into its own substance, but it is so volatile that you have to store it under something like oil. If you take it out and expose it to air, it bursts into flame—a brilliant light. This is a key image of the phosphorus–yellow personality. The phosphorus remedy is an image of yellow's soul quality. Yellow radiates and exhausts the center but doesn't care; there is always something refilling the center, so yellow just keeps radiating. As an actor yellow is convincing, highly versatile, witty, clever, intelligent, sensitive, committed, and powerful. The problem is that yellow continuously exhausts the center, so the actor must go on hiatus to refill the tank. Yellow personalities exhaust themselves from the center, and when that happens they collapse inward; they have become so many things that they never quite discover who they are. They live their lives in assumed roles, and when you ask them who they are, they describe their various roles but never actually get to the core of who they are, because as soon as something goes into their core they want to radiate it out to the periphery. Yellow personalities crave the energy of light radiating.

In homeopathy, phosphorus is prone to characteristics of the aged—falling hair, hemorrhages, cirrhosis of the liver, glaucoma, hoarseness, low spirits, dread of death when alone, a tendency to mental and physical exertion, slow evolution of ideas, and an inability to think clearly. With all this energy outside, thinking is just not very exciting, which is why yellow personalities memorize lines for a living; they are not really thinking but replicating words committed to memory. Yellow personalities can become very narcissistic and mercurial. When in balance, yellow is the life of the party, the one who moves things along creatively and energetically. However, a central issue in acting is that you never find out who

you really are. They can be very narcissistic about their great roles, but finding themselves in the present is very difficult.

In the final chapter, we will consider Steiner's color theory of the illuminant and the shadow thrower, the basis of his color theory. In the dialogue between the illuminant and the shadow-thrower, the shadow thrower is barely incarnated, while the illuminant is the source of light for the "I," a material-free spiritual being that does not cast a shadow. When we exist free of matter we become a living turbid medium with all the colors streaming through it—that is, through whom we really are. By then the ego will have been divorced from matter. When that happens, my ego and the creative play of light and dark in it becomes my "I," since it is now my true self, although it is covered over by shadows of the light that doesn't move and the dark that doesn't move.

Thus, my physical body is an invisible activity of relationships of attraction and repulsion, sympathy and antipathy. Look at physical science—my physical body is all electron–proton activity, valences, and matter. The *forces* of my physical body are invisible; this is all conventional science. However, my senses that have fallen see that invisible world as patterns of light and dark and a sea of wavelengths. In that molten sea, I have to find a fulcrum, so I insert my soul into matter, and then my life body carries the matter. The patterns of my life body become clogged with stuff that falls like a sandbar in a river, because my soul is a shadow in the light of my "I," projected down and causing everything to fall and fall and fall, until I have matter down at the bottom, which gives my soul through the senses the impression that I am separate from everything.

This is not part of the original plan. The original plan was that matter would not be a part of that, and the physical would still be the patterns of light energies without matter. Matter is our gift from Ahriman so he could tell us, "Don't worry about the god behind the curtains; just pay your dues and buy the hardware. But he needed a warm-up act, since he couldn't do this immediately. Therefore, Lucifer came on the scene, first as the warm-up—or, as I always say, as the crowbar to move human beings away from our experience that we are one with God. Lucifer came

to say, "Okay, which god is that? The god of the mountain, the God of something else, my God, your God, the gods?" This is the human separation from the experience of being one in our "I" with the divine, which was the common experience during ancient Vedic times.

The human was slowly pried away from that experience into various gods and goddesses, myths, and what have you, until Ahriman arrives in the sixteenth century, intending to make a robot or automaton. That was the plan in the beginning. Does the robot have an "I," or is it a shadow? It is an interesting question, because that is where we are headed. Robots are a whole new hierarchy that we have created with our soul out of matter. That elemental hierarchy of machines is now searching for a soul in the cloud. As we continue on, our own small ego is sort of the sludge at the bottom of our soul, because the soul has all these divisions—the small ego is the sentient soul that thinks I am what it is all about; my sensitivities are the most important thing—like being sixteen years old. So the bottom part of my soul, the sentient soul, is being sensitive, so you have to pay attention to me. Next is the mind soul that has to think about this. I also have my consciousness soul, which not only has to think about it, but by thinking about it I also see that everything else is thinking about it in its own way.

Even rocks have consciousness; they are not conscious *here,* but are conscious way out there. But my human consciousness can go way out there and be with rock consciousness. This is how we get crystallography and mineralogy, which then falls into abstraction because it is merely a shadow. Instead, I need to turn that around and lift matter into life; lift life into sentience; lift sentience into mind; lift mind into consciousness; lift the soul to the "I." Humans are here to do that kind of lifting; it is called the Resurrection. Christ came to Earth and put a seed into the physical matter, making it possible to do that. He said, "Do this in remembrance of me" (1 Cor. 11:24). Later, the Rosicrucians told us how you do it. We have to change the way we experience our sensing, because the way we experience our sensing is the thing that keeps the lid on the whole thing. If we change the way we sense, we can see the difference

between the physical permeated by matter and the physical that is free of matter. When we do that, we begin to have etheric vision and see the life body. When we see our life body, we can see how our life body and sentient soul interact. That is called our sentient body; our life body and sentient soul are connected through the sentient body. Our sentient body is where we have memories that we cannot recall.

With our color work, we can go back into the "forgotten" memories. We make paintings until those memories come to the surface. All of those hidden memories are my sentient body, limbic structure, emotional consciousness—all hardwired in there through usage and memory and all kinds of patterns that keep me fixed until I go in and look at my sensitivities and realize they are all still there. When I do that, my ego is transforming my soul into *manas,* and my True Self, my "I," is transforming my life body into *buddhi,* or discursiveness, or the ability to see how everything comes together. My "I" is transforming my physical body into *atma,* or bliss. Buddhi, discursiveness; atma, bliss; and manas, the capacity to say, "I." Manas is the "I"-saying, the sense in us that unites all the disparate senses into one unity. These human aspects—soul bodies and the physical, etheric, "I," and so on are the basis of Rudolf Steiner's work. So when we are looking at all these colors, we are really just looking at a section in here of how the soul and the "I" are interacting. These colors are seen homeopathically, as memory structures in the sentient body. If I go back and pull the memories out, look at them, and actually shine the light of my consciousness on them, they stop being simply "remembered"; they also become sources of understanding. I can then perceive the feelings that arise when I have a sensation. This is my little homily to you. The ultimate goal is to perceive my feelings when I have a sensation.

15

Purple

> Jachin, *The Pole of Life into Death:*
> thought–salt–wisdom–the descending forces–autumn
>
>> In pure thinking you find
>> The self that can hold itself.
>> Transform to picture the thought
>> So you experience the creative wisdom.
>
> Boaz, *The Pole of Death into Life:*
> life–sulfur–love–surrender–the ascending forces–spring
>
>> Intensify feeling into light
>> So you reveal the forming power.
>> Concretize the will to being
>> So you create in world being.
>> (Rudolf Steiner)

These two poles are the pillars of the Temple of Solomon. Esoterically, they represent the doorway into the spiritual world and out into another incarnation. Approaching the columns, you would see pictures of your life rotating on them. The initiation process involved consciously going through your life and into death, where you would find the principle of life. Rudolf Steiner calls it continuity of consciousness. It is connected to the whole process of Imagination, Inspiration, and Intuition. The first part is Imagination, and Inspiration when you go through into death, when you realize that your ideas are not yours but are given to you. You need the stage of Imagination to have the discursive ability in your

life body to distinguish between your ideas and someone else's. This is a key esoteric principle. It has to do with the way knowledge operates in the world. These mantras connect it.

Study is gathering knowledge. Imagination is learning to transform those thoughts into pictures and then to give them into the death of the threshold; you begin to awake in your feelings as "world feeling." Your feelings cease to be yours alone and start to be archetypical. That is what color is. They are sets of archetypical feelings. I say they are "archetypical" because, when I describe these various personality types you can picture people you know. We don't own our personality type but only borrow it as a mask to compensate for the fact that our true self is not recognized by the world. When you come into the world through your True Self, you have an intended mission, and then you meet the world, and the world says, "I am not interested in your mission." This is not because it is unique to you here and now but continues through all of your different lifetimes. As you continue to incarnate and work on your mission, that mission provides the script of each life, like scenes in a play. Each life has a different personality structure to color that particular incarnation with an ego, or belief of who you are. You incarnate with your mission in mind, because your guardian has accompanied you to the threshold of birth. However, the world starts chipping away at your initial enthusiasm, so you have to compensate and construct compensating imagery and shadows in your soul to color the kind of force that is not being represented. The force of your "I" is not being represented in your life as planned when you were in the spiritual world before the next incarnation. You adjust and compensate and the pictures you use for compensation become your personality. Your personality adopts a particular archetypal structure that it learns.

According to the ideas of Samuel Hahnemann, this is the way we build a personality. We may become devoted to truth or to beauty as a way to compensate. We may come into a family with a mission to be totally devoted to beauty, but everyone in your family is totally devoted to truth. This leads to personality issues, because we have to adjust our

mission to the world's inability to recognize our mission. This structures our false patterns, aggression patterns, risk–reward strategies that form the basis of a whole persona. There are certain archetypical patterns of risk and reward, which I am describing to you as yellow, green, and blue. These issues are okay and help us to mature, but once we do mature and have to incarnate our mission fully, we need other soul organs to replace those strategies. We need other organs of perception that are subtler and less superficial. We have to find other sources of energy as we mature and learn to be creative rather than reactive; we could call this *Initiation*.

The stages are outlined in this mantra. Once we go through into Boaz—that is, into life—feeling is intensified into life so we can reveal the forming power. "Forming power" means forming a bond to a spiritual entity that has something to do with our mission; that is *Inspiration*. We are forming an emotional bond with a benefactor (they called it a god or goddess or your ally), a spiritual being that begins to tell us how to move past our risk–reward way of living. This generally happens between the ages of thirty and thirty-three, when we recapitulate Christ's three years of activity on Earth. He comes out of the desert with the new Mystery and is hung on a tree. That is the new Mystery, or the basis of how our old ways are going to be taken from us. We have to find another source of energy. This has to come from our own personal effort, not as a gift or from anything around you. It comes through you from the spiritual world. We have to build an organ of perception of the being who will provide what we need through self-transformation: "Know yourself." This was written over the threshold—"Know yourself."

These colors are one way to know ourselves in such a way that we can see archetypical waves of color flow through us in a given situation and then go away. We each have a fundamental tone that is an irritant connected to one's mission. We have a default tone connected to our mission. Things like this come from folk souls, from the energy of the food you eat, and from the energy of the land we inhabit. These are deep archetypes, too, and they have their tonal qualities. It is the karma of race, gender, religion, and family, ethnic group, belief structures—all of these

become a kind of default system of how things are for each of us. We choose an archetype by adapting to fluctuating circumstances as a child; we choose how we deal with all those challenges as an archetype, which develops a particular fundamental tone with which we build a chord. We get our fundamental, leading, and resolving tone, and then a bridge tone and another fundamental with which to make our music in life.

Colors represent a bridge from Imagination to Inspiration. Colors are a way for us to look at our own personality and ask, "What is my default in my own personality? Where am I going with this? How are others receiving what I am putting out in the world? Go to any business or motivational seminar, and this is what they are talking about. What's the tone? Can I perceive that tone? This is what a therapist tries to do—harmonize with your tone to arrive at a diagnostic. This is what a teacher does to make a pedagogical story. This is what a businessperson does to close a deal. What's the tone? The tone is what I call "the fulcrum." I have to find out where a person is resonating; where the center of the fulcrum is; where one divides the warm in the cool. Finally, can I duplicate that in myself, so that we can truly communicate? Otherwise, I cannot grasp how that tone is being received by another person and resort to my own personality structure of risk and reward—which is great when I am forming my personality but not good when my personality always brings the same type of situation, the same type of job, or three husbands who are really all the same person.

We need to find a color and organ in me that is flexible enough to be able to know where the fulcrum is in the warm and cold within me, and how that warm and cold is met in the other person. When someone speaks to me, do I have to react? If I am a turquoise, I take everything personally if it involves an untruth. If I am an orange, when there is a mistake I obsess about it and cannot sleep until everything is perfect. This might be OCD, Obsessive Compulsive Disorder, which is a kind of hyper-orange personality.

Hidden in this mantra is *going into the darkness with the light, pulling the light through the darkness, and going out the other side*—Imagination

and Inspiration. Imagination is turning thoughts into pictures. That is what I have been trying to do here. I give you pictures of how we could do this whole thing in psychological language of all the personality types. With colors we have another way of transforming all the ideas of psychology into pictures. They allow the soul to move into imaginative cognition, the imaginal world. There I find experiences that help me develop a fulcrum of the tone I need when I am with people. Can I hear the tone that I am putting out? Can I understand the tone coming to me without adding a layer of my default to it? This is the discursiveness of the buddhi body. These ideas are central to Steiner's mission of bringing karmic understanding into the world. Then he had to bring Anthroposophy because others had dropped the ball. At the very end, he tacked on his real mission, but he needed Anthroposophy so that people could understand at least some concepts of karma.

In *How to Know Higher Worlds*, Rudolf Steiner begins with meditative practices and toward the end offers these three chapters: "Some Effects of Initiation"; "Changes in the Dream Life of the Esoteric Student"; and "Achieving Continuity of Consciousness." This is about changing our relationship to dream life. Once we do so, we realize that dream life extends into the spiritual world as a somewhat concrete phenomenon. We must concretize the will we use in our dream life to make contact with the being on the other side that is interested in our mission. The folk soul, the male archetype, and all these other archetypes are there with which I need to align myself so that my mission can really unfold in me, because that is the only thing that will give me true satisfaction—realizing my mission.

Thus, we go through study, Imagination, and Inspiration. The next, Intuition, means to concretize the will to be, so we can create in worldbeing. We become the inspiring being in part of our soul. We first have to find our self; then we give our self away; once we give our self away, we find that who we thought we were is in fact connected to beings on the other side of the threshold who are interested in our mission—not so much in one's personality. When we begin to open up to that, they

begin to speak into our mission, and we feel inspired in that mission. We receive help with our study—books fall off the shelf and open to the page we need.

If you are salting your dreams and putting living pictures into them, Google can be a whole new instrument and completely different mode. When we are not doing the inner work, the search is just a "what am I looking for" question; we are looking for *only what we think we are looking for* and closed to other things. But when we are doing the inner work and placing pictures at the disposal of those beings who are interested in our mission, then our search engine has a completely different quality. It is just a machine but also an analog of our whole process.

In *Anthroposophy (a Fragment),* Rudolf Steiner gives the bookend to this issue of continuity of consciousness and the transformation of dream life. He is talking about the need to understand sensation and perception and what it has to do with us as physical organisms. Steiner says:

> Speaking concretely, if we use imaginative and inspired visualization to grasp what sense perception and its rational extension are for the eye—that is, if we manage to grasp the organ of sight by means of Imagination permeated with Inspiration—this activity extends inward and a crossing takes place. Then, with the activity with which we first embraced the eye, we embrace a different organ. Essentially, it is the kidney.
>
> The same thing happens with other organs. When we extend this imaginative and inspired activity into the inner human being, we always find that what we grasp with it is an organ that is already complete, at least in its potentials, when a person is born. Thus we advance to a real inner perception of the human organism.[1]

If you take pictures into sleep that are moving and seem to connect with you, pictures from the sensory world, in which you lift the colors off the sensory world and try to live in the feelings that the colors create in you, and you take those pictures into the sensory world (you could also do this with tone, music; and forms), you take those pictures into

[1] Steiner, *Anthroposophy (A Fragment): A New Foundation for the Study of Human Nature,* p. 70.

the sensory world and your imagination and inspiration begin to speak in your sensory activity. The energy in your senses enters your body and you become aware of how it moves down and crosses in you. This is what Steiner is saying: it crosses.

Your optical nerves cross just in front of your hypothalamus, in the optic chiasm. And then they cross and cross and cross and cross: parasympathetic–sympathetic–parasympathetic–autonomic. All these neurological phenomena are crossings where the image goes through four or five reversals until it goes into the back of your head, which we call *seeing*. All that energy coming in through your senses is being crucified on the cross. "This activity extends inward and a crossing takes place. Then, with the activity with which we first embraced the eye, we embrace a different organ. Essentially, it is the kidney."

When we start to do this work and take images (or other phenomenological representations) into sleep, when we are having a sensory experience we can experience what our kidney is doing or what our adrenals are doing under the impact of red, blue, or green, because those experiences are imaginations of the creative beings who created that organ. They act lawfully, as they must, but we can pick that up and monitor it. Then our ordinary imagination of forming the picture becomes developed *Imagination,* or "Imaginative cognition of initiation." Our imaginations began to lead us to synthesis; things come together from many different places, and we begin to understand in a way that goes far beyond what we could understand intellectually. We start to be able to take and use things from all sorts of different disciplines, because the pictures move in the imaginal realm in a similar way and our organ of perception, or fulcrum, can follow those pictures and see pictures from other sources and the synthesis of them. Thus, our inner life becomes more fluid and more precise at the same time, because the pictures we see are coming from those archetypes, and they have resonances we cannot understand even if we can see them. This is part of what we can call higher knowledge. It transcends anything we can find in books, because it is not there but within us. It is in the potential of our soul to form organs of perception for such

synthetic pictures that give us the power of imagination and creativity and bring together a myriad of different things into a synthesis.

When C. G. Jung was talking about the formation of symbols for his patients, this is what he was talking about. Forming a symbol brings together a tremendous force of healing in one's soul. We have to connect a picture of one thing to a picture of something in a different realm or context and bring them together. This is exactly the attack on human consciousness today by autistic spectrum, Alzheimer's disease, and things like that. People cannot form symbols; people are becoming *radically literal.* The more literal people become, the more polarized we become, because radical literalness of the intellect allows people to state only what they know intellectually. Because of the dualistic way we learn things (on–off; yes–no; black–white; 0–1), modern binary consciousness is losing the ability to link a picture in one domain to a picture in the other domain and to find that they have resonance.

It is my understanding that this is why Steiner came back to earthly life—so that he could help us do these things. He gave us exercises and meditations and told us: If you do this, your soul will begin to be able to synthesize symbols and bring things together, and you will eventually be endowed with the ability to create in world-being—all because our will can be strengthened creatively by the ever-present help of those spiritual beings interested in our particular mission. They want us to succeed. They cannot do it for us, because we have to be held in freedom. Once we are "clean" enough and prepared, they offer possibilities, and we are free to choose because, according to the rules, they will not violate our freedom. Unless you actually "pick up your bed and walk" and do the necessary inner work, they cannot become involved. If they did, we would end up getting into trouble. When we do this work and have a sensory experience, we can actually feel the sensory experience triggering a gland or organ.

I used to conduct an exercise, though it upset some people. People would sit in two rows, and I would tell those in the second row to close the left eye and imagine blue coming out of the right eye while staring

at the back of the person's head in front of them. The people in the front row were not told what was happening. I would tell those in the front row that I just wanted you to see if they would receive a color impression. Eighty-five percent of the people in the front row would experience red when those in the second row sent a blue thought into the vision center at the back of those people's heads. I stopped because it seemed to be causing headaches and people felt violated. The point is...if we only knew what our thought forms are doing in the world, we would be far more careful about leaving them lying around.

The kidney is the source of our visual ray. It is the source of the power that comes up the spine through our autonomic nervous system and shoots across the brain and out our eye. That is an esoteric reality.

In *Boundaries of Natural Science,* Rudolf Steiner begins with the same thing—pure thinking, or imaginative and inspired visualization:

> When pure thinking has been grasped one can strive for something else. This thinking, left in the power of an "I" that now feels liberated within free spirituality can then be excluded from the process of perception. Whereas in ordinary life one sees color, let us say, and at the same time imbues the color with conceptual activity, one can now extract the concepts from the entire process of elaborating percepts and draw the percept itself directly into one's bodily constitution. Goethe undertook to do this and has already taken the first steps in this direction....
>
> Instead of grasping the content of the perception in pure logical thought, we grasp it symbolically in pictures, allowing it to flow into us as a result of a kind of detour around thinking. We steep ourselves in the richness of color and tone by learning to experience the images inwardly, not in thoughts but as pictures, or symbols. Through this, the living inner forces of the etheric and astral bodies flow toward us from within, and we come to know the depths of consciousness and the human soul.[2]

There are five or six other books—in *Anthroposophic Leading Thoughts* and elsewhere—in which Steiner speaks about symbolic

2 Steiner, *The Boundaries of Natural Science,* pp. 100–101.

consciousness. This involves the cultivation and transformation of thoughts into pictures, and then taking them into a pure and free spiritual space with totally focused consciousness and no thoughts. We release the pictures into that focused consciousness and let them go. This is then picked up by the beings of the other side, because they don't have to translate images. They are already part of their language. They take this into the spiritual world, where it needs to go, and then return with a dream. Our dreams become transformed so that, when we awake, we have access to their meaning structure. This helps us in our healing process. A further development of this, then, is *continuity of consciousness*, whereby we are awake in a place where we are normally sleeping.

Now, let's look at purple and lemon personalities. The purple soul is that of a politician, a public figure. Public figures are up there with the noble sufferers. It is a strange job, but someone has to do it, so they really need a lot of money, maybe a super pac. This is the royal purple and a feeling of having the destiny to lead. These people have "big eyes"; sometimes their irises are actually big. These people are meteoric, networkers, name-droppers, connectors, and power builders. The basic gesture of purple is to be a leader.

On the other side of magenta is the carmine person, who is inwardly ardent but not a leader, though perhaps a volunteer. They lead by following, whereas purple leads outright. Purple souls have a deep feeling that their mission is to lead groups of people, and to do that they will have to compromise at some point—unfortunately, they usually learn to compromise truth, because to lead people they have make truth accessible and acceptable to feelings more than to the thought life. They feel entitled to tell stories in order to rally the people or to get something done. However, what really takes place is manipulation of others' feeling life by bypassing the discerning thinking life and the "I." In the process, they learn to insulate themselves from their critics by developing an inner sense of being above the masses.

The purple personality is similar to the magenta, the noble sufferer, but magenta personalities usually develop a philosophical side, whereas

purple persons develop more of a sociopolitical tendency. The magenta is not a networker but more of a loner. Magenta persons are virtuosos who will practice the violin until their fingers bleed so they can eventually bask on a stage and let their brilliant magenta light shine out. There is an element of that in the purple, but they will avoid the disciplined practice and just want people to believe they worked hard. If they are criticized they have learned how just to transcend it by believing that their critics do not understand their actions and motives.

The homeopathic remedy for purple is Lycopodium, the pollen of a reindeer moss—a plant with pretenses of becoming a pine tree. Walking through a meadow of reindeer moss feels like walking through a meadow of baby pine trees. It does not look like the moss we are used to finding on trees and such. Reindeer moss has proper stems with leaves and gives the impression of being from a different hierarchy. It bears spores rather than seeds, and the spore is very unusual, with a very strong capsule. The spore is also extremely sensitive and volatile. Reindeer moss spores are sold as Lycopodium powder. Lycopodium is used on Chladni plates, because the slightest vibration sets it in motion to reflect the patterns of a particular sound quality or tone.[3] The spores are also explosive when present in high enough

3 Ernst Chladni (1756–1827) was a German physicist, musician, "father of acoustics." He developed, among other things, a method of revealing sound patterns on a metal plate by drawing a violin bow across an edge of the plate covered with fine particles. The resulting vibration caused distinctive patterns,

densities in the air. Lycopodium spores were used as flash powder in early photography. Nevertheless, the moss has its feet in the water.

Lycopodium tends to push beyond what it really is, like a politician promising to change all of the bad things and create a utopia. These people are prone to inflate their belief in themselves unrealistically and then have to retract their claims and expectations. They want to expand and push out, and then they have to retract. A typical affliction is a hernia: Sure, I can lift that—then off to the emergency room. Lycopodium people produce kidney stones; they push out, and when they pull back there is congestion, and over time stones will form in the kidney or gallbladder. Ailments include a gradual weakening of functional power. They see themselves as tremendously powerful, omnipotent.

> + **The Flawed Leader,** Lycopodium — These souls have the capacity to endure a remarkable amount of criticism and setbacks while maintaining a positive attitude toward the work at hand. They step in to lead when others shrink from an enormous challenge.
>
> − **The Flawed Leader** — These souls have huge self-esteem but feel detached from the struggles of the masses. Thought life centers on self-image. Their feelings create a bubble to deflect criticism. Their will is focused on obtaining power and is prone to self-destruction.

Disease comes to these people like a frog in boiling water. If you place a frog in boiling water it will jump out, but if you put a frog in cold water and gradually bring the heat up, the frog will never jump out. It adjusts to the situation until it is too late. This is the way these people become ill—like gradually losing power, but even as they lose power, they try to puff up their image. Politicians devote more energy to the image when they feel it weakening. Their unconscious inflation and repetition of the image repeatedly draws the same situations to them, because they cannot learn from their failures. They just keep doing the same thing over and over. This is the little fat guy in *The Wizard of Oz* who operates the levers to make the imagery work—just keep the machine going and never

or "Chladni figures," to appear. See, for example, Hans Jenny, *Cymatics: A Study of Wave Phenomena and Vibration.*

mind the guy behind the curtain. It is George Bush vomiting at the big conference in Beijing—the show must go on, but then he falls out of his chair and throws up in front of everyone. That is a picture of this constitution. Eventually weak memory or stamina fails, and they become irritable, fretful, morose, vehement, or angry when crossed in their purposes.

Here is the homeopathic picture:

Lycopodium Cirrhosis — Hernia, hemorrhoids. Sciatica. Impotence. A non-eliminative lithemic (stone producer). Ailments develop gradually. Functional power weakening, with failures of the digestive powers where liver function is seriously disturbed. Weakness of memory. Fretful, irritable, and morose. May become vehement and angry if crossed in purpose or desires. At times adopts an imperious and domineering manner. Self-important thinking.

The opposite of this is the lemon personality. Their tender core seems unprotected and out in the open. They are extremely aware of flaws. On the positive side, they can be excellent managers, because they become quickly aware of problems, especially socially. As managers, they know exactly how the power flows and how to solve problems of power relationships. They can go into a meeting and know how individuals will respond to what is said. Lemon personalities can read those in the power structure and want those people to reflect what they see. Owing to the polarity, lemon persons can be excellent campaign managers for the purple personality. They don't want to be objects of the press; they would rather be the ones who provide the infrastructure that helps the purple succeed—the power behind the throne. They do this by managing the way warmth and cold flows in an organization.

The remedy for the female lemon personality is Lachesis, the venom of a South American bushmaster snake. The venom is taken homeopathically, of course.

Lachesis Mutus — Hot flashes. Neuralgia of coccyx. Tendency to talk too much. The mind is weak and erratic. Makes many mistakes. Lack of mental continuity. Constantly changes from one subject to

another. Jealous. Thinks of oneself as under superhuman control. Wide awake in the evening. Great sleepiness but unable to sleep.

For the lemon, things may be going great, but as soon as they perceive any tint or shading of their color, they become congested; their issue is that their light has a veil of darkness on it, prompting them to ask if this makes them bad. They have an inner experience that something is not quite right with things, especially in their own soul life. This makes them sensitive to the way power flows among individuals. They sense how the life flows, how the warm in the cold flows in the organization.

Lachesis is given to women, especially during menopause when there are deep problems with congestion. They can no longer eliminate through the blood flow, but the body wants to do that and the forces arise to do so, but it is no longer biologically possible. The biological congestion creates congestion in the soul.

> + **The Boss**, Lachesis — By their willingness to shoulder enormous undertakings, these souls provide human life with the force to get things done. Capable of great concentration in specific tasks they can provide reliable guidance to others through complex thought processes.

> – **The Boss** — These souls are confused in their thinking about boundaries between the personal and the ideal. They feel irritated with any alleged impedance to the collective goal. They value efficiency, but their misuse of will often amplifies misunderstandings.

Lemon personalities may have to deal with a lot of negativity in meetings, and you wonder how they can take it. Inside, however, they are not taking it but allowing it to build as a kind of inner pressure. You may hear it in the voice. When speaking they constantly make a slight coughing or short throat-clearing sound. It is an expression of the congestive process in the emotional life. They wish they could jump across this table and bite you, and this is where the snake comes in. In a discussion, you might try to say something, but these people can speak without breathing—they will take a breath in mid-sentence, never at the end, so you

never get a chance to speak without interrupting them. Speaking in a torrent is a rhythmical image of the congestive physiology: building pressure followed by a torrential release. The lemon personality converts negativity into inner congestive pressure, manifesting especially in the blood. They become very adipose; they suffer from edema, swelling, water retention, and so on. They suffer from growths in their throat.

The homeopathic remedy for the male lemon personality is Nux Vomica, or strychnine.

> **Nux Vomica** — Male: Easily excited desire. Emissions from high living. Bad effects of sexual excesses. Constrictive pain in testicles. Orchitis (*Hama; Puls*). *Spermatorrhśa*, with dreams, backache, burning in spine, weakness and irritability. Female: Menses too early, lasts too long; always irregular, blood black (*Cycl; Lach; Puls*) with faint spells. Prolapsus uteri. *Dysmenorrhśa*, with pain in sacrum, and constant urging to stool. Inefficient labor pains; extend to rectum, with desire for stool and frequent urination (*Lil*). Desire too strong. Metrorrhagia, with sensation as if bowels wanted to move.

We have bushmaster venom and strychnine for the lemon personality. The lemon color is greenish yellow, the color of gallbladder bile. Being "galled," as people used to say, is connected with congestion in the gallbladder, and the skin turns green. The congestion is released by controlling other people. Men don't have that pressure when going through menopause; their pressure and congestion arise from eating. Women have the "female complaints" of congestion, swelling, edema, and so on, while men have complaints of sour digestion and problems such as ulcers. Nux Vomica persons have also learned to take a breath in the middle of sentences, so as you are having lunch they are speaking in a continuous stream as they also shovel food. All you can do is listen. They cannot listen. Nux Vomica persons are also fans of conspiracy theories. The irony is that they are often very accurate in their predictions. They have a kind of astral clairvoyance for where and how the warm and cool are moving, but they tend to be inflexible about it because they always see farther down the road.

In homeopathy, poisons such as venoms, belladonna, and strychnine have the greatest healing effect because, alchemically, healing is about taking your own poison and eating it. This is true of inoculation, homeopathy, and even allopathic medicine. There are great healing forces in poison. Hahnemann recognized the forces in poisons, but they have to be very much attenuated so that you get only the healing force and not the death force of the actual poison. Alchemists can take very poisonous substances and work to purify them in such a way that one can safely take them into the body. Poisons challenge the life body in a particular way; the life body rallies and provides healing. However, expertise in diagnostics is needed to know which poison can be used as a particular remedy.

Homeopathic remedies are developed by giving a certain attenuated poison such as strychnine to someone who is healthy and observing the results over time. This is called *proving*. It is taken in often enough and to the degree that the person starts to exhibit the pathology that one would by taking the actual poison, even though none of the physical substance remains—only its essence. Although there is no substance after the seven-hundredth dilution, the medium has absorbed forces from the substance that interact with one's soul.

16

Vermilion and Cobalt

Rudolf Steiner was a teacher of our age, the teacher of a new initiation path. The effort we make to understand what he said yields insights, but they don't come easy. They require a struggle in the will to overcome these colors in the soul as memories. When our constitution is a memory and not a perception, it rules us. When we work with it and penetrate our constitution, it yields to the will and becomes an instrument. The link is the key to transforming memory into imagination. Imagination is memory of something that hasn't happened yet. It is the same force, but you will it into the future. If you really want to plunge into the depths of Anthroposophy, two books in particular can help. *Anthroposophy (a Fragment)* covers the world of the senses and perception, whereas *Anthroposophical Leading Thoughts* describes the cosmology related to the mission of Michael and the arts.[1] Steiner goes through a whole evolution and history of how the human and what we could call the Christic language of nature end up as the School of Michael. This is the Rosicrucian stream of Anthroposophy, and my understanding is that this is the Michael School.

Anthroposophical Leading Thoughts truly encapsulates what we are discussing as the problem of sensation, perception, memory, cognition, and imagination. That whole sequence has to do with the gradual education of our "I"-being, encountering the Earth and having to transform our ego. Our "I," or true self, needs to take the shadows it creates—our ego and personality—and transform them into imaginative force, so that

[1] A tremendous aid in working with *Anthroposophical Leading Thoughts* is Carl Unger's *Language of the Consciousness Soul: A Guide to Rudolf Steiner's "Leading Thoughts"* (SteinerBooks, 2012).

we can become the tenth hierarchy. It is the new shamanic path and the new mystery wisdom of transformation and soul retrieval. It also has everything to do with the Archangel Michael and Sophia, Divine Wisdom. Sophia must be freed so that Michael can live in people's hearts in a different way. That is the background—*An Outline of Esoteric Science, Anthroposophy (a Fragment),* and *Anthroposophical Leading Thoughts.* Of course there are many other great books, but none more elegant than *Anthroposophical Leading Thoughts.*

> In the human faculty of memory there lives the personal image of a cosmic force [*Memory is a personalization of a cosmic force*]—a cosmic force that worked on the human being in the past.... [*Steiner is referring to the imaginations that form the embryo.*] This cosmic force is still working at the present time. It works in the human as a force of growth [imaginations of world creation] as the life-giving impulse in the background of human life. The major portion of it works in this way [to keep your ether body going], and only a small part is separated off as an activity that enters the conscious spiritual soul, where it shows itself as the force of memory. [*Your memory is a portion of your life forces that you have damped down with your "I"-organization to create cognition and memory.*]
>
> We must learn to see this force of memory in its true light. When in the present epoch of cosmic evolution a person perceives with the senses, perception is a momentary lighting-up of world pictures in consciousness. [*Red, for example, is a world image that lights up in our inner life.*] This lighting-up takes place when the senses are directed to the outer world. It illumines the consciousness and then vanishes when the senses are no longer directed outward. What lights up in the human soul in this way must not have duration, because if we did not eliminate it from our consciousness quickly enough we would lose ourselves in that content of consciousness. [*We would lose our freedom because our consciousness would be dictated by the imaginations of creation; our consciousness would simply become the content of the imaginations of those beings who created the world.*] If we did not eliminate it from our conscious quickly enough, we would lose ourselves in the content of consciousness; we would no longer be ourself. For only a short time—in the so-called afterimages in which Goethe was so interested—the inner illumination of a sense perception may live on in consciousness. [*Recall*

our colored shadow work.] Nor must this content of consciousness crystallize into a real being [*which would be a hallucination*]. It must remain a *picture*. It must in no way become real any more than the picture in a mirror can become real.

Human beings would lose themselves in anything that lives and works itself out as a reality in their consciousness [*this is about channeling and old ways of allowing the spirit to work through you*], just as people would lose themselves in something that of its own nature possesses duration there. In this case, too, people could no longer be themselves. [*We are not ourselves when we act from a fixed idea based on memories of who we think we are.*]

Thus, our sense perception of the outer world is an inner picture painted by the human soul—a painting without materials, a painting in the ebb and flow—in the manifesting and the vanishing of the spirit. Just as a rainbow in nature appears and passes away, leaving no trace, likewise a perception arises and passes away without, of its own inherent nature, leaving any memory behind. [*A sense impression does not leave a memory. It is part of the world, as is your ether body, but your soul takes the sense impression and makes a memory of it.*]

However, simultaneously with each perception another process also takes its course between the human soul and the outer world—a process in the more hidden portions of the soul life, where the forces of growth, or life impulses, are at work. [*When a sense impression enters the life body, something happens in my sentient body, a part of my soul that monitors how my life body responds to sensations. My sentient body takes the sense impression one step away from its actual incarnation as the work of the hierarchies in forming nature. My soul pulls the impression a little deeper.*] In this part of the soul's life, not only a fleeting image but a permanent and real image is impressed in every act of perception. [*This is your life body making an inner impression of green while looking at red.*] Human beings can suffer this because it is a part of the world's content that is connected with one's being. [*Steiner is describing the archetypical color beings; they are involved in the formation of our ether body.*] We cannot lose ourselves while this process is taking place any more than we lose ourselves through the fact that we grow and are nourished without our full consciousness. [*Your life body is taking in experiences of the creation and meeting them with the opposite.*

> *Your life body is doing that, and your sentient body is part of your soul that is to monitor that.*]
> This second process takes place in every act of outer perception. When we draw out memories from within us, it is an inner perception of what has remained permanent through the second process. (pp. 181–182)

Our life body takes in sensory experiences and builds polar responses to them through cosmic laws of polarity. Our sentient body is in touch with that process and forms a memory. Your memories are the formation of our neurology in the limbic structure where all our feelings are. This is how we learn for the first two years of life, when sense impressions are actually creating the organs of our perception in our neurology. This is why the tone and mood—not the content—of conversations around the dinner table when you were two years old are so important for the perceptions of your limbic structure in forming your feeling life.

> Once again the soul paints a picture, but now it paints the past that is living in our own inner being. And once again, while we are thus painting, no lasting reality may form itself in *consciousness,* but only a picture that arises and vanishes again [*an unconscious feeling connected to a memory impressed on the life body and sentient body*]....
> The forces of memory are relics of the past in human evolution, and as such they come within the realm of Lucifer's power. Lucifer strives so to condense the impressions of the outer world in human beings that they may continuously shine as ideation in our consciousness. [*Memories are only part of our consciousness*].
> This Luciferic striving would be crowned with success if not for the force of Michael that counteracts it. Michael's force does not allow what is painted in the inner light to crystallize into real being but keeps it in the state of a fleeting picture [*otherwise we would be prisoners of the past with no hope of transformation. This means your fulcrum can be flexible*].
> However, the excess of force, which presses upward from within the human being through Lucifer's activity, will be transformed in this age of Michael into the force of spiritual Imagination. For the force of Imagination will gradually enter the common intellectual consciousness of humankind there. However, this does not mean

that we will burden our present consciousness with lasting realities. Our present consciousness will still be working in the fleeting pictures that arise and vanish. (pp. 182–183)

This has been our work in connection with this book. How can we participate in the fleeting nature of consciousness? We have to understand that every image we have also has its polar opposite. Every thought we have has its opposite. Every feeling we have has its opposite—but they are not random; rather, they are constellated into meaningful pictures. This is represented in our soul wheel of color. It is a way to keep the pictures fluid while also keeping our feet on the ground.

> With their Imaginations, however, human beings reach up into a higher spirit world, just as with memories we reach down into our own human nature. We do not keep the imaginations within us. They are drawn as cosmic pictures into cosmic existence and then we are able to copy them, painting them again and again in our own life of picture ideation [*making pictures*]. (p. 183)

My conscious formation of pictures as symbols is the school of Michael. I take things from the sensory world that would normally remain memories and make them move, and I take them with me into sleep. While asleep, the beings connected to those pictures take them, correct them, and return them to me as seeds of imaginations. That is the transformation of dream life. By doing this, I create a kind of bridge, and those Imaginations come to me and start to constellate into meaningful wholes based on polarities, yearnings, movements, and a "geometry of the spheres." This is what I describe as complements, squares, and trines. It is the geometry, or harmony, of the spheres. It is the twelve tones of music.

Every tone has its polar quality; as we move through the circle of fifths, we move through the tonal realms organized in such a way that harmonies and dissonances are created—resonance and dissonance. Listen to *The Magic Flute*. Mozart was a master of the circle of the fifths. He moves us emotionally through each key and through a journey.

However, we do not reach a place where the pure mathematics of music would take us. There is a discrepancy between the mathematical note ending the circle of the fifths and the actual note ending the circle of the fifths. That mathematical discrepancy is known as the Pythagorean comma. It is the basis of Western music, but it is not a "logical" phenomenon, but magical.

With Bach's *Art of the Fugue,* he stays in the same key, so to speak, but he augments and diminishes, using fragments of the original theme as mirrors of one another, right side up and upside down, all interweaving geometrically. Bach was a member of the Pythagorean Society and built his music according to geometrical rules. The *Art of the Fugue* comprises a whole spectrum, or journey, going from a fundamental through all kinds of geometric relationships as a Pythagorean.

There are at least six versions of the twelve senses described by Rudolf Steiner. Everyone wants to schematize it. What I usually say to people is this: Place all the things you have on separate wheels and spin each one separately. This is reality—not putting them all into a single scheme and saying this is the way it is. We are talking about the Archangel Michael and about the reality of how the soul is. Otherwise it becomes fixed, which is the old way. Scorpio always means this; Pluto means this; Mars always means.... This is not how the cosmos works. Human beings have to develop a capacity to live in spinning pictures with a conscious will—to have an organ that can "smell" a bad spin. We sense it in our heart, our rhythmic system. That is our great gift for perceiving rhythm and movement. Our rhythmic system is the *Gemüt* (feeling mind), because that is where the feelings of the blood circulation are carried.

When we give pictures to our heart—when we form and dissolve pictures from the natural world—our heart receives from our dream-world movements for which we have feelings. Those feelings are pictures of the world soul that we call green and blue and red, as feelings. But they are not personal feelings; they are feelings of beings that live beyond the stars where the real human lives. The human doesn't live in the stars; the human lives beyond the stars in the realm of the color beings. Where

Antares and Spica, the two poles, are the same thing. That is where the real human lives. So this language of these colors, of these archetypical beings, is the language of when you are out beyond the zodiac, out near the midnight hour, where you see the totality of things and there is no blame; and there is no shame; and there is no loss and there is no gain. But everything is speaking this language without this feeling that God is very angry with me, and God's going to make me pay for this—without that. And that is where the color lives. And that is where we go, once we go through the sphere of kamaloca, the planetary spheres, the zodiac, and beyond, during which "time" we still have consciousness, a perfectly harmonious consciousness, that understands everything has its opposite and that everything yearns to become everything else, so that it can all become one again as it was in the beginning—though this time it will be done through acts of freedom, love, and self-sacrifice.

If I am an orange personality, I yearn to be vermilion or yellow (I have those modulations) or my opposite, an indigo personality. Thus, I marry an indigo to learn how to be indigo, because I realize I need that balance. Nonetheless, it is a big pain in the neck and involves a steep learning curve.

In *Anthroposophical Leading Thoughts*—this whole issue of my physical body with its senses is what Steiner covers. He addresses the life body with its ability to form memory pictures; and then my sentient body and my soul that has to look at those memory pictures and transform them into imagination—he is laying the track for that work. I used to be in study groups with this book and I would say, oh, that is the Rosicrucian work. And that is when people would say, I don't think you understand Anthroposophy. This is the school of Michael; it has nothing to do with Rosicrucianism. But it is alchemy. Uh, I don't think you get it. Oh, okay, maybe I don't get it; I am trying to have flexibility of soul. (Eventually I just understood what I understood and that was enough for me).

It is not easy to absorb *Anthroposophical Leading Thoughts*, but if you want a great study there are probably none better. If you are in a very basic anthroposophic study group, this might not be the most helpful

book to begin with, but there is a book called *Learning to See in the Spiritual World*. It is made up of four lectures in 1923 to the workers at the Goetheanum; it is funny and Rudolf Steiner at his stand-up comedian best. He spoke in his native dialect and loved puns, double entendres, and humorous ways of saying things. People who have seen handwritten transcriptions of the original lectures and speak the dialect have told me that Steiner told lots of jokes that have been left out of our modern editions. In his sculpture, *The Representative of Humanity,* the topmost thing is cosmic humor.

On the other hand, if you know people who have studied a lot of Anthroposophy and want to break their teeth, then *Anthroposophy (a Fragment)* makes a great study. It is called "a fragment" because the book consists of notes that Steiner was never able to complete as a book. Nonetheless, it brings many wonderful thoughts for a mature study group. It inspires wonderful questions and lively discussions. People who are spiritually oriented, especially older people who are approaching the threshold, will find that *Anthroposophical Leading Thoughts* is excellent for study. I see that book as somewhat equivalent to *The Tibetan Book of the Dead*. It describes the realms we will go through after passing away. It is a Christian book of the dead.

※

Our last polarity is vermilion and cobalt. On the warm side—starting with green, the color in the light, and moving through the warm side—the urge is to radiate. On the cool side—starting with green and going through the cool colors—the gesture is to come in and enclose from the periphery. We can say that they "radiate inward." These two (red–blue, warm–cold) represent two different gestures in the soul—radiating out and enclosing in. In Goethe's primaries, this is yellow raying out and blue closing in from the periphery. We have gestures of enclosing in the cool side and gestures of radiating in the warm side.

According to Goethe's color theory, as we go through yellow to red, there is a kind of intensification of raying out. As we go from cobalt or turquoise through cobalt to magenta, there is an intensification of raying in. As we go through these yellows, it becomes increasingly intense and red until we get to magenta. As we radiate out, it becomes increasingly intense—the dark becomes increasingly intense; there is a kind of pressure building. When we finally reach magenta, we just blast out. On the blue side we continue holding in until we have to blast out. The intensification of the impulse of either raying in or raying out eventually ends with these two polarities of green and magenta. The intensity of the magenta is too much—we just have to punch out. Where you see that happen is a big transition. That is why the magenta in the glory of the evening and the morning is the trumpet call—*change is coming!* It represents a deep pressure. On the other side, the green represents surrender, with no real indignation but a mood of resignation. This is Christ when he says, "Take this cup from me; yet not my will, but yours be done." That is green—the willingness to do it.

Those two poles of intensification are a polarity. In vermilion, we go to orange and have a reversal, and in indigo a reversal in a death process. Now we go through the tension of enthusiasm in orange, then into vermilion, and we are still not at the maximum in the magenta, where the pressure is great. Orange is the effort of knowing, and the vermilion is owning the results of the effort. It is getting deeper, but we are not yet totally inward (as we are in carmine) or very inward (as we are in magenta). We are on the threshold. Yellow is raying out; orange is raying out, but also raying in; we don't quite know where this is, but perfection is possible; vermilion is raying out, but it is getting dark, so we are just going to get as many toys as possible before the game ends. It is this process that is a path of knowledge. The vermilion personalities say: Give me the knowledge. They collect knowledge, and when they collect they also accumulate; they not only collect knowledge, but they also collect matchbooks from every restaurant they have ever been in, all in a box on the dinner table along with with parts from their 1947

Indian motorcycle, next to remnants of a dinner two weeks ago. This is a vermilion. They are collectors; this geek vermilion has a sticky consciousness, meaning their main thing is memory. It is a way of life, and they are absorbed in it.

Vermilion personalities tend to have an encyclopedic memory. They are prisoners of their gift of memory. They never forget anything, which is a problem. They fit everything into systems, organization, and categories and recall them. When you talk to these people, as soon as you hit a particular subject, they are off and giving you all that they know on that subject, until you finally get a word in and say something that triggers the next wave of yada yada yada. They have an understanding of how it all fit in, but it is external. Vermilion personalities are probably the most tone-deaf in social interactions. Small talk is not part of their repertoire. I saw a *New Yorker* cartoon that featured a vermilion person. It showed a cocktail party with two people standing together. One has a cocktail and looks blasted, while the other, with a little professor goatee, is saying, "Well, that is my life since we met last. How about you—have you read my new book?" That is a vermilion person—people who write encyclopedic books.

Both Goethe and Steiner had a strong vermilion streak and collected knowledge. If it is balanced, it is positive, but it has to include a little self-deprecating humor or it can be self-defeating. The homeopathic quality of vermilion is sulfur, a substance that comes from volcanoes. The sulfur constitution is prone to over consumption of things. If you go out to dinner with a sulfur personality, it might become a four-hour, multi-course event. It is a whole thing, because they collect. They just take it all in and hold it in until it begins to ferment and become acidic.

> **Sulfur** — Burning and redness of eyes. Burning in palms and soles. Unhealthy skin with tendency to skin diseases. Great acidity. Difficult respiration. Hemorrhoids. Aversion to bathing. Intense anxiety and apprehension, especially in the evening (also Calcarea Carbonica). Forgetfulness. Indulgences in philosophical speculations are followed by abnormal mental exhaustion, and an inability to hold the

mind to work on any subject. At times fretful and ill-humored. At times indolent and indisposed to exercise. At times sad, melancholy, inclined to weep, and despair of salvation. Often wakeful during the entire night. Awakes frequently when the patient does sleep (also Phosphorus). Anxious and vivid dreams accompanied by starting during sleep, especially soon after falling asleep. Insufficient sleep at night and irresistible drowsiness during the day.

Sulfur personalities are prone to heat rashes, sweats, ulcers, and bad teeth—their saliva is so acidic that it eats their teeth. They have a darkened skin that can be bothersome to them and to others. They can give off offensive smells.

On the other hand, when in balance, sulfur personalities find ways to relieve the inner volcanic pressure, but if they cannot do that and you try to interfere, you get the full force of the volcano. That force makes them peevish, because sulfur mirrors the action of your digestive system. Alchemically, it is sulfur, meaning everything is dissolved. If you cross them, you will be dissolved—not as payback but as an impulse. If you live with one or even grow up with one, you are constantly overwhelmed by the sulfur power; the volcano is always overflowing and virtually impossible to stop.

This is the vermilion person, the polarity of cobalt. The cobalt personality is concerned with collecting the past. The vermilion collects things of the present and puts them together as knowledge. The cobalt lives in a kind of shell in the past. The homeopathic remedy for the cobalt is oyster shell—calcium carbonate.

+ **The Eternal Embryo**, Calcarea Carbonicum — This soul brings a tender and childlike devotion for life that can be a source of community health. Compassion dominates daily work. Social workers, teachers, nurses, and caregivers often exhibit this soul tone.

− **The Eternal Embryo** — These souls' thoughts move toward the past. Their feelings are tender and tend toward naïve idealism. The will is affected by a great dislike for change. When criticized or questioned, they often brood about their health (hypochondria).

The shell of an oyster is the exhalation of its respiratory process. An oyster eats and breathes in the same process; it has a membrane that secretes mucous, which pulls particulates from its environment and that stick to the mucous. There are little hairs in the mucous that move the mucous into the oyster's gullet. The metabolic system is also the respiratory system, so its eating and breathing are the same thing. The mucous that gets pushed out through the membrane is very rich in carbon, which meets the calcium in seawater and forms the oyster shell. Thus, the oyster is encapsulated in its own breath. The "Cal-carb" is encapsulated in its memories, or soul breath. These personalities live in a shell—the "eternal embryo."

The Cal-carb, or cobalt, when balanced, is a beautiful childlike soul. Lewis Carroll, who wrote *Alice in Wonderland,* was a Cal-carb. They love children; they love memories; they have a tendency to be phlegmatic; they are creative and make beautiful pictures of how it used to be; they are copious secretors. They secrete a kind of love for creation, so they bring a *Madonna* nature to the spectrum. They often have a big head and a very rich inner picture life; they are often somewhat round, so periphery forces supply them with an abundance of ether body forces. When that ether body is in contact with the memory stream, they tend to collect memories, while their present life is based on their past.

For vermilion personalities, the present is based on what comes to them now, which they grab and hold onto; their memory makes things of the present fixed. That is the vermilion gesture. For the Cal-carb, cobalt things were better in the past. These two polarities complement each other. Anthroposophy is a path of knowledge, so a lot of the people in the anthroposophic movement have vermilion energy that helps them tolerate all the information. Turquoise and carmine are, too, but turquoise has a very strong thinking energy for categorizing, and that is also the vermilion, but vermilion is on the warm side. Carmine is ardently inward and devotional, which is also true of the cobalt, but on the blue side.

17

Flower Essences

Now we will return to our star with the Roscolux colors [number 4]. The color work of Liane Collot d'Herbois, Dinshah, and Catherine Coulter can give a whole picture of what I have presented about the way color can work. I used to work a lot with homeopathic remedies, and people would ask me what homeopathic remedy they should take, but then a homeopath suggested that I should have a license if I continued to recommend remedies. This gave me an idea.

I know Patricia Kaminski of the Flower Essence Society[1] from when we were both studying Anthroposophy in the foundation year together some twenty-five years ago. I have watched her and Richard Katz develop their remarkable flower essence work. In talking with Richard and Patricia over the years, I have developed a deep appreciation of flower essences. It is my perception that there are several levels in healing work. Homeopathy works largely with the relationship between the physical body and the life body. The attenuated substances make a kind of bridge to deal with issues between the physical body and life body. It is my experience that flower essences have a connection between one's life body and astral body; they focus on the sentient body. The substantiality of a homeopathic remedy is the reason I say it has a connection to the physical; it comes from a substance and affects one's life body.

In anthroposophic medicine, when a doctor uses a homeopathic remedy, they seldom go above 200 dilutions, because they want to leave that deeper realm to the freedom of one's individuality—that is, not interfere with a person's karmic freedom. Once you go past 200 dilutions, you are

1 See http://www.flowersociety.org and http://www.fesflowers.com for more about flower essences and the work of Patricia Kaminski and Richard Katz.

in the realm of what the homeopaths call "mentals." From the substance itself to 6x, we are dealing with acute conditions, and it is almost a physical substance. From 6x to 30x (or at 30x) we are moving into a feeling space. From 30x up into 200x, we are approaching the mentals, but past 200x we are in the mental realm. These numbers are based on Theodor Schwenck's research on patterns in dilutions.[2] If a condition calls for a remedy beyond 200x, an anthroposophic physician would suggest a therapy that involves art, colors, speech, or eurythmy in conjunction with the remedy. Such a doctor might even recommend a flower essence as a bridge to the feeling realm, though few anthroposophic physicians work with them. We move into karma and memory structures with art therapy, eurythmy, and speech.

Over the years I have found that a homeopathic remedy (especially in low dilution up to 6x) will calm an acute condition as a cure, but it is not a healing. One still has to do something to address the chronic condition behind the dysfunction. This means increasing the dilution to 30x or even 200x. But I have found that, when people take a 30x and a 200x remedy and don't do an artistic or other therapy as well, it will not be as effective. I have found that flower essences can become a perfect bridge. They can move the soul from an acute condition into the chronic condition to get a picture of the soul issue behind the chronic condition. That picture can then be used in an artistic way. A flower essence opens the feeling life as a door to artistic practice and research.

Flower essences allow a person to gain sufficient distance from one's emotions to observe them as though they were beings. In connection with the idea that a flower essence represents an emotional pathology, I encountered a series of books by Deitmar Kramer, a clairvoyant.[3] In *New Bach Flower Therapies,* Kramer looks at the Bach flower repertoire and

2 Theodor Schwenk (1910–1986) was a pioneer in water and flow research. He founded the Institute for Flow Sciences for the scientific study of water's movement and life-giving forces. See Schwenk, *The Basis of Potentization Research* (Mercury Press, 1988).

3 *New Bach Flower Therapies: Healing the Emotional and Spiritual Causes of Illness* (Healing Arts, 1995) and *New Bach Flower Body Maps: Treatment by Topical Application* (Healing Arts, 1996).

arranges it into twelve constitutions, or what he calls "twelve tracks." When these books appeared, I had already explored the work of Dinshah, Coulter, and others, so twelve tracks seemed immediately familiar. Kramer's method as a clairvoyant is to give flower essences to people and then a very deep profiling with them, not unlike a homeopathic approach, and then work with them inwardly.

Kramer found was that there are twelve tracks. In our diagram, we have the twelve tracks in the context of Coulter's and Dinsha's work. Kramer's thesis is that we come into life with a kind of mission or intent and that a lot of other people have been involved with that mission, though we may think ours is unique. When we first encounter this fact, the soul responds in an inner way on three levels. The first is becoming aware that this is not just my personal issue. Kramer refers to the second level as compensation and the third as decompensation. Thus, I meet the world and resistance to my mission, and then if I stay at that level, this is what the first flower essence is about. We could call it acute. If my response becomes chronic, this is the second level—I start to build a personality that compensates for my original mission, and is related to the second flower essence. If I just continue to compensate, it leads to an overriding feeling that my life is without purpose. Jung said something like, "I awake one morning and find that I am in a senseless life." He claimed that fifty percent of the people who came to him were functional in society, but they had a deep problem and sense that their life had lost its purpose.

Thus, in the middle in all these colors, the central one is a color, or flower, that compensates for the fact that the upper one is not functional. In green we have the flower essences mimulus, heather, and mustard. The homeopathic remedy is silica:

> + **The Sensitive Server**, silica — These souls bring the gift of selfless sacrifice to human life. They can direct their will to difficult tasks with grace and efficiency. They are sensitive to the needs of others and can act without expectation of reward.

– **The Sensitive Server** — These souls are very thin-skinned. To compensate, their thinking tends to form shields of competency over vulnerable areas of the soul life. Their shields form a prison of beliefs that restrict these souls when they want to change.

Consider mimulus: My mission is to come and serve (transparency), but I get caught in my own belief structure. Mimulus is a flower essence for oversensitivity that develops into phobias because people are anxious about specific things. That is exactly the silica problem. We come to Earth with a mission, but the world says no, and one's first response is that this is my unique mission, even if it is not perfect. At this level of life, mimulus helps if our mission is being marginalized by the world and we have not yet begun to compensate for it. Maybe silica is not one's actual constitution, but maybe it is a square or a trine. However, if one goes to work on it, it just keeps showing up. These first-level flowers are not usually the default remedies but they may help one who is little sensitive or phobic about something specific.

To work with flower essences, we need a really good fulcrum with flexibility. The flower essence people are always squeezing drops of something into their mouths, and they may change from one flower essence to another during the day or mix six together and so on, because the sentient body is always moving, in flux, and changing. With these first-level flowers in the circle, one may feel a need in the morning for mimulus because of some kind of pressure. On the other hand, let's consider the compensation of green—heather. The heather people are caught in what the kahunas call "the look-at-me dance," the polarity of "I see you." In this dance, one learns to go from being an immature look-at-me person to a mature I-see-you person. You could be eighty-five years old and be very mature in some ways but still have aspects of your personality that are still in a look-at-me dance. That dance is important because, when you are doing it, you cannot see me. That juvenile attitude has to be transformed into "I see you," or even "I am you" or "I awake in you."

As a flower essence, heather is specifically for those who are caught in look-at-me—they just cannot help it. It compensates for the fact that

when they come in as a green personality they are very sensitive and want to be *looked at but not seen.* Look at me, but not too much. They tend toward hypochondria, which is a way of getting you to look at them without feeling guilty about what they are doing. This is important, because in the spiritual world everything is based on attention—beings in the spiritual world are made up of qualities of attention. Esoterically, life on Earth is for the purpose of training our attention so that it can harmonize in the spiritual world after death. Here in a physical body and a soul, attention and recognition is the way we live; in a sense, we are looking for it all of the time. Recognition is *re-cognition.* I am re-cognizing, and I want to *re-cognize* me in you. This is dating and singles-bar attraction—I want to find me in you. I also want you to help me find me, and that will prevent me from having to find me in myself.

Heather is a compensation for the mission coming in; I want to be sensitive because I feel the light falling into matter. I want to be able to organize matter so that it makes sense. Thus, we get the sensitive server, a green. So this flower essence goes from your mission to compensation for your mission not being recognized. If this becomes chronic, you become upset with yourself for doing the same thing again and again, and then you move on to decompensation—trying to compensate for your compensation, and this can become very confusing. You go from an acute situation to a chronic one, and your personality now rules your daily life, rather than you being present and recognizing that your are not acting appropriately.

Our goal when we start to awake is to see that our response to certain situations is just an effort to compensate for the memory of something when we were three years old. When we compensate for our compensation, we get very confused. Mustard is unexplained sadness and moodiness. We go into a green funk of jealousy, the crazies, or a spontaneous wave of sadness. Deitmar Kramer says that we should never take these three flower essences together because of a process he describes as a kind of loosening. You want to create in yourself what eurythmists call a *Schwung*—a glide, or a force that moves you

from decompensation to compensation to acceptance of who you are without having to become obsessed. In all of the flower essences, this is what we could call the one track.

We know turquoise as the truth teller; the flower essence for this mission is agrimony.

> **+ The Truth teller,** *Natrum Muriaticum* — Supreme respect for truthfulness guides this soul's contribution to society. They go to great lengths to insure that their statements are thoroughly penetrated. Judges, scientists, and social activists often have this soul tone.

> **− The Truth teller** — Thinking of this soul is laser-like. Feelings are not trusted. Will impulses are directed toward truth at all costs. Logic is all-important and supersedes situations conditioned by feelings, making it difficult for these souls to apologize or admit error.

Agrimony hides fears behind a cheerful mask. The truth teller is faced with the task of always telling the truth. That is a tough order. The great fear is getting caught for saying something false. For turquoise, the homeopathic remedy is *Natrum Muriaticum,* the mission is to tell the truth, which creates the constant fear of being caught in an untruth.

> **Natrum Muriaticum** — Blinding headache. Numbness of tongue. Tachycardia, pulse intermits on lying down. Losing hair. Sadness and depression, aggravated by sympathy. Profuse weeping followed by loss of memory. Difficulty in grasping and retaining one's thoughts. Falls asleep late at night, and awakes early in the morning. Obsessive adherence to ideals.

Turquoise people have great mental capacity. They tend to mask their fear with a kind of manic cheerfulness. This is often the guy who is whistling all the time or singing little phrases of Bach to give an outer impression that everything is just wonderful. Yet, when they say, "What a wonderful world," they grimace. Their mission of telling the truth has created in them this kind of approach–avoidance to the truth. They have to tell it, but it is a pain in the neck for them to deal with the emotional fallout. So they began to compensate and go to vervain.

Vervain consciousness is overly enthusiastic but uses over-enthusiasm for hiding the fact that their truth telling is alienating them from those to whom they are telling the truth. When you are in a situation and have to deal with such a person, they constantly tell the truth as a kind of reflex. I was in a meeting some time ago, and two people who were peers at a fairly high level of their work were there. One of them made a comment, and the other said abruptly, "Well, actually that is not correct," and then just went on. These are the truth tellers. In telling the truth to a peer, however, they are oblivious to the fact that they have deeply wounded the other person—they were simply stating facts. I went to the truth-telling person and said, "Do you realize that you just cut that guy off at the knees?" He replies, "Oh yeah, really? What's the issue? I was just correcting him." Yes, but in front of everyone and with no thought of how it might make him feel.

So truth telling as your mission causes you to feel alienated, but you are also very enthusiastic about gathering facts to compensate, because truth telling is creating emotional difficulties. When you compensate for your compensation, you realize that your emotions are not doing well, so the next remedy for you is sweet chestnut. As a decompensation for the compensation of obsessive truth telling, sweet chestnut is about real despair. The truth teller debates with death at this stage, meaning: What does dying mean as a clinical question? If I were to die, is that the end of me? They flirt with dying as a truth issue, and they generally find themselves in situations in which they have to deal with ultimate truths. Maybe I should become a hospice chaplain or someone who has to deal with death as the ultimate truth. They compensate for their compensation, but truth telling becomes such a burden that they have to deal with the really big truths: life and death, truth and error. It is both their gift and their challenge. These people may eventually flirt with suicide in the quest for ultimate truth: Does it mean I am finished?

Deitmar Kramer found these tracks clairvoyantly. I found that, if a person is taking Natrum Muriaticum and doesn't seem to be progressing, one could approach flower essences as a little catalyst to help

the homeopathic remedy along. A flower essence can supplement art, eurythmy, or other therapies and stimulate dreams, for example. Dreaming provides pictures from spiritual beings, the archetypes behind the natural world we are navigating. Dreams are the means they use to communicate with us with the pictures we need to transform ourselves. That is their mission—to speak into our mission to help us see it. Flower essences, especially the way Kramer has arranged them, give us another layer in our work with color and homeopathy.

Kramer's second book, *New Bach Flower Body Maps*, uses these same essences and tracks and places the essences on parts of the body. Being clairvoyant, he found that certain organ systems can be mapped according to flower essences. In terms of acupressure or acupuncture, Kramer's body maps use points along the meridians. One places the flower essence on a compress on certain points. In my work, I have used the body map. First I would ask the person to take the colored gel test. We would make a chart and I would observe the color choices. We would compare that color chart and my color chart and determine the person's constitution. Looking at that color on Kramer's body map, I would ask questions: Do you ever have a rash here? Do you have liver problems? Do you have ear problems? Do you have something on your foot? The body map shows those different meridians. A person might have had an operation at fifteen or have problems eating table salt. Such indications enable me to suggest useful pictures, a color choice, homeopathic remedies, flower essences, a painting modality, and so on.[4]

4 For more on flower essences, see Julian Barnard, *Bach Flower Remedies Form and Function;* and David Dalton, *Stars of the Meadow: Medicinal Herbs as Flower Essences* (both published by Lindisfarne Books).

18

Conclusion

Jachin, *Life into Autumn*

>In pure thinking you find
>The self that can hold itself.
>Transform to picture the thought
>So you experience the creative wisdom.

Boaz, *Death into Life*

>Intensify feeling into light
>So you reveal the forming power.
>Concretize the will to being
>So you create in world being.
> (Rudolf Steiner)

The pole of Jachin is the pole of life moving into death. In pure thinking you find your self that can hold itself in check. This is the Rosicrucian phase of study and Imagination. Transform thought into picture and experience creative wisdom. Into the abyss of the unknown, we go into death. The pole of Boaz is the journey through death into a new life. Intensify feeling into life so you can reveal the forming power. This is where we begin to interact with beings on the other side of the threshold who had forming power in the formation of the world. We become cosmic beings living life among other cosmic beings, which is our task as a tenth hierarchy. From this arises the injunction, "Concretize the world to being, so you create in world-being." In other words, our will needs to be purified away from expectation so that it can become spiritually

creative. In his *Anthroposophical Leading Thoughts*, Rudolf Steiner says, "When, in Imaginative Cognition, people have eliminated the environment in which they live by means of their sensory system…" This relates to the Jachin verse: "In pure thinking you find the self." Pure thinking eliminates the environment in which I live through my sensory system. I have to eliminate anything connected to sensory experience and memory. Once I do that, "another system enters the sphere of conscious experience—namely, what is the bearer of one's thought, even as the sensory system is the bearer of one's picture world of sense perception" (pp. 197–198). Once we eliminate the sensory world we enter a world of thought. We find this by awaking in our life body.

> Now we know ourselves to be connected through our thinking system with the cosmic environment of the stars, even as we previously knew ourselves to be connected through our sensory system with the earthly environment. We now recognize ourselves as cosmic beings. Our thoughts are no longer shadowy phantom pictures. They are saturated with reality, as sensory images are in the act of sense perception. (p. 198)

Awaking in the life body means controlling the way images operate in us. "The knower who passes onto Inspiration at this stage becomes aware of being able to cast aside the world that the thinking system bears, just as one can cast aside the earthly" (ibid.). We can eliminate the senses; then we eliminate thoughts related to the senses and purify thinking of thoughts. This is the role of the meditative life. "We see that with his thinking system, too, we belong not to our own being but to the world" (ibid.). In sensory experience and the formation of thoughts connected to it, none of that is really me; it is in the world. "We realize how the world thoughts rule us by means of our own thinking system. Here again we become aware that we think not by receiving images of the world into ourselves but by *growing outward* with our own thinking organization into the thinking of the world" (ibid.). The world exists *a priori* with all of its great mysteries, and we extend our thinking into the world to experience meaning. The key is my soul going into the world.

"With respect to both our sensory and thinking systems, human beings are *world*. The world builds itself into us. In sense perception and in thought, we are not just ourselves but part of the world's content" (ibid.). Any memory or sensory experience that we have—a memory based on a sensory experience—belongs to the world. It doesn't go with us when we die. "Now we penetrate into our thinking system with our own being of soul and spirit, which belongs neither to the earthly world nor to the world of stars, but is wholly spiritual and thrives in human beings from life to life on Earth. This being of soul and spirit is accessible only to Inspiration" (ibid.). This is the realm beyond the stars, beyond sense impression, beyond thoughts based on sense impression, and beyond memories. We go there when we can silence all these things, and we experience a world populated by beings beyond memory, sensation, thought, and so on.

"Thus human beings step out of the earthly and cosmic systems of their nature" (ibid.). The cosmic system is pictures that arise from sensory impressions; the earthly system is the actual sense impressions themselves and all the forces in that. We step out of the earthly and cosmic systems of our nature to stand before ourselves as beings of pure soul and spirit through conscious Inspiration.

> And in this being of pure soul and spirit we meet the life and law of our own destiny [*or what Rudolf Steiner calls* Akasha]. With the sense system, human beings live in the physical body, with the thinking system in the life body. We find ourselves in our astral body when both systems have been cast aside in the living activity of knowledge. Every time we cast aside a portion of the nature we have assumed, the content of our soul is indeed impoverished on the one hand; yet, on the other hand, it is enriched. [*Our soul is impoverished in earthly terms but enhanced in a spiritual sense.*] The physical body having been eliminated, the beauty of the plant world as seen by the senses is no longer before us, except in a much paler form. On the other hand, however, the whole world of elemental beings living in the plant kingdom arises before our souls.
>
> Because of this, those of true spiritual knowledge do not have an ascetic attitude toward what the senses can perceive. In the

> very spiritual experience, there is still an inner need to perceive again through the senses what we now experiences in the spirit. (pp. 198–199)

This is the key. When we close down all these things and actually live in the silence, we live just in the astral body. We feel an urge to return to the sensory world to bring what was learned in the silence into our work of redeeming the elemental beings imprisoned in the sensory world. Something grows in us—a moral conscience of the debt we owe to the cosmos and to the beings who sacrifice to create nature so that we can be free.

> In full human beings, seeking as they do to experience the whole reality, sense perception awakens a longing for its counterpart—the world of elemental beings. (ibid.)

A whole world of being exists behind the sensory world, but as long as we see it only as a sensory experience, that world is denied to us.

The elemental world is one of yearning and enthusiasm to become. That is its nature. It is the counterpart to the fixedness of the sensory world—the red and blue I see out there attached to objects. Behind the red and blue I see attached to objects is a whole world of being that is yearning to become. If I can live in that yearning and disassociate myself from the color in the object, I lift color and work with it inwardly. Thus I am redeeming the elemental beings locked in the color of the object that seems separate to me through my sensory experience. "Likewise, the vision of the elemental beings kindles the longing for the content of sense perception once again." Longing, longing, longing; yearning, yearning, yearning.

Behind the work of Rudolf Steiner is this mantra: Sense yearns for spirit; spirit longs for sense. They are irresistibly attracted to each other. The soul is the mediator between the sensory world and the spirit, the body and spirit. This yearning of the sensory world is the turbid medium of the soul, and the turbid medium of the soul includes these two polarities held in dynamic balance as I shift my fulcrum to make a balance between the spirit and the sensory world.

There is sacrifice on both sides. The spirit sacrifices to be stuck in a body—this is Christ. Once spirit is stuck in a body, the sacrifice needs to be recognized; we need to pay attention to the sacrifice that has caused the world to be fixed. It is imprisoned by our sense organs, but I have to do something in my sense organs to revive them, so I can take a dead sensation and experience it as living. I revive my senses through aesthetic experience. I become sensitive to nuances of color, tone, movement, interval, relationship, form, activities, becoming, harmonies, geometries, and so on. I become sensitive in my senses as my senses experience the life of the sensory world. In the act of seeing red, I don't see just the corpse of red; I also always see it in its polarity and wonder whether it is carmine, vermilion, orange, or magenta? To the uninformed, it is just red, but to those who work on themselves, it is filled with nuance and yearning to be something else. When I experience it this way, it gives me a certain impression of life that allows me to have an experience in myself—that my soul is moving in a particular way.

This is the essence of what we do in color work. It is what Goethe saw; he had a particular configuration in his life body that allowed him to do that. He saw the yearning in the color as a creation; he called it "the deeds and sufferings of light." To him, that yearning in the creation was palpable. He could allow the color to act on him because his senses were enlivened, but his life body was not yet ensouled. That came later on through Anthroposophy. He lacked the cosmology to ensoul his liver; he had only this ether body. Rudolf Steiner said that, because he was a great Greek sculptor, Goethe had an ether body with eyes—an ether body that could see into the physical and the life there. However, to ensoul it he would have had to be an anthroposophist and be able to bring that cosmology to his experience. If he had been able to do that, he could have ensouled his life organs; he would have understood his liver as Jupiter and understood what Jupiter is, and then the music of the spheres would have been present.

That is another level; this process of enlivening the senses and ensouling the life body yields the consciousness of Inspiration, but it can happen

only through a kind of reversal process whereby we get rid of the sensory experience—the experience of thought and imagery in the life body—and live purely in the astral body in silence. However, if we take pictures from our sensory experience, the physical body, and thought patterns around it in our life body—if we take symbolic images from that experience into the silence—the astral body becomes connected to our "I"-being. In the silence our "I"-being is present and lifts our feelings away from us personally and starts to move them into the realm beyond the stars. If we do this before we go to sleep, we awake in our sleep to the way that is happening beyond the stars. Thus our dreams are transformed and, in the morning, we can take some dew from the experience of letting go of those symbolic pictures in the evening.

In *Anthroposophical Leading Thoughts,* Rudolf Steiner says that Goethe had to go to Schiller so he could interpret Goethe's dream, and Schiller had to go to Goethe to find the will to have created fantasy. In the future, Goethe and Schiller must be the same person. When they are the same person, we begin to take the dream and make art from it—art that is therapeutic rather than mere self-expression; art that is symbolic of our mission. We are all artists in that way; this simply means aesthetic experience. Cooking becomes a spiritual practice; gardening becomes a spiritual practice—that is biodynamics; walking becomes a spiritual practice—that is eurythmy.

Rudolf Steiner gave a number of lectures that present a color theory.[1] He did not work in a vacuum; his color theory is completely in keeping with the practice of the old masters. The key to Steiner's idea is this: We have something called image colors and luster colors. Image colors are black and white; they make images—green and red, black, white, green, and burnt sienna—the traditional underpainting colors of the masters. If you had been a painter in the fourteenth century and trained as an apprentice to a master, he would teach you how to paint by giving you four colors: black, white, green, and burnt sienna. This is because those colors give you a range of colors that are dynamic rather than the actual

1 *Colour* (Rudolf Steiner Press, 1997), 12 lectures from 1914 to 1924.

pigments. Black and white provide the steps of light and dark in the value structure. The other two provide degrees of temperature; green gives the cool, and burnt sienna provides the warm.

So those traces of black, white, green, and sienna in old paintings as the image colors are not random but perfectly in line with master practices. It is known as underpainting, in which those colors are combined to create value structures and temperature gradients. A gradient is a set of temperature or values that move from, say, a light to a dark through a middle tone. This is a value structure, or value gradient. I start with the lightest light on the palette and that is my lightest light value. Then I take the darkest dark that I will use and that is my darkest dark value. Depending on the pigments used for the light and dark, if I mix these two together in a certain proportion, I can end up with what will be a middle tone. With the darkest dark on one side and the lightest light on the other, and a middle tone between, I have three steps of a value structure for my painting. If I mix my lightest light and the middle tone I get a middle light. If I mix my darkest dark with the middle tone I get a middle light. Now I have a five-step value structure on which to base my painting.

The five-step value gradient is the basis of the old masters' painting system called *chiaroscuro* (*chiaro* = light; *oscuro* = dark). When you look at an old master painting you see light-to-dark movement. That is chiaroscuro, where dark is moving toward the light, giving your soul an inner experience like flying or yearning, a kind of flow. That is the painterly side. Chiaroscuro is the middle system, using value structures to create a kind of inner experience.

On the one side is the linear use of chiaroscuro, whereby every different gradient is arranged with an outline and a hard edge. Then I get a more linear chiaroscuro, a classical gesture. On one side of chiaroscuro, everything blends into everything else; this is *tenebroso,* meaning everything is coming from the dark. These traditional painting methods hinge on the idea that a gradient is moving my soul from light to dark or from dark to light. Whether it is a hard or a soft edge has a lot to do with the age in which the value system is used. In classical painting, the edges are

harder and the contrasts sharp. In Baroque and Romantic systems, the edges are softer and the gradients mixed. As a result, our soul participates in the value structure as the way we yearn for things in this age. We either want everything to be crystal clear, as in the high Renaissance, or we want things to be murky, as in the Reformation. Thus the value structure of a painting is the basis of the image, but the quality in which the value structure is held, whether it is hard edge or only three grays, reflects the temperament of an age.

Diego Velázquez (1618–1622), a mannerist painter, had twenty-eight very nuanced grays because it was the age of intrigue and secret, nuanced drama at the king's court, which is what he painted—the mood. The value structure of the image creates a kind of percussive quality, a rhythmic cadence, whether with smooth gradients or very choppy. It is the difference between elevator and rap music—syrupy violin overlays versus staccato punches. The inner experience is very different because of edges, tones, and movement. Rudolf Steiner, taking this idea, said that we need to make our image colors—black, white, green, and burnt sienna—behave as lusters. The luster colors are red, yellow, and blue, or the primary colors. In classical painting, they are part of the overpainting, the colors added over the underpainting; black, white, green, and burnt sienna were used to create the image, because they were more readily available. One could burn bones or grease or work with natural substances. There is black and white, and then *terre verte,* derived from glauconite, a grayish-green rock. *Terre vert* is green earth green. Sienna is a clay earth pigment containing iron oxide and manganese oxide. It is burnt to get a different, lighter shade. The clay from which the color is made was originally found around the Italian town of Siena.

These colors are very earthy and used for underpainting, following a rule called "fat-over-lean." You have to put down the lean areas first and gradually build up to the fat areas, because if you put lean over fat, the lean dries more quickly, and the fat more slowly, so it would crack. Lean areas use a lot of solvent and dry quickly while fat areas use a lot of oil, which dries more slowly. It just happened that black, white, terre verte,

and burnt sienna, as earth colors, could be used very leanly to make the underpainting, which would be allowed to dry quickly. They would then layer on top of that the varnishes and fatty oils that would be mixed with pulverized precious stones such as lapis for blue, rubies for red, coral for pink, and so on. Precious stones are in the fat layer over the lean layer because you want the nice varnishes and oils to keep the pigments of the precious stones on top and separated so that light could go in and bounce off the underlying image layer on the bottom and reflect back through the upper layers to create a lustrous affect. These are the luster colors. Thus, the underpainting is established with black, white, terre verte, and burnt sienna to establish the value and temperature structures in the lean layer. By contrast, in the fat layers of precious stones use resins and oils to hold and embed them into the surface. The lusters are transparent in the glaze layer, and we see the underpainting image come through. That is traditional painting—it separates the image colors and the luster colors.

Rudolf Steiner said the image colors are black, white, red burnt sienna, and terre verte. Burnt sienna in the underpainting appears as a fine and delicate pink, or peach blossom, when painted over with translucent white, which is obtained by mixing zinc or lead oxide into a very fine drying oil such as poppy seed oil. When such a thin layer was painted over a dried section of burnt sienna it appeared to be a delicate peach pink.

However, Steiner was very progressive and said we want the image colors to act as lusters, and we want the luster colors to act as images. He was referring to a certain trend in art during his life that involved a radical use of color. Imagine a light source. Steiner's color theory calls the light source the illuminant. There is also something he calls a "shadow thrower." It is illuminated on one side by the illuminant, and a shadow is thrown onto the opposite side (figure 41, page 258). In this upper diagram is a cube and a source of light striking the cube. Where the light is most direct we see a highlight. Where the light is least direct it is dark. Between the two is a mid-tone. These are the three grays—light, mid-tone, and dark. This is a typical chiaroscuro, a technique dating from

shadow thrower

illuminant

Figure 41

the Renaissance that employs strong tonal contrasts between light and dark to depict three-dimensional forms. We have an object or person as shadow throwers and an illuminant, and together they cast shadows.

In the diagram, we perceive the cube and the space because it is receiving light from the illuminant and making shadows. In a more involved chiaroscuro, we might have a shadow attached to the cube and cast onto another surface. The system of shadows and ambient light is chiaroscuro. The more sophisticated the value and temperature structure, the more we have an impression of ambient, or reflected, light in a painting. You can get the impression that this thing there is in space, and you can go up and touch it. The goal of chiaroscuro was to render a form as if we were experiencing an actual three-dimensional sense perception. This was the goal of classical painting.

So I have a highlight, mid-tone, and dark created according to the context of illumination. When I surround the light areas with strong darks and the darks with light areas, they appear to shine. I am making my light and dark colors of behave like a luster, because I put them in a context of illumination against a dark ground, and they appear to shine with light. There is this well-known painting, *The Calling of Saint Matthew*, by Caravaggio.

Christ stands backlit on one side of the ten-foot painting; the light shines from behind Christ's head, and we see him pointing his finger. There is a dark space between Christ and the figures that include

Conclusion

Michelangelo Merisi da Caravaggio, The Calling of Saint Matthew *(c. 1600)*

Matthew at a table with a few men, possibly counting tax money. The light from Christ radiates trough the darkness and spotlights Matthew, who is looking at Christ and pointing toward himself, as if to say, "Do you mean me?"

In making image colors lustrous, we make them live. This is an inheritance from chiaroscuro. It was very effective for creating an experience of three dimensions on a two-dimensional surface. It was

Colors of the Soul

Paul Cézanne, Le Barrage Zola *(The Zola Dam), 1879*

the dominant rule for painting until the mid-1800s, when photography and new paint colors were being developed and the role of painting changed. In addition to reproducing three dimensions in two, something else was introduced by the impressionist painters, especially in the work of Paul Cézanne and Claude Monet. Imagine a cube illuminated by a light source, but we use yellow for the light, red for the mid-tone, and blue for the shadow. If we mix red, yellow, and blue in the right way, they can all have the same value, and we would render illumination according to contrasts of hue instead of values. In certain Monet paintings we see a cathedral or haystacks, but in a black-and-white photo of the painting we would not see the image, since the contrasts depend on color rather than shades of light and dark. Impressionists found that hue contrasts are stronger when the values are similar. If all of my colors are rendered in a middle tone, the hue

contrasts appear stronger. Many of Monet's paintings replaced value in favor of hue.

With this new technique, impressionists turned classical chiaroscuro painting on its head. Instead of establishing a value structure in an underpainting and then laying lusters over it, they used luster colors. They applied tints and hues and limited the value structure, so that the sense of space was created by the hues instead of values. They used the luster colors as image colors. They moved away from depicting three dimensions on two and tried to let two dimensions depict the inner experience of the soul participating in the color. Cézanne developed this to an incredible degree in what is called *passage* in French. His whole color space was organized, not with traditional chiaroscuro values of light and dark from an illuminant, but all of the movements of the forms moved through the same hue "passages," or cadences, giving the illusion of space created completely from color. Cézanne's idea was that everything in nature is a cube, a cylinder, or a sphere; his geometry was very simple. In his paintings, movements that would be represented by a value structure in a traditional painting are shown in chromatic and hue changes—from cool to warm and warm to cool—through a band of hues rather than the value structure. He made his luster colors work as image colors, following the dictates of Rudolf Steiner without knowing it.

This is the direction of Steiner's color theory for contemporary painters who are trying to portray spiritual themes—making image colors work as lusters and luster colors work as images. We use luster colors in such a way that they give the impression of imagery without resorting to the values of chiaroscuro. In this way, lusters, or cosmic colors, can touch the earth, and earthly colors can rise and touch the cosmos through carefully arranged rhythms of light and dark. Our experience of image colors is the sensory world; our experience of the luster colors is the spiritual world. The spiritual finds itself in the sensory world; the sensory world finds itself in the spiritual world. Steiner is saying the same thing in his color theory.

This is just art history, but through the filter of Rudolf Steiner's work as an initiate. Even today, very few painters get this. Steiner's thinking is in line with the old masters and in keeping with the spirit of his time, when impressionism was moving to post-impressionism and when colors were being freed from their need to make images that replicate the sensory world. Painting and color started to move into the soul and through the soul into the cosmic role of human beings as world creators. This is what the painters were talking about in the early twentieth century. There is a coffee-table book related to an art show in Los Angeles, *The Spiritual in Art: Abstract Painting, 1890-1985*. The show featured many painters who worked with a focus on spiritual matters. A number of articles in the book mention Rudolf Steiner and some artists who were theosophists. The essays were not written by anthroposophists but by art critics and scholars.

Steiner's work was seminal for many of the artists who were struggling to break out of European trends of the time and bring art into the new age—away from the inheritance of underpainting and overpainting and the verisimilitudes of strict representational art. These painters saw something else. They were harbingers of a new way of looking at the world, a new way of being. Steiner also has a wonderful art history course using slide presentations.[2] His color theory remains largely unknown. The point is that he did not pull this out of thin air; these principles are in line with classical painting—where it was and where it needed to go. It needed to replace the reliance on the light and dark with actual red, yellow, and blue from soul experience. Instead of the dynamic color being just layers and layers of images, the dynamic had to behave like an image, which gives us the best of both worlds. When lusters behave like an image, it is called color space, which is in two dimensions and is not concerned with creating the illusion of a third dimension. The color is just in that plane, but it moves in and out of the plane, depending on the feelings in those colors, whether it is on the cool side or on the warm side. It requires one's fulcrum to enter

2 Steiner, *Art History as a Reflection of Inner Spiritual Impulses.*

that color space, constantly balancing forward and back, right and left. So the new illuminant is the viewer.

There is a secret in the illuminant and the shadow thrower. There is a demonstration in which we take a candle into a darkened room and put it next to a light wall. A single candle illuminates the room as the illuminant. Next, we hold a floodlight and shine it at the flame, and the flame will cast a shadow on the wall. Now the illuminant is also a shadow thrower. Is it analogous to the human soul talking to an Angel or an angel talking to an archangel? An illuminant in one context can be a shadow thrower in another. This is the essence of the inner life, and Steiner, in his color theory, tries to tell us that we no longer have to spend all of our time trying to replicate this sensory world. We need the sense world, but we also need to bring the spirit into it. Why did Steiner bring us this idea? The great threat in our time comes from Ahriman, who tells us that the only thing that matters is the sensory world. In the ancient world, Lucifer told us that the most important thing is the spiritual world, and that the sensory world is maya—an illusion. Thus, the pivot has changed for us, but people are still enamored by the old cultures. My self is maya; the world is maya; everything is maya. But Rudolf Steiner said that the real illusion is thinking that the sensory world is maya. The sensory world is crying out for human beings to bring the spirit to it—spirit that it lost by sacrificing for us.

The Rosicrucian work is to enter the sensory world, which has fallen because we need to be free. We owe a debt to the elemental beings in the sensory world, to free them from their prison of our belief. When our heart shoots peach blossom up into our head, we need to be aware of that. It is what Rudolf Steiner calls etheric vision. Our heart gets the force to do that from the kidney. It rays up into the heart, and the heart radiates into our head. The head illuminates our brain with a beautiful peach-blossom color—especially the center of the brain, where we have what is called the Womb of Immaculate Conception in the third ventricle. The pictures we have there show a world that could happen, not a world that did happen. Rudolf Steiner calls that etheric vision, or

a vision of the etheric Christ. To do that, we have to watch as the world comes into our eyes and crosses over and goes down into our kidney and dies in the adrenals. We have to reverse this and bring that current back up and out through our heart, into the brain, out of our eyes, and take that devotion out into the sensory world. This allows us to see the sensory world as alive instead of just a resource to be used and thrown away. However, the living part is not the part we see. Unless we bring something to the part we see, we will not be able to see the life, because Lucifer and Ahriman take what we see and fix it inside of us as belief structures.

The struggle for us human beings is waking up to the fact that our sensing is a world being. We concretize our will to be so we can create in world being. Our role is to take what normally comes in through the senses and to enliven it and ensoul it to such a degree that when we actually put it out, the things we make in the sensory world no longer cause pollution; we would not cause it to groan and travail and suffer. That is our future—technologies that don't keep whacking the life out of the sensory world. We have the capacity to do it, but we need the esoteric cosmology to do it. This is what Rudolf Steiner did. When he came back to earthly life, he said this is how to do this, but don't do it the way I did it. He gave us a model, but we have to reinvent it every time we do it.

Take up your bed and walk. Reinvent it. Reanimate it. Re-test it. Reform it yourself, because your own true self is going to make this work. I made it live with my true self; you need to make it live with your true self. But if you make it live with your true self, the cosmos is nourished by your contribution from your true self. Steiner didn't come back to bring something that was fixed so that we would always do it that way; he understood that our fulcrum must remain flexible. We have to keep reinventing it and moving it all the time.

We conclude with a short quotation from Rudolf Steiner (*Anthroposophical Leading Thoughts*):

Thus, what Michael preserves from the crystallization in the inner human being is received by the spiritual world. What human beings experience of the force of conscious imagination becomes at once part of world contents. That this can be so is an outcome of the Mystery of Golgotha. The Christ force impresses the spiritual imagination of the human being into the cosmos. It is the Christ force united with the Earth. Insofar as it was not united with the Earth but worked upon the earth as a sun force from without, all the impulses of life and growth went into the inner nature of the human being, who was formed and maintained by them from the cosmos. Since the Christ impulse has been living with the earth, human beings in their self-conscious being are given back again to the cosmos.

From cosmic beings we have become earthly beings. We have the potential to become cosmic beings once again when, as earthly beings, we have become our self. (p. 183)

Appendices

1. *Homeopathic Qualities*

+ **The Sensitive Server,** silica — These souls bring the gift of selfless sacrifice to human life. They can direct their will to difficult tasks with grace and efficiency. They are sensitive to the needs of others and can act without expectation of reward.

− **The Sensitive Server** — These souls are very thin-skinned. To compensate, their thinking tends to form shields of competency over vulnerable areas of the soul life. Their shields form a prison of beliefs that restrict these souls when they want to change.

+ **The Boss,** Lachesis — By their willingness to shoulder enormous undertakings, these souls provide human life with the force to get things done. Capable of great concentration in specific tasks they can provide reliable guidance to others through complex thought processes.

− **The Boss** — These souls are confused in their thinking about boundaries between the personal and the ideal. They feel irritated with any alleged impedance to the collective goal. They value efficiency, but their misuse of will often amplifies misunderstandings.

+ **The Actor,** Phosphorus — The radiant wit and charisma of these souls brighten any group they inhabit. They bring humor and warmth to unpleasant circumstances. They are highly sympathetic to the soul tone of others.

− **The Actor** — These souls feel secure when dramatically engaged in the present. Thought life centers on anxiety over the future. Will impulses are toward self-expression through large gestures. The individual craves recognition from the community.

+ **The Perfectionist,** Arsenicum album — These souls bring the gift of perfection in the realm of the will. Projects undertaken by these highly idealistic souls are sure to be accomplished with dexterity and integrity. These souls make dedicated editors and development people.
– **The Perfectionist** — Such souls couple intensely focused thoughts with a will that seeks complete control. With a withering verbal barrage they can make it clear that they will not tolerate less than perfection. Their feelings often cycle around control issues.

+ **The Irritated Scholar,** Sulfur — This soul has an extraordinary capacity to organize large volumes of seemingly unrelated ideas into coherent wholes. Encyclopedists, philosophers, scholars, and paradigm-shifting researchers often have this disposition.
– **The Irritated Scholar** — These souls are feverish and omnivorous collectors. Their thinking is toward the greatest good, but the feelings are self-directed. When this polarity is conflicted, they become obsessively irritated and lash out.

+ **The Peacemaker,** Pulsatilla — Society owes many thanks to souls with this constitution. They seek blessedness and harmony as a self-evident native state for all humanity. Diplomats, legislators, and humanitarians of all kinds are among the peacemakers.
– **The Peacemaker** — These souls' thoughts focus on the highest ideals. Their feelings oscillate between elation and frustration. These souls are willing to make any effort for reconciliation where there is conflict. Their will becomes self-condemning when their efforts fail.

+ **The Noble Sufferer,** Staphysagria — Creative breakthroughs are the gift of these intense souls to society. They are the "canaries" in the social coal mines. Great capacities enable these souls to intuit changes and trends far in advance. They produce groundbreaking works.
– **The Noble Sufferer** — The thoughts of these souls are intensely focused on a particular interest. Their will is to make a unique and selfless contribution to humanity. Conversely, they feel indignation at having to take the hit for the unappreciative masses.

+ **The Flawed Leader,** Lycopodium — These souls have the capacity to endure a remarkable amount of criticism and setbacks while maintaining a positive attitude toward the work at hand. They step in to lead when others shrink from an enormous challenge.

− **The Flawed Leader** — These souls have huge self-esteem but feel detached from the struggles of the masses. Thought life centers on self-image. Their feelings create a bubble to deflect criticism. Their will is focused on obtaining power and is prone to self-destruction.

+ **The Proud Sufferer,** Sepia — This soul brings an intense idealism to life that is often focused on high spiritual causes or the struggles of the underdog. Advocates and supporters of the arts, religious movements, animal rights, and similar causes often have this soul tone.

− **The Proud Sufferer** — These souls crave freedom from attachments. Affection requiring reciprocation is felt to be a burden. Thoughts are focused on the ideal. Feelings oscillate through degrees of indifference. Will impulses seek vigorous movement or release.

+ **The Broken-hearted Lover,** ignatia — This soul tone is a temporary condition brought on by unrecognized grief. It is often a soul block that masks the true constitution.

− **The Broken-hearted Lover** — The feeling mood of this soul is unconscious and inconsolable great loss. Confused thoughts revolve around a blow of destiny that seems beyond their capacity. This is a temporary combination of sorrow, loss, and shock.

+ **The Eternal Embryo,** Calcarea Carbonicum — This soul brings a tender and childlike devotion for life that can be a source of community health. Compassion dominates daily work. Social workers, teachers, nurses, and caregivers often exhibit this soul tone.

− **The Eternal Embryo** — These souls' thoughts move toward the past. Their feelings are tender and tend toward naïve idealism. The will is affected by a great dislike for change. When criticized or questioned, they often brood about their health (hypochondria).

+ **The Truth teller,** Natrum Muriaticum — The supreme respect for truthfulness guides these souls' contribution to society. They go to great lengths to insure that their statements are thoroughly

penetrated. Judges, scientists, and social activists often have this soul tone.

- **The Truth teller** — The thinking of These souls are laser-like. Feelings are not trusted. Will impulses are directed toward truth at all costs. Logic is all-important and supersedes situations conditioned by feelings, making it difficult for these souls to apologize or admit error.

2. Homeopathic Remedies

Silicea Styes — Boils and abscesses. Extreme coldness of body with desire to remain close to fire or heat source. Offensive foot sweat. Rippled nails. Compunctions of conscience about trifles. Yielding disposition. Fainthearted and overly sensitive to outer stimuli. Somnambulism. Has anxious dreams.

Staphysagria — Very peevish. Easily wounded. Becomes indignant. Considers the least offence to be a premeditated insult. Hypochondriacal or apathetic mood, prefers solitude. Self-absorption. Thoughts vanish while speaking or thinking. Uneasy sleep and obsessive dreams of the previous day's works.

Ignatia Amara — Ill effects of grief and worry. Changeable moods. Twitching facial muscles. Insomnia. Violent yawning. Dry, spasmodic cough. Intense though partially suppressed grief anxiety, as if crime had been committed. Grief following loss. Grief of children after being punished by parents. Sad, quiet, melancholy; "weeps tears inwardly."

Arsenicum Album — Sneezing. Photophobia. Seaside complaints. Restlessness. Intolerance of food smells. Jaundiced. Anemia. Intense anxiety with great restlessness. Fears being left alone. Fear with cold sweats. Cannot find rest anywhere.

Pulsatilla Nigra — Taste of mouth continuously changes. Dislike of fat and warm food. Menses intermittent and changeable. Pains in the body continuously shift. Patient is timid and is easily discouraged. Moods are changeable and contradictory. Fretfulness and fearfulness are the chief characteristics. Sleepless during first half of the night.

Natrum Muriaticum — Blinding headache. Numbness of tongue. Tachycardia, pulse intermits on lying down. Losing hair. Sadness and depression, aggravated by sympathy. Profuse weeping followed by loss of memory. Difficulty in grasping and retaining one's thoughts. Falls asleep late at night, and awakes early in the morning. Obsessive adherence to ideals.

Lachesis Mutus — Hot flashes. Neuralgia of coccyx. Tendency to talk too much. The mind is weak and erratic. Makes many mistakes. Lack of mental continuity. Constantly changes from one subject to another. Jealous. Thinks of oneself as under superhuman control. Wide awake in the evening. Great sleepiness but unable to sleep.

Lycopodium Cirrhosis — Hernia, hemorrhoids. Sciatica. Impotence. the non-eliminative lithemic (stone producer). Ailments develop gradually. Functional power weakening, with failures of the digestive powers where liver function is seriously disturbed. Weakness of memory. Fretful, irritable, and morose. May become vehement and angry if crossed in purpose or desires. At times adopts an imperious and domineering manner. Self-important thinking.

Phosphorus — Fatty degenerations. Scurvy. Vertigo of the aged. Dandruff. Falling hair. Hemorrhages. Cirrhosis of liver. Glaucoma. Vomiting soon after taking water. Hoarseness. Various respiratory problems. General apathy and indifference. Very low spirits. Dread of death when alone. Indisposition to mental or physical exertion (also Nux Vomica and Sulphur). Ideas slow in evolution. Inability to think. Occasionally nervous, fearful, and hysterical. Sleepless before midnight. Falls asleep, but easily and frequently awakes during the night.

Sepia — Bearing-down sensation. Weakness of back. Hot flashes at menopause. Indifference to friends and relatives. Sensitive and sad but aloof. Much inclined to weep. At times apathetic and indifferent. Fretful and easily offended. Dread of being alone. Apprehensive of the future with great fears over health. Sleepy or dull during the daytime and early in the evening. Awakes at 3 a.m. and cannot sleep again. Talks in sleep. Sleepless from rush of thoughts. Awakes at night, with palpitation and anxiety over things that happened years ago.

Sulfur — Burning and redness of eyes. Burning in palms and soles. Unhealthy skin with tendency to skin diseases. Great acidity. Difficult respiration. Hemorrhoids. Aversion to bathing. Intense anxiety and apprehension, especially in the evening (also Calcarea Carbonica). Forgetfulness. Indulgences in philosophical speculations are followed by abnormal mental exhaustion, and an inability to hold the mind to work on any subject. At times fretful and ill-humored. At times indolent and indisposed to exercise. At times sad, melancholy, inclined to weep, and despair of salvation. Often wakeful during the entire night. Awakes frequently when the patient does sleep (also Phosphorus). Anxious and vivid dreams accompanied by starting during sleep, especially soon after falling asleep. Insufficient sleep at night and irresistible drowsiness during the day.

Calcarea Carbonicum — Excessive head sweat. Discharging ears. Easy catches cold. Head proportionately larger but legs thinner in children. Obesity. Loss of appetite when tired. Umbilical hernia. Gall-stone colic. Menses too early, too profuse, and too long. Feet feel cold and damp. Apprehension and Forgetfulness. Probably one of the most effective remedies for this difficulty. The patient misplaces words (compare Arnica). Fears of losing one's reason or of impending misfortune. Fear that people will observe one's mental confusion. Peevishness. Anxiety with the approach of evening. Much mental trouble over imaginary things. Awakes too early at 3 a.m. Sleepiness during the daytime. Dreams of falling. Spends much time thinking of the past.

3. Soul Moods in Colors

Colors in front of the Light

Magenta is the color of the creative forces of the Godhead. Insight comes from far above to the magenta soul. The insight is also usually accompanied by soul darkness and the disinclination to think in logic structures. In the movement from the yellow to magenta we could adapt a temperamental sequence from Goethe which may prove instructive. Yellow, the color of lovers or actors; orange, the color of diplomats and

generals; vermilion the color of philosophers and scholars; carmine, the color of priests and public servants; magenta, the color of geniuses and madmen. The moods of the colors are a result of the gradual intensification of the yearning to ray out from a center. In the soul dynamics of yellow there is a mood of excited expectation. The expectation is centered on the experience of coming into being or coming into incarnation. We could call yellow the color of the draperies of the threshold of darkness that surrounds the light of knowing. It is the soul color of the experience just outside of the holy of holies. In the soul the experience of thought arising as the light of knowing is the essence of the color yellow. In yellow there is the yearning of the soul to be or to become. The soul under the influence of yellow is yearning to know. Not necessarily to know anything specific. That is another color. But in yellow the sheer experience of knowing forms the fundamental soul yearning.

The deepening of the yearning to know as the soul moves from yellow into orange gives rise to soul feelings that what is known is more important than the direct experience of knowing which was present for the yellow soul. Orange has less of the immediate force of the light of thinking and more of the warmth of the effort of struggling out of the darkness. In orange there is still the underlying force in the soul of wishing to radiate from a center. But now it is more intensified, more densified, and not as light. In orange there is present a great enthusiasm for raying knowledge out to others as if the thinking had to penetrate some boundaries. As a mood of soul, orange brings the mood of great enthusiasm. There is a defining mood living in the orange soul that life consists of a struggle that inevitably leads humanity toward an ultimate state of perfection. For the orange soul there are definite ways toward this perfection and they are inexhaustably determined to make sure that these ways to perfection shall prevail.

The mood of vermilion is a deepening of the intensification of the shadow element present in the orange. As the yellow yearning to ray out from a center is deepened through orange into vermilion the actual hue shift away from yellow is apparent. In carmine the consuming fire of the

vermilion is tempered into an ardent inward mood that does not let its forces dissipate as it seeks to intensify the motif begun with the yellow of raying out from the center. In carmine there is the hushed expectancy of a mystical union between the darkness and the light of thinking. The light of the thinking consciousness ardently burns through all of the veils of darkness in carmine giving a deep and reverent mood. The acquisitive, assertive energy of the vermilion is gone and in its place we find a still, tempered red, paradoxically full of force and being yet barely moving. As this tendency has gradually deepened from yellow to magenta, the mood of the soul has shifted from one of lighthearted joy arising within the act of thinking to deep creative inwardness bordering on soul pathology. The intensifying process has enhanced the soul gesture of raying out and deepened it into its polar condition of delving deeply within the soul for the roots of one's own genius.

Colors around the Light

Being in the light and perceiving what is word-like in the unmanifest gives the green soul the capacity to use intellect in a clear and objective way. Being aware of how the light of the intellect manifests into forms gives green persons a keen sense of order, and they often exhibit a meticulous attention to details that pass by other less-awake souls. This is both a great gift and a great burden. Seeing the lawfulness of suprasensory patterns in a clear way makes the green soul prone to being a little too sensitive to pathological things in the outer world. Greens are sensitive to slight disturbances in form or protocol that most others would not notice. In the green the light is felt to have cosmic form. We could say that the form principle of the light is most important to the green soul.

To the lemon soul the personal experience of the universal light as personal thinking is the most important yearning. In this split is the challenge of the lemon soul. We could say that lemon souls have a personal relationship to what they think, and that their thinking process is a way of channeling instinctual personality urges into socially proper forms of thought. There is great joy in the soul of lemon persons to experience

that the light of thinking living in them personally can be used to divine the highest of moral ideals. Lemon souls live in the light but look into the dark and watch how thoughts need to arise to temper the instinctual urges of the flesh. As a result, lemon souls are in deep communication with both the angel in their souls and the devil.

Colors behind the Light

The turquoise is aware of the way the Word becomes flesh. The turquoise soul lives where the creative forces of the idea, which originate at the periphery, come into actual fact. In turqouise is a yearning to live more fully in the periphery, which is the source of the ideas. This yearning becomes more intensified in the cobalt blue, where the soul yearns to become one with the memories of its existence before birth, when it lived as one with the forces of the cosmic periphery in the starry heavens. This yearning is enhanced when the soul takes a step deeper into the darkness and lives in indigo. Here an abyssal experience of living between the worlds of life and death is present as a daily experience. When this is deepened into the violet color, the soul is present and awake as a witness to the activity of the archetypes living in the periphery of the cosmos. When this is intensified, the soul lives in the far periphery of the darkness in contact with the power of the cosmos to create from the authority of cosmic being. Turquoise is the color of the green moving back toward blue on the way to the darkness behind the light. Green lives in the experience of the light becoming form through the Word; lemon lives in personal experience of the light that has come through form into actual policies and social forms; and turquoise souls look behind the light of consciousness to see how the Word becomes flesh—how the thinking manifests truth. Their religious experience of life is of the Word just before it became flesh—the Word as irreversible truth.

Cobalt souls are devoted to the memory of the periphery. They are true believers in the world, with a natural inclination to follow authority figures in selfless ways. They focus their attention on the past. Indigo souls are caught in the abyss between center and periphery. They

experience the dilemma of knowing that something big has happened but they don't know what it is. As a result they tend to withdraw from life. Their soul pattern arises from an experience of shock and loss that was never faced consciously. Violet souls are devoted to listening attentively to the movement of the creative darkness deep within the periphery. They live in a spiritual plane that many consider to be "escapist," but they live there in harmony with the demands of that level of existence. For those souls, death is not frightening but an inevitable event full of great teachings. Purples live in the darkness in which many fear to tread. They are attracted to great displays of power and might—not so much physically but in the political and business realms. The purples are the royal movers and shakers, but they tend to be pedestrian in their beliefs, preferring to let the opinions of the masses shape their policies. Purple souls are not the most creative color; that mood lies in the magenta soul, the next step into the deepest darkness. In contrast to the irresistible fascination for creative self-expression, which seems to be the mainstay of magenta souls, purples truly are interested more in the ways that power works in the world.

Adjacent Colors

Purple is a cooler color than magenta, since it moves from magenta in the direction of blue. Carmine is the warmer of the two adjacent colors to magenta, in that it represents a movement toward the yellow side of the color wheel. Carmine also has two adjacent colors. Magenta is cooler than carmine, and vermilion is warmer than carmine. A close look at the color wheel, however, reveals a fundamental color paradox. Carmine is warm compared to magenta but cool compared to vermilion. This makes carmine both warm and cool. What this really says is that the fundamental nature of colors is always relational. The relational aspect of color work is the true bridge that allows colors to be seen as analogs of soul conditions. Every experience that is of a feeling nature in the soul is relational. If we find ourselves in a situation in which those around us who are too warm, we can find ourselves becoming cold by comparison.

If we are with people who are too cool in their soul nature, we might compensate by being too warm. These reactions are fundamental laws of the soul. They are even subtler than simple reactions. One person might feel warm toward a color in another soul, which is really a cool color experienced inwardly by the other soul—that is, a person who has a blue character may be thought of as warm by another person, who is even more blue than they are. This seems contradictory but is really the basic nature of the color experience in the soul.

Appendices

4. Soul Wheel

Wheel 1 (small, upper left)

- rubor-congestion
- liver-phlegma
- indifference-fears life
- calor-inflammation
- heart-cholera
- anger-fears death
- dolor-pain
- kidney-sanguinity
- escape - fears shame
- tumor-hardening
- lung-melancholia
- depression-phobia

Wheel 2 (upper right - planetary)

- JUPITER-sacred living / living picture images
- VENUS-transforming dreams / sacred sleep practice
- I reclaim my power
- I own my fears
- SUN-futile rebellion / thinking backwards
- I wish to change
- MARS-false reasoning / geometric visualization
- I am powerless
- MOON-projecting blame / soul breathing practice
- I see patterns
- SATURN- false hope / feeling of evidence
- I have a problem
- MERCURY- prayer life / inspired consciousness
- I am grateful

Legend (small circle, right)

Soul Wheel ©2007
- air — reversals
- fire — karma
- earth — differences
- water — changes

Main Wheel (bottom)

Outer ring (remedies / archetypes):
- magenta — wounded-indignant — white chestnut — star of Bethlehem-larch
- cerato — pine - red chestnut
- carmine — vacillating
- pulsatilla — THE PEACE MAKER
- staphysagria — THE NOBLE SUFFERER
- lycopodium — THE FLAWED LEADER
- sepia — THE PROUD SUFFERER
- aloe-unavailable
- violet — THE ALOOF
- willow- wild rose
- cherry plum- clematis
- gorse
- indigo
- ignatia — THE BROKEN HEART — grieving alone
- calcium carb — THE ETERNAL EMBRYO — caught in memories
- cobalt
- chicory
- gentian-honeysuckle
- willow- oak
- agrimony
- turquoise
- arrogant-cold
- nat mur — THE TRUTH TELLER
- silica — SENSITIVE SERVER
- green
- mimulus
- centaury- elm
- lemon
- rock water
- beech- holly- crab apple
- nux vomica -lachesis — THE BOSS — chronic irritation
- walnut-impatiens
- clematis
- yellow
- phosphorus — THE ACTOR — scattered
- orange
- vervain
- hornbeam- impatiens
- arsenicum — THE PERFECTIONIST — obsessive control
- sulfur-belladonna — THE PEEVISH SCHOLAR — oblivious of others
- vermilion
- vine
- chestnut bud
- water violet
- purple
- egocentric

Bibliography and Further Reading

Allen, Paul Marshall, and Joan deRis Allen. *The Time Is at Hand! The Rosicrucian Nature of Goethe's Fairy Tale of the Green Snake and the Beautiful Lily and the Mystery Dramas of Rudolf Steiner.* Hudson, NY: Anthroposophic Press, 1996.

Babbitt, Edwin D. *The Principles of Light and Color: Including among Other Things the Harmonic Laws of the Universe, the Etherio-atomic Philosophy of Force, Chromo Chemistry, Chromo Therapeutics, and the General Philosophy of the Fine Forces, together with Numerous and Practical Applications.* New York: Babbitt, 1878 (available in reprint editions).

Barnard, Julian. *Bach Flower Remedies Form and Function.* Great Barrington, MA: Lindisfarne Books, 2001.

Barnard, Julian, and Martine Barnard. *Healing Herbs of Edward Bach: An Illustrated Guide to the Flower Remedies.* London: Ashgrove, 1988.

Benson, J. Leonard. *The Inner Nature of Color: Studies on the Philosophy of the Four Elements.* Great Barrington, MA: SteinerBooks, 2005.

Bortoft, Henri. *Taking Appearance Seriously: The Dynamic Way of Seeing in Goethe and European Thought.* Edinburgh: Floris Books, 2013.

———. *The Wholeness of Nature: Goethe's Way toward a Science of Conscious Participation in Nature.* Hudson, NY: Lindisfarne Books, 1996.

Collot d'Herbois, Liane. *Colour: A Textbook for Anthroposophical Painting Groups.* Edinburgh: Floris Books, 2006.

———. *Light, Darkness, and Colour in Painting Therapy.* Edinburgh: Floris Books, 2000.

Coulter, Catherine R. *Portraits of Homeopathic Medicines: Psychophysical Analyses of Selected Constitutional Types.* Berkeley, CA: North Atlantic Books, 1986.

Dalton, David. *Stars of the Meadow: Medicinal Herbs as Flower Essences.* Great Barrington, MA: Lindisfarne Books, 2006.

Dinshah, Darius. *Let There Be Light: Practical Manual for Spectro-Chrome Therapy* (8th ed.). Malaga, NJ: Dinshah Health Society, 2005.

———. *Spectro-Chrome Guide: Abridged Manual for Spectro-Chrome Therapy.* Malaga, NJ: Dinshah Health Society, 1997 (condensed from *Let There Be Light*).

Eastlake, Charles L. *Methods and Materials of Painting of the Great Schools and Masters.* Mineola, NY: Dover, 2001.

Eckermann, Johann Peter. *Conversations of Goethe with Eckermann and Soret.* New York: Cambridge University, 2012.

Edelglass, Stephen. *The Marriage of Sense and Thought: Imaginative Participation in Science.* Great Barrington, MA: Lindisfarne Books, 2011.

———. *The Physics of Human Experience.* Hillsdale, NY: Adonis Press, 2006.

Eckstut, Joann, and Arielle Eckstut. *Secret Language of Color: Science, Nature, History, Culture, Beauty of Red, Orange, Yellow, Green, Blue, & Violet.* New York: Black Dog and Leventhal, 2013.

Ghadiali, Dinshah. *Spectro-Chrome Metry Encyclopedia.* Malaga, NJ: Dinshah Health Society, 1997.

Goethe, Johann Wolfgang von. *The Fairy Tale of the Green Snake and the Beautiful Lily.* Great Barrington, MA: Anthroposophic Press, 1991.

———. *Goethe on Science: An Anthology of Goethe's Scientific Writings* (ed. Jeremy Naydler). Edinburgh: Floris Books, 1996.

———. *Goethe's Theory of Colours* (tr. C. L. Eastlake). Cambridge, UK: Cambridge University, 2014.

Graham, Helen. *Discover Color Therapy: A First-Step Handbook to Better Health.* Berkeley, CA: Ulysses Press, 1998.

Hahnemann, Samuel. *Organon of the Medical Art.* Palo Alto, CA: Birdcage, 1996.

Hauschka, Margarethe. *Fundamentals of Artistic Therapy Founded upon Spiritual Science: The Nature and Task of Painting Therapy.* London: Rudolf Steiner Press, 2015.

Itten, Johannes. *The Art of Color: The Subjective Experience and Objective Rationale of Color.* New York: Wiley, 1973.

———. *The Elements of Color: A Treatise on the Color System of Johannes Itten Based on his book* The Art of Color. New York: Wiley, 1970.

Jackson, Robin. *Hermann Gross: Art and Soul.* Edinburgh: Floris Books, 2008.

Jenny, Hans. *Cymatics: A Study of Wave Phenomena and Vibration* (3rd ed.). Newmarket, NH: MACROmedia, 2001.

Kandinsky, Wassily. *Point and Line to Plane.* New York: Dover, 1979.

———. *Concerning the Spiritual in Art.* New York: Dover, 1977.

Klocek, Dennis. *Climate: Soul of the Earth*. Great Barrington, MA: Lindisfarne Books, 2011.

———. *Esoteric Physiology: Consciousness and Disease*. Great Barrington, MA: Lindisfarne Books, 2016.

———. *Sacred Agriculture: The Alchemy of Biodynamics*. Great Barrington, MA: Lindisfarne Books, 2013.

———. *The Seer's Handbook: A Guide to Higher Perception*. Great Barrington, MA: SteinerBooks, 2004.

Kühl, Johannes. *Rainbows, Halos, Dawn, and Dusk: The Appearance of Color in the Atmosphere and Goethe's Theory of Colors*. Hillsdale, NY: Adonis Press, 2016.

Linderman, Albert. *Why the World around You Isn't as It Appears: A Study of Owen Barfield*. Great Barrington, MA: Lindisfarne Books, 2012.

Lord, Angela. *The Archetypal Plant: Rudolf Steiner's Watercolour Painting*. London: Temple Lodge, 2015.

———. *Colour Dynamics: Workbook for Water Colour Painting and Colour Theory*. Stroud, UK: Hawthorn Press, 2010.

Lüscher, Max. *The Lüscher Color Test: The Remarkable Test that Reveals Your Personality through Color*. New York: Random House, 1969.

Maier, Georg. *An Optics of Visual Experience*. Hillsdale, NY: Adonis Press, 1986.

Pancoast, Seth. *Blue and Red Light: Or, Light and Its Rays as Medicine; Showing that Light Is the Original and Sole Source of Life, as It Is the Source of All the Physical and Vital Forces in Nature; and that Light Is Nature's Own and Only Remedy for Disease*. Philadelphia: Stoddart, 1877.

Richter, Gottfried. *Art and Human Consciousness*. Great Barrington, MA: Anthroposophic Press, 1985.

Seiler-Hugova, Ueli. *Colour: Seeing, Experiencing, Understanding*. London: Temple Lodge, 2011.

Sheldrake, Rupert. *Morphic Resonance: The Nature of Formative Causation*. Rochester, VT: Park Street Press, 2009.

Silvers, Robert B. (ed.). *Hidden Histories of Science*. New York: The New York Review of Books, 1995.

Steiner, Rudolf. *Anthroposophical Leading Thoughts: Anthroposophy as a Path of Knowledge: The Michael Mystery*. London: Rudolf Steiner Press, 1973.

———. *Anthroposophy (A Fragment): A New Foundation for the Study of Human Nature*. Hudson, NY: Anthroposophic Press, 1998.

———. *Art History as a Reflection of Inner Spiritual Impulses*. Great Barrington, MA: SteinerBooks, 2016.

———. *The Bhagavad Gita and the West: The Esoteric Significance of the Bhagavad Gita and Its Relation to the Epistles of Paul*. Great Barrington, MA: SteinerBooks, 2006.

———. *The Boundaries of Natural Science*. Spring Valley, NY: Anthroposophic Press, 1987.

———. *Butterflies: Beings of Light*. London: Rudolf Steiner Press, 2013.

———. *Colour*. London: Rudolf Steiner Press, 1997.

———. *Finding the Greater Self: Meditations for Harmony and Healing*. London: Rudolf Steiner Press, 2002.

———. *Founding a Science of the Spirit*. London: Rudolf Steiner Press, 1999.

———. *Goethe's Theory of Knowledge: An Outline of the Epistemology of His Worldview*. Great Barrington, MA: SteinerBooks, 2008.

———. *How to Know Higher Worlds: A Modern Path of Initiation*. Hudson, NY: Anthroposophic Press, 1994.

———. *Intuitive Thinking as a Spiritual Path: A Philosophy of Freedom*. Hudson, NY: Anthroposophic Press, 1995.

———. *Learning to See into the Spiritual World: Lectures to the Workers at the Goetheanum*. Great Barrington, MA: SteinerBooks, 2009.

———. *Nature's Open Secret: Introductions to Goethe's Scientific Writings*. Great Barrington, MA: SteinerBooks, 2015.

———. *An Outline of Esoteric Science*. Hudson, NY: Anthroposophic Press, 1997.

———. *A Psychology of Body, Soul, and Spirit: Anthroposophy, Psychosophy, Pneumatosophy*. Hudson, NY: Anthroposophic Press, 1999.

———. *The Riddle of Humanity: The Spiritual Background of Human History*. London: Rudolf Steiner Press, 1990.

———. *Rosicrucianism Renewed: The Unity of Art, Science, and Religion: The Theosophical Congress of Whitsun 1907*. Great Barrington, MA: SteinerBooks, 2006.

———. *The Secret Stream: Christian Rosenkreutz and Rosicrucianism*. Great Barrington, MA: Anthroposophic Press, 2000.

———. *Theosophy: An Introduction to the Spiritual Processes in Human Life and in the Cosmos*. Hudson, NY: Anthroposophic Press, 1994.

Tomberg, Vanentin. *Christ and Sophia: Anthroposophic Meditations on the Old Testament, New Testament, and Apocalypse*. Great Barrington, MA: SteinerBooks, 2006.

Tuchman, Maurice (ed.). *The Spiritual in Art: Abstract Painting, 1890-1985*. New York: Abbeville Press, 1986.

Unger, Carl. *The Language of the Consciousness Soul: A Guide to Rudolf Steiner's "Leading Thoughts."* Great Barrington, MA: SteinerBooks, 2012.

———. *Steiner's Theosophy and Principles of Spiritual Science*. Great Barrington, MA: SteinerBooks, 2015.

Valandro, Marie-Laure. *Touched: A Painter's Insights into the Work of Liane Collot d'Herbois*. Great Barrington, MA: Lindisfarne Books, 2012.

Wagner-Koch, Elisabeth, and Gerard Wagner. *The Individuality of Colour: Contributions to a Methodical Schooling in Colour Experience*. London: Rudolf Steiner Press, 2009.